D0207838

Santa Cruz Island Figure Sculpture

and

Its Social and Ritual Contexts

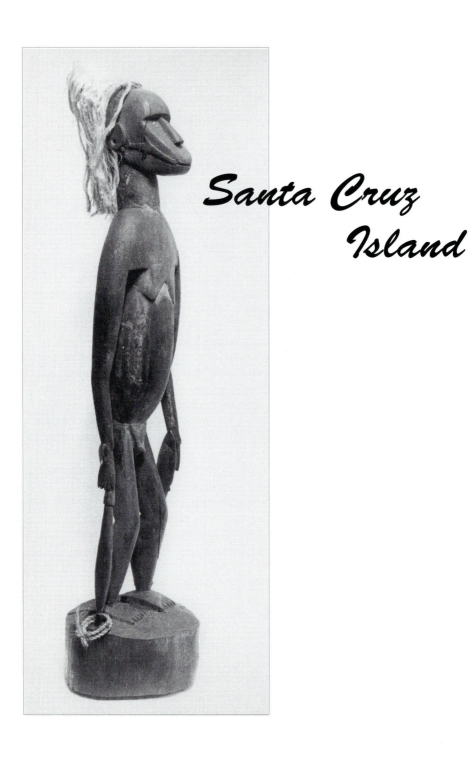

Santa Cruz Island

WILLIAM H. DAVENPORT

Figure Sculpture

and Its Social and Ritual Contexts

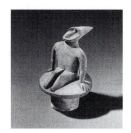

University of Pennsylvania Museum of Archaeology and Anthropology
Philadelphia

Copyright © 2005 by UNIVERSITY OF PENNSYLVANIA MUSEUM
OF ARCHAEOLOGY AND ANTHROPOLOGY
3260 South Street
Philadelphia, PA 19104-6324

First Edition

All Rights Reserved

Library of Congress Cataloging-in-Publication Data

Davenport, William H., 1922–
 Santa Cruz Island figure sculpture and its social and ritual contexts / William H. Davenport.—1st ed.
 p. cm.
 Includes bibliographical references and index.
 ISBN 1-931707-81-2 (hbk. with accompanying CD : alk. paper)
 1. Solomon Islanders—Material culture—Solomon Islands—Nendö.
 2. Solomon Islanders—Solomon Islands—Nendö x Social life and customs.
 3. Art, Solomon Islands—Solomon Islands—Nendö. 4. Sculpture, Melanesian—
Solomon Islands—Nendö. 5. Nendö (Solomon Islands)—Social life and
customs. I. University of Pennsylvania. Museum of Archaeology and
Anthropology. II. Title.
 DU850.D38 2005
 730'.99593—dc22
 2005014144

Figure on p. ii from Museum of Mankind, photograph © The Trustees of The British Museum; see Plate 8. Figure on p. iii from Field Museum of Natural History; see Plate 37.

Printed in the USA on acid-free paper.

*Dedicated to Joseph Alū of Banūa, Selwyn Balū of Nule,
and to Menaplo of Napu*

Contents

Figures

Preface

B ill Davenport worked overtime before his death in March of 2004 to complete the final editing of this book of figurative sculpture from Nendö (Ndeni, Nitendi, Nidu, Santa Cruz Island). He nearly succeeded.

Nendö (length: 25 miles, width: 14 miles) is the largest of the Santa Cruz Islands, which along with the atolls Tikopia, Anuta, and Fatutaka comprise what is now called the Temotu Province of the Solomon Islands nation in Melanesia in the southwestern Pacific. Today Nendö has nearly the same population, ca. 5,000, as records reveal for the year 1976, when the Santa Cruz Islands group was, and would remain until its independence in July of 1978, part of the British Solomon Islands Protectorate. Lata, the capital of the Temotu Province with a population of ca. 1,500, is on Nendö. It has an airport to and from which planes fly two or three times a week to Honiara, the capital of the Solomon Islands on the island of Guadalcanal.

Bill's work on Nendö was done between 1958 and 1976 before there was an airport and during the period of the Protectorate. His many close friends there included both his informants in the villages and officers of the British Colonial service. This book, at its core, is the result of these cherished and lasting friendships. In it are anecdotal biographies of early European art collectors in the area and photographs with well-documented catalogue entries of the 55 extant standing and seated wooden representations of the island's traditional gods (*dukna*) and supernaturals (*leimuba*). There is also an engaging and previously unrecorded presentation, transcribed and distilled from local informants, of the oral myths, rituals, and ceremonies by means of which Santa Cruz believers distinguished, celebrated, and communicated with their deities.

That Bill could not finish this final project, so vitally important to him as a Pacific anthropologist, art historian, and friend of the people of the Santa Cruz Islands, has led those of us who knew him to complete the task in his honor and in his memory in conjunction with the Publications Department of the University of Pennsylvania Museum of Archaeology and Anthropology.

While Bill in the list below has acknowledged the support of a number of his colleagues and friends in Pacific studies, I myself simply wish to acknowledge and thank two people: Walda Metcalf, Director of University Museum Publications, and Jennifer Quick, Senior Editor and a longtime friend of Bill's at the Museum. They have made this book possible. I would also like to thank Deborah Waite, Professor of Art History at the University of Hawaii and a specialist in the arts of the Pacific, for her wisdom and counsel, and William Cruz for his patience and skill as designer and cartographer.

Bill first cultivated his dreams of the far Pacific as a child in the Depression 30s in southern California. At the age of 14 he shipped out of Los Angeles on a commercial freighter to end up to his surprise and amazement, albeit briefly, in a jail in Singapore. In the Pacific Theater during World War II, Bill rose to the rank of lieutenant in the Navy's Merchant Marine at the age of 22, maneuvering small vessels in and around Pacific island reefs and inlets. He then studied at the University of Hawaii, from which he graduated in 1952, majoring in anthropology while working simultaneously both with Hawaiian archaeology and art.

Bill did his first field work on the Santa Cruz Islands between 1958 and 1960. He returned there four more times: for two years each between 1958–60 and 1964–66 and for an additional two summers in 1974 and 1976. He was, he remembered, his informants' post hoc informant on World War II, a conflict which had seethed around them but about which they understood little except that it had had disastrous results for their lives and land. In his later field trips, he recalled being an informant of an entirely different nature. People came to ask Bill about their old gods, which had been systematically deposed by the Christian missionaries before and during his years on the Santa Cruz Islands. Local cultural memory had been immortalized on his 3x5″ notecards.

In a poignant juxtaposition of tradition and technology, John Still Menivi, son of Menaplo of Napu village to whom Bill had dedicated this book and surrogate son of Bill himself from his first years in the Santa Cruz Islands, e-mailed me just after Bill died to ask for help in paying the "bride price" for his son, who was unable to marry without the traditional payment to his future father-in-law. Thus, a Gift American Express Travelers Check sent by FedEx to Banua became the final and electronic coda to a friendship that had been forged with a place and a people over 46 years, thousands of miles of distance, and across two centuries.

To write the first catalogue raisonné of a genre or style of art is a daunting task. One must search the texts, follow every lead, carefully cull originals from copies, inquire of colleagues, galleries, museums, and collec-

tors worldwide. That the sum total of authentic works is small does not mean that the mental geography was likewise. Bill's acknowledgments give clear evidence of the international scope of his research and contacts. He wished mention and thanks to be given to the following: Marie Claire Bataille-Benguigui, Lissant Bolton, Alan Borg, William Cranstone, Regine de Ganay-van de Broek, William Donner, the late Douglas Fraser, Allan Frumkin, the late Roger Green, Wendy Harsant, Ingrid Heermann, Ellen C. Higgins, Dale Idiens, Iolanda Jon, Adria Katz, Christian Kaufmann, Françoise Keller, Roger Lefevre, Phillip Lewis, Bruce McFadgen, the late Douglas Newton, Hanns Peter, David Roe, Roger Rose, Sir Robert Sainsbury, Donald R. Simmons, Dorota Czarkowska Starzecka, Waldemar Stöhr, Alessandro Tana, Hermione Waterfield, Raymond J. Wielgus, Lynette J. Williams, P. C. Lincoln, and Martin Wright and Faith Dorian-Wright.

This book, written by a scholar in command of the breadth and depth of his material, is both ur text and essential benchmark. It is the former because it is an authentic record of a cultural matrix which is barely now either lived or remembered by the descendents of whose who created it. It is the latter because all putative Santa Cruz figural sculpture discovered in the future must be judged and measured against this corpus of authenticated originals.

Nancy Davenport

Bill Davenport at home, Graciosa Bay, Santa Cruz Island (Nendö), 1967.

xiii

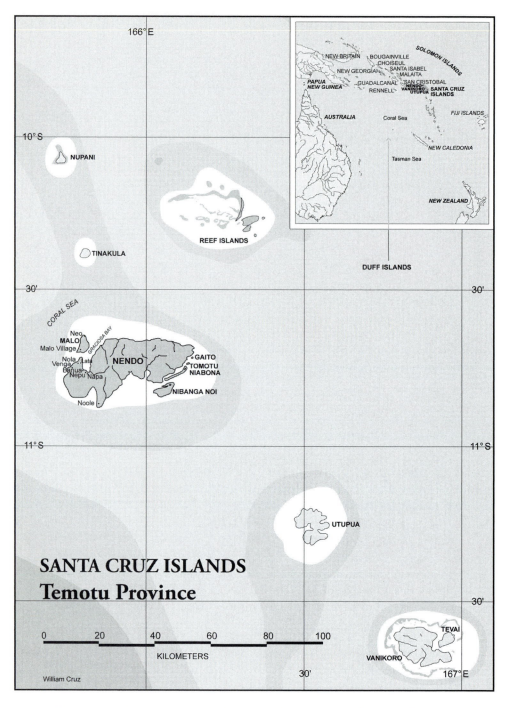

Figure 1.1. Santa Cruz Island (Nendö) and adjacent islands; inset, Solomon Islands. By William Cruz.

1
The Collectors

*T*he collection of sculpture discussed and pictured in this study comprises all the known specimens of a unique genre of tribal art from a single place, Santa Cruz Island, located in the southwest Pacific Ocean (Figure 1.1). This is the ethnographic and tribal art region called Melanesia. I shall refer to Santa Cruz Island as Nendö, which is its name in the main language of the island.[1] Altogether there are 55 specimens, shown as plates in this catalogue. All are figurative, that is they resemble the human body, and all can be categorized as sacred icons that depict deities or other supernatural beings in the religious and mythic domains of Nendö culture. As of the year 2000 these 55 figures were located in museums and private collections in 10 countries: England, Scotland, France, Germany, Switzerland, Belgium, the United States, New Zealand, Australia, and the Solomon Islands.

In the most widespread dialect spoken on Nendö[2] the sculptures are called *munga dukna* (*munga* = "image," "likeness," "representation"; *dukna* = "deity" or "supernatural being"). As a category of material culture *munga dukna* also includes other sorts of images such as roosters, lizards, sharks, and possibly snakes because some deities were, under certain conditions, represented by such animal forms. However, this book does not include the animal representations of *dukna* because very few of them exist, and very little is known about the deities who revealed themselves in non-anthropomorphic forms. One exception is the *dukna* Opla who, according to myth and legend, is said to have commanded his worshippers to change their carved depictions of him from humanlike to that of a rooster.[3]

Nendö is the largest island in the Santa Cruz Islands group, both in area and population, yet it is small when compared with most of the Solomon Islands which lie directly to the west and with which the group was merged to form the British Solomon Islands Protectorate (BSIP) in the late 1800s. (The Santa Cruz Islands are now part of the Solomon Islands nation.) Reli-

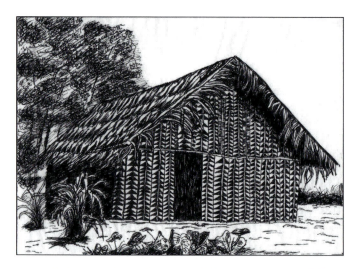

Figure 1.2. Sacred storehouse (madukna). *Drawing by Sioban Brady after Graebner (1909: pl. 21).*

gious carvings in anthropomorphic form were made and used only on Nendö. Elsewhere in the Santa Cruz Islands the deities were represented by carvings and drawings in geometric patterns (see Davenport 1972:46–47) or by reproductions of weapons and tools, such as spears and adzes.

On Nendö, geometric designs were applied as surface decoration to some religious objects, such as special dance clubs (*napa*; see Koch 1971: Abb. 143; Waite 1983: pl. 35), and to the outside walls of sacred storehouses (*madukna*) in which religious paraphernalia were kept between public rituals and celebrations and in which private rites were occasionally performed. Because of its distinctive exterior the *madukna* was the most conspicuous structure in a village, and it stood somewhat separated from the dwellings (*mabau*) and the men's houses (*madai*), usually in the rear or to the side of the settlement area (Figure 1.2).

Dwellings were usually built with front doors facing toward the men's house; men's houses were built either facing toward the sea or on the main path leading in and out of the village. Village gardens were usually located at some distance behind the settlement in the forest (Figures 1.3 and 1.4). These relative locations and orientations of structures reflected a bipolar and bi-gender opposition of the people: men's turf at one pole, women's space opposite. This was duplicated within a dwelling, with male space around a

2

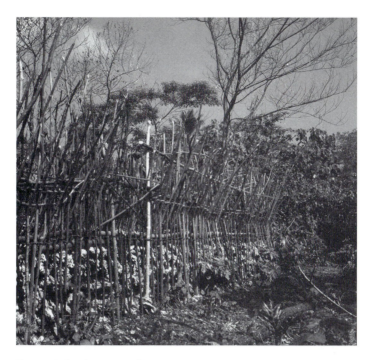

Figure 1.3. A new garden.

Figure 1.4. An old garden.

central hearth and on the side with the front door, women's space at the back of the house where a cooking hearth was located, as well as a rear door which opened onto a path that led to the gardening space some distance away. This spatial arrangement enabled men and women to go about their everyday business with a minimum of face-to-face encounters.

Returning to the subject of *munga dukna*, the individuals who were responsible for collecting and/or removing these 55 images from Nendö were a varied group. Most were Christian missionaries, some were ethnographers, one was a trader, two were visiting yachtsmen/travelers, one was a Protectorate official, another was the European manager of a timber extraction concern that briefly operated on Nendö, and one other an art dealer who went to Nendö just to see if he could find another image (and he did).

The missionaries who collected were Europeans associated with the Melanesian Mission (Anglican); they usually resided on the island for various intervals and lived in close relationship with the people. Initially, the missionaries preferred to destroy images publicly or have their owners do so both as a demonstration of their new faith and proof that such sacrilegious acts would bring about no retaliation from the traditional deities. This is the main reason why so few specimens of the sculpture and other sacred material culture were available when the missionaries reversed their policy of destroying sacred objects and began to collect them for overseas museums and individual collectors (and, of course, to be paid for their efforts).

In several instances early on when missionaries brought about the destruction of sacred objects, the sacrilegious acts were followed by sudden unexplained deaths, epidemics, severe storms, and periods of drought, which had the opposite effect on the people's religiosity than had been intended. The waves of epidemics that swept Nendö and the surrounding region around the turn of the century, reducing populations everywhere by one-half or more (see Rivers 1922), were interpreted by religious leaders as due to the anger of deities, provoked by the destruction and desecration of sacred material representations of them. The missionary effort to bring Nendö into Christendom was a very lengthy affair. And it was costly: several missionaries and lay workers lost their lives in the prolonged effort.

The first image to be collected (Plate 23) was obtained in 1882 by the missionary Alan Lister Kaye, and it is known only through a drawing of it that was published in the Edge-Partington album of Pacific Island artifacts (Edge-Partington 1890, I:163). Lister Kaye collected only a few objects from Nendö as "curiosities," but he neither published nor informed anyone we know of about the circumstances of his acquisitions. Unfortunately, the

piece he collected and any notes that he may have made have been lost track of, possibly destroyed.

The last image to be collected (Plate 51) was obtained nearly a century later in 1986 by a dealer/collector who spent but a few hours on the island and took virtually no notes about his lucky acquisition.[4] By that time it was considered that Nendö had been completely converted to Christianity for several decades, there were ordained Anglican ministers in residence, the Melanesian Mission was operating a secondary school there, and the Solomon Islands government maintained a radiotelephone station, a post office, and subdistrict administrative offices there. The island also had a landing strip, and there was regular air service by small plane to Kira Kira, San Cristobal, and to Honiara, capital of the Solomon Islands on Guadalcanal. Even tour ships occasionally called into Graciosa Bay on Nendö, and the appearance of a cruising yacht from time to time did not cause a stir.

Three images (Plates 39, 40, and 41) were commissioned by an ethnologist, myself; another (Plate 47) was probably obtained directly from its owner by the anthropologist Felix Speiser; and one (Plate 46) was obtained by Charles van den Broek, a yachtsman who came to Nendö on a large yacht in 1935. Although van den Broek was not ashore much, he managed to purchase the object, and his wife made excellent pencil sketches. His description of his acquisition is unusual for its candor, sensitivity, and clarity:

> I wanted to find an object which had become very rare, a shark god. At two hours [walk] from Nole [Noole, on the south coast of Nendö] can be found Nimbelowi [also called Neboui]. A fisherman's house [actually a men's house, *madai*] there is quite vast. All the fishing gear is piled up there. Around the central entrance a few old men are seated on little stools…[They] seem less accustomed to having contact with strangers than those of the other villages…A native with splendid earrings of turtle shell is leaning back on one of the posts holding up the roof. Above him, on a shelf, five skulls are lined up. The holes of the eyes and nose have been plugged up with bungs of wood.
>
> Four other skulls grimace on the walls…On the central post, a tiny little figurine, very finely sculpted represents a seated man. It is a shark god, the principal personage of all the legends [which suggests the Meboku myth sequence described in Chapter 5]. His face is stylized in the African manner: prominent and elongated chin. Soot has darkened this statuette considerably. The man with the turtle shell ornaments seemed to be a living and grotesque replica of the figurine; he got from me a stick of tobacco in homage to the divinity. The timid attempts we made to obtain the statuette were not successful. One could not even touch it we were told. The last time a man had committed the

sacrilege of taking it from its house he had his leg broken by a shark. Before going out to fish the natives present to him a fine offering after which they go out reassured; the god will protect them…The shark god is venerated now in a few villages of the coast, quite far from Graciosa Bay where the Methodist [*sic*] is found. I had only one idea in my head: to acquire one of these precious figurines. I visited all of the villages [hamlets clustered around a men's house]. At Nimbelou when I spoke of the shark god they seemed not to understand me…Finally, I discovered one of these figurines, sculpted with an incredible finesse out of an old piece of wood, entirely blackened by the smoke of many hearths which had been lit since the day this little work of art had been finished. At first the men did not want to hear anything. I sat down and palavered for two hours brandishing bank notes. These semi-savages only had gained from civilization the value of money. I sensed interested glances directed toward the money; I was so determined that at the end I got what I wanted. I had to make a general distribution of tobacco beyond the purchase price. I also had myself to take down the shark god. Everyone looked with attention at this white man who did not fear to touch this all-powerful god. When I had it in my hands no one would come near to me any longer…I had an object which was very curious and of considerable ethnographic interest; but in my heart of hearts I thought with melancholy of the shelf now empty, before which nine generations of guardians, represented by nine skulls. I was only a vandal…

But I consoled myself in reflecting on the fate which would have befallen this charming divinity. Missionaries would come who would surely burn it. With luck, it would have fallen into the hands of an American scholar who would have made a gift of it to a museum in his country.

Myself, at least, I will bring it to France where there is no other. (van den Broek 1939:121–30; Girard 1971)

The largest number of specimens were obtained during the late 1920s, several years before van den Broek made his acquisition and wrote the account just quoted. By this time, after many years of relatively unsuccessful proselytizing, the labors of the missionaries of the Melanesian Mission were finally being rewarded with conversions. It was also about this time that the trader Fred Louis Jones began collecting ethnographic materials as part of his trading business. His customers for these objects were in New Zealand and England. At this time, too, the resident missionary on Nendö was the Reverend George West who, with the consent of his Bishop, began to collect religious carvings instead of destroying them. Some of the carvings he collected were sold to Jones, and others he sold or gave to clients in New

Zealand and Australia. Most of the finest specimens among the 55 that remain came through Captain Jones or the Reverend West. West used the proceeds from his collecting to help offset the costs of his missionary work; Jones looked on the artifact business in the same way he looked at the other commodities he bought and sold. He was in the islands to make a living.[5]

Despite his dedication to eradicating the traditional religion and spreading the Word of God, the Reverend West could be quite objective about collecting images, and he seemed to have derived some personal satisfaction from making particularly desirable acquisitions. In a personal letter on November 19, 1930, to the anthropologist H. D. Skinner in New Zealand, West wrote the following about the figure in Plate 26:

> Another image is a man and a woman standing side by side. I am sorry the woman got broken off but it was broken before I got it. But when the natives gave it to me I did not want to let them see that I was keenly interested in it and left it lying on a rock on the beach where they had put it, while I went about my business ashore, and when I came back about 2 hours after the tide had come up and carried the woman away but left the man standing, some kiddies had seen it floating but were afraid to go near it, and although we searched for a while we could not find it and it was not till about a month later after that a native brought it along having found it washed on the beach, but parts of it were broken an arm and an ear I think.

Most of the images were collected from northern coastal villages on Nendö, because that area had the best anchorages and landing places for the small ships used by the Melanesian Mission, Captain Jones, and the few others who occasionally called. This was also the most densely populated part of the island, hence the most attractive to both Jones and the missionaries. Three of the specimens (Plates 42, 43, and 44) were collected in 1897. Two (Plates 40 and 41) were collected in 1958–59) and were made expressly for the collectors; another (Plate 35) was made in 1977 or 1978 and given as a parting gift to a European who had resided on Nendö for several months as manager of a timber extracting operation. Technically, these latter are "curios," but their style and distinctive features do not appear to be significantly different from specimens that are known to have been made earlier for use in traditional religious rituals.

Among the missionaries associated with the collection of carvings, the name of A. E. C. Forrest has special significance. Forrest took up residence on the north coast of Nendö at a place called Nelua in 1887. That was five years after Lister Kaye had collected the first carving and more than four

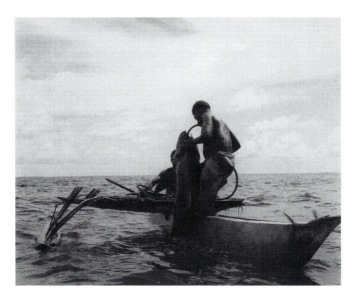

Figure 1.5. Fishermen catching a shark with a noose.

decades before a *pax Britannica* was finally established throughout the Santa Cruz Islands. At Nelua he built a rude schoolhouse made of local materials for young students, made friends with and secured the support of Natei, the notorious "big man" of the area, and also operated a small trading business.[6]

Forrest, a lay missionary, was unusual in his ability to learn local languages and for his keen interest in the customs of the people around him whose children he was trying to influence in his schools. He is remembered by the name Mebuano, meaning "Mr. Shark Man [of the -*no* species]" because of his determination to catch sharks in the dangerous local manner, from an outrigger canoe and using a noose (Figure 1.5). Forrest/Mebuano also explored the island more extensively than any European before him, so that he became personally known to more local people than any other European. By Nendö criteria, Forrest/Mebuano even became a rich man (*bonia*) from selling the sharks he caught to local men for consumption in their social rituals.

He also was host to several natural scientists who came to Nendö to undertake research, among whom was Wilhelm Joest of Cologne, Germany. Forrest/Mebuano arranged to have three very similar images (Plates 42, 43, and 44) carved for Joest, but we do not know who the carver was or exactly

where he lived. Most likely it was at or near Nelua. Joest took ill while staying with Forrest/Mebuano and was eventually evacuated on a French ship that had made an unexpected call at Graciosa Bay, which is some distance to the east of Nelua. Forrest/Mebuano made all the arrangements with the captain of the ship to take the prostrate Joest aboard. Unfortunately, Joest died aboard that ship a few days after it left Nendö. Joest's ethnographic collections, which Forrest/Mebuano had looked after, eventually reached Germany.

In 1897 Forrest/Mebuano was abruptly relieved of his missionary duties for grave but unspecified moral offenses. He left Nendö on the Mission ship, telling his local friends that he was going away to get pigs for feasts. Subsequently, he committed suicide in the New Hebrides (now Vanuatu). The details of this unfortunate incident have never been fully divulged by the Melanesian Mission, but the memory of Forrest/Mebuano remains ever green.

A name that remains as *in*famous as Forrest/Mebuano's remains famous is that of District Officer C. E. J. Wilson. Wilson was assigned by the British Solomon Islands Protectorate (BSIP) as the resident administrator of the Santa Cruz Islands around 1925–26. Wilson officiated from an office located in the south of the group at Vanikoro Island and toured the other islands with a squad of Solomon Islander police whenever a vessel was made available to him. Wilson was a zealot who set about attacking all visible manifestations of traditional religion. On Nendö he seized sacred objects (*munga dukna*), burned sacred structures (*madukna*), and even razed whole villages in the Graciosa Bay area.[7] It is not clear at all why he was so zealous and so destructive in his attempt to rid the island peoples of their religion. When word of Wilson's actions reached higher authorities, he was called to account for the harshness of his methods.

There were official investigations, hearings, and a trial. But in the end no one was censured or convicted of misconduct. By the time all this was over, Wilson had served out his contract and was no longer an officer and resident in the Protectorate. Many critical documents relating to the Wilson affair are no longer in the BSIP Archives, and what became of them is not known. Over time the official version of the affair, now part of the oral history of the Mission and the old Protectorate, has become muddled.

District Officer Wilson's attempts to suppress the traditional religion seemed to have had little effect on the religiosity of Nendö people, but it did cause them to conceal and disguise their public rituals just in case another European zealot took offense at them. Nendö people even ceased placing images on altars inside their dwellings. For a time the Melanesian Mission interpreted the people's change in behavior as an indication they were ready to abandon their traditional religious beliefs and observances and

Figure 1.6. Graciosa Bay, Nendö.

embrace Christianity. But soon the Mission realized that there remained pockets of firm and committed traditional belief; these would endure, in fact for some decades to come.

2
Iconography and Style

*T*his chapter offers a general overview of the style and iconography of Nendö figurative sculpture. No extant figure today is complete in that none is fully clothed, painted, or decorated. Provided below is material useful for envisioning these figures as they once existed and were revered in Nendö culture.

Nendö figurative sculpture is a unique genre of tribal art, which is to say it comes from a single location and it has an identifiable style all its own. Some of the style features are purely formal and some are iconographic. In the latter the references, or iconic meanings, are to cultural significates. As necessary I shall make ethnographic digressions in order to explain such iconic references. As indicated, all 55 of the surviving specimens are anthropomorphic, and all are representations of deities (*dukna*) or supernatural beings called *leimuba* ("short people" or "little people"). Quite likely, 47 of the specimens had been used ritually at some time because they were obtained directly from their last owners and users, or an heir, and/or they bear some indication of ritual use.

The most convincing indication of ritual use is the presence of turmeric, a substance Nendö people regarded as containing some supernatural properties and which was often smeared on sacred objects in order to sacralize them. On the other hand, eight specimens were never intended to be used in religious rituals. Three of those were collected by the anthropologist W. Joest (Plates 42, 43, and 44), I collected three in 1958–60 (Plates 39, 40, and 41), and two were apparently carved as gifts to Europeans, one probably in the 1960s (Plate 34), the other in 1978 (Plate 35). In a strict sense, these eight are ethnographic curios, imitations, as it were, of objects that in their original context became sacralized through ritual use.[1] As it often is with curios of this kind, especially those made before a curio industry has developed, they possess the same style features found on genuine artifacts that were

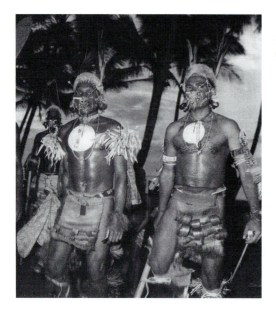

Figure 2.1. Nela *ceremonial attire.*

made for and used in traditional contexts. In their finished and complete state nearly all pieces of Nendö figurative sculpture were intended to be fully dressed and adorned in traditional formal wear (Figure 2.1). This is how humans envisioned the supernaturals: always elegantly attired, singing and dancing in their remote communities located in the far western sections of Nendö where humans seem never to have lived[2] (or if some did dwell in these remote places, they were very few in number).

In the earliest period of mythic history, the *dukna* created and modified the most conspicuous features of the landscape, then they begat offspring, most of whom are the active deities of the present. Next is a sort of inter-mediate mythic period, during which the first humans were born who in time peopled Nendö. This took place sometimes before, sometimes after the other islands of the group were inhabited by humans. Nendö mythic time is different from the European concept of historical time. Part of this differ-ence is due to the fact that *dukna* are immortal; temporal duration from the birth or first appearance of a *dukna* until he or she begets offspring is very elastic if one tries to equate it with time as it is conceived and measured in the present.

Dukna do exist in the same time frame as humans, but continually move back and forth between their supernatural domain of elastic time and the three-dimensional, diurnal world in which long periods are measured genealogically in human birth-to-death intervals. The principal work and responsibilities of the *dukna* who have made themselves known to humans (and presumably there are many others who are not known to humans) are directed toward the monitoring and guidance of the lives and affairs of Nendö persons. Being both supernatural and immortal, *dukna* are freed of working to feed themselves; sometimes they mate and have offspring, sometimes they engage in activities familiar to humans, although enduring domestic life is not characteristic of their existence. They seem to live mostly a life of leisure.

Carvings were not the only way in which *dukna* were represented. They were and still are depicted by costumed impersonators, a small group of specially selected young men who make up a lavishly costumed and adorned chorus at public song and dance feasts. Such choruses are, in effect, human

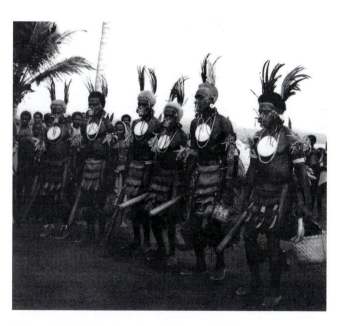

Figure 2.2. Nendö ceremonial dance (nela).

imitations of the *dukna* engaged in their favorite pastimes, singing and dancing. The costumes and body decorations that members of these choruses wear are similar to those applied to the carvings. These song and dance fests (Figure 2.2) are described in detail in Chapter 3.

Over time the adornments on the sculptures have deteriorated, slipped out of place, and even become detached and lost. Plates 3, 24, and 25 retain more remnants of clothing and ornaments than any others in the collection. Virtually no conservational restoration has been applied to any of the objects, even though some of the finest have been exhibited from time to time in the great museums, such as the British Museum, that own them.

I cannot explain why so many figures have been stripped of adornments or have lost the most important ones such as skirts and breech clouts. Some tidying up and partial stripping may have occurred when the figures were received abroad merely to satisfy the aesthetic tastes of those connoisseurs and curators who thought sculpture should be viewed as pure form, uncluttered by applied garments and other decoration. It is even possible that some of the last owners on Nendö stripped their figurines as they turned them over to the collectors as an act of rejecting them as objects for veneration.

For viewers of the photographs reproduced here, most of whom will be unfamiliar with Nendö culture, it is nearly impossible to mentally reconstruct what some of the figures might have looked like when they were objects of religious veneration. So in this chapter, along with discussing points of sculpture style, I shall attempt to explain what some of the adornments were, how they looked, and what they signified.

One specimen, Plate 52, is slightly different from the rest in that it represents a type of supernatural being that, strictly speaking, was not worshipped or venerated as a tutelary deity. This is the class of supernaturals called *leimuba*. The *leimuba* are believed to live in isolated communities deep in the rainforest, where humans rarely venture. Their communities are so well hidden that humans could never find them even if they tried, and presumably many have. The *leimuba* are shrouded in mystery. They cannot be summoned by prayer, but individual *leimuba* might suddenly appear to a human and bestow a good luck token of some kind or possibly a roll of valuable red-feather money, then, just as suddenly, disappear. Usually, *leimuba* seem to select humans who are in dire financial straits as the recipients of their gifts.

It is problematic whether *leimuba* have speech even to communicate among themselves. They never speak to humans when they appear to them. Besides rolls of red-feather money (Figure 2.3), the tokens *leimuba* hand out are small images (such as Plate 52) or miniature utilitarian objects such as betel, mortars and pestles, or eating bowls. These are to be carried about

14

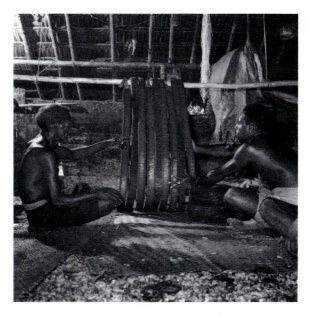

Figure 2.3. Rolls of red-feather money displayed on a special length of bamboo (noali).

secretly as good luck charms. *Leimuba* are always conceptualized as males, and no one is certain whether there are females or whether they reproduce or whether they are immortal as the *dukna* are. Semantically, there is a reluctance to classify *leimuba* as true *dukna*. Several persons I knew well described *leimuba* encounters they had experienced and stressed how they were virtually paralyzed with fear. Yet, no one could explain why they experienced such fear, because *leimuba* never harm humans in any way. The fear seemed to be part of an aura that surrounds them when they appear.[3]

All the other figures depict a category of protective or tutelary deities who exercised a great amount of control over the general welfare of their worshippers, or as I shall often refer to them, their clients. As Menaplo of Napu village, a devout traditionalist, once lectured me, "Tutelary *dukna* can do harm to others, even cause death, at the behest of their clients. Nothing really significant ever happens to an individual in which a *dukna* is not somehow involved. A *dukna* can assist its client, and it can punish him or her for behavior it considers offensive."

Superficially, the relationship between a tutelary deity and its client is in some ways similar to that of a very authoritative and intolerant parent to a child. Nendö people are well aware of this similarity, but there is one crucial difference: fathers do not use supernatural powers to control the behavior of sons and daughters. When missionaries first introduced the Christian concept "God the father," it was mistakenly translated and understood as "the *dukna* named Got [God] who is like *tutenge* [my father]," and this made no sense, because parents are strictly humans who do not possess supernatural powers.

I digress here to explain Nendö concepts of power. The kind of power exerted by a human in order, say, to paddle a canoe through the water or the power of an engine that propels a ship through the sea—that is, mechanical power—is termed *matu*. The power of speech to order someone to do something (the imperative mode) is also *matu*. *Matu* can be broadly defined as a force that can alter something in the everyday environment. In contrast, *malutu* is a supernatural force that only *dukna* possess and by means of which they bring about miraculous events. About each named tutelary deity there is a myth (usually lengthy and in several versions) or a set of fixed beliefs that demonstrate the strength and scope of that deity's supernatural power. Since the myths are believed to be true accounts of extraordinary events, they constitute the proof of the miraculous power, the *malutu,* that *dukna* can summon when they wish to (see Chapter 5). The whole religious domain of traditional Nendö society was based upon and derived from these sacred myths.

Still, Nendö people were and still are philosophical relativists, and they firmly hold to the principle that what is good and true for themselves is not necessarily good and true for the other Melanesian societies they know about. Moreover, they projected this view onto the European contact situation, especially to the preachings of missionaries. What is good and true for Europeans is not necessarily good and true for the people of Nendö. It took many decades for this attitude to be understood by the early missionaries, but for Nendö people it constituted their first line of defense against Christianity.

Appearance of the Carvings

Most of the figures represent the *dukna* standing: in only four instances (Plates 4, 20, 24, and 37) is the figure seated. This has to do with a characteristic habit of the deity depicted. For example, Plate 4 was identified by some informants as Melake because in the myths about him he is always sitting under a great tree as he intently fishes for a specific species of highly valued fish. The figures are usually carved with the image standing on a circular base

that is a cross section of the log used for the sculpture. A number of soft and medium hardwoods were utilized, the same woods as those used for making canoe bailers, food bowls, and a variety of other household utensils. Even the hardest of these woods are relatively easy to carve when they are green.

Sex is always indicated by genitals and by the clothing applied to the image. In all but four instances (Plates 4, 26, 34, and 39) the figure is male, and in one of the exceptions (Plate 26), the female is paired with a male. In only one piece (Plate 46) can the genitals be said to be exaggerated. It is possible that the large penis of this figure represents a physical characteristic the deity it represents had, but the name of that deity was never recorded by the collector, van den Broek, even though his account of the acquisition, quoted in Chapter 1, is the longest and clearest there is.

In one singular piece (Plate 14) the figure is perched atop what was at one time a sizeable post. The figure is a capital and below it are two pegs and low-relief geometric designs carved as embellishments. This specimen was probably a post-altar on which were hung fancy plaited baskets (*tepeliki*) containing food offerings.[4] It was quite likely to have been used by a worshipper who resided in and made his offerings in his men's house or in the privacy of a *madukna,* the sacred structures where religious paraphernalia were stored between public rituals. The hanging of food offerings was more characteristic of other islands in the Santa Cruz Islands, but was apparently a ritual alternative on Nendö.

The figures range from 9.0 cm (3½″) to 125.0 cm (49½″) in overall height. Within this range are two distinct subgroups: one group of 47 larger figures ranging from 19 cm (7¾″) to 125.0 cm (49½″), and another group of 8 miniature pieces (including Plate 52, discussed above) ranging from 9.0 cm to 14.0 cm (3½″ to 5½″). In brief, the functional differences between these two groups was that the larger pieces were placed on relatively permanent altars in dwellings and men's houses, as already described, while the smaller pieces were portable images that could be carried about by the worshipper and utilized when he was away from his household or men's house altar.

The explanations I was always given by informants stressed the use of portable figures in hazardous places and situations. The figures of the deities on these smaller carvings are in three instances (Plates 20, 37, and 53) incorporated into useful objects: stoppers for water bottles or large lime containers (used for betel) that men took along with them while they worked and traveled. The dangerous work and situations most often mentioned were fishing for shark and other large fish, hunting birds for the red feathers used for making the red-feather currency (always dangerous because it could take the

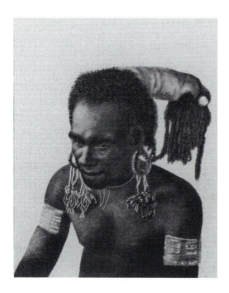

Figure 2.4. Man wearing abe;
*Vanikoro, Santa Cruz Islands.
From Festetics van Tolna
(1903:268).*

hunter into areas belonging to an enemy community), and trading visits to men's houses in hostile communities.

The Abe Headdress

As mentioned above, Nendö images were always clothed and bedecked with body ornaments. The most common articles of clothing on images are men's breech clouts, women's knee-length skirts, men's breast ornaments and nose pendants, and the men's headdress called an *abe*. Unlike the other articles of male clothing which are applied to the figure, the *abe* headdress is always carved as an integral part of the head of the image, projecting backward or curved backward and downward over the figure's back. The *abe* has become a kind of identifying characteristic of Nendö sculpture for some authorities on Melanesian traditional sculpture. That is not a totally bad criterion to use for identifying Nendö figurative sculpture, but as can be seen in the photographs not all Nendö carvings have an *abe*. Female figures do not have it, because it is an article of male clothing, and the miniature figure (Plate 52), mentioned above, has no *abe*, because the *leimuba* are not conceptualized as wearing one.[5]

The deity Melake is credited with being the first to wear an *abe*, perhaps even inventing it. Some versions of Melake tales have him wearing a simple type; other versions describe him wearing the elaborate down-curving type.

In either case, a simple *abe* was worn by older men as an everyday head covering, especially by those who were becoming bald or whose hair was thinning and turning gray, and was always worn by men of wealth or high social standing (Figure 2.4). For occasions calling for more formal dress, men might change from a simple to an elaborate type of *abe* (Figure 2.5). The *abe* as a mark of senior social position was discarded during the 1930s, during which time European soft crown hats with a brim became a status marker, albeit one that very few men were able to obtain. Even in the 1950s such a hat was the most desired article of trade a senior man could hope to obtain from a European, and by then the *abe* was not worn at all. The only *abe* I saw during my field work was a damaged specimen that my friend and informant Menaplo of Napu village kept; it was a keepsake from former times when he had been a more influential person and had worn an *abe* outdoors at all times, both as a status indicator and a way to hide his bald spot.

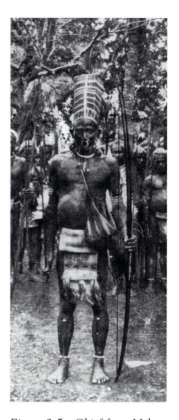

Figure 2.5. Chief from Nelua, Nendö, in elaborate abe. *From Speiser (1915:151, pl. 4).*

The simplest *abe* was a light circular framework wrapped with a covering of either plain or painted bark cloth—a sort of high hat without a brim. The more elaborate *abe* were cone shaped and worn off the back of the head. Some projected straight back, others curved down over the back, and they were variously decorated with clusters of human hair falling away from their tips, or they had lateral rows of fluffy white fringe made from *Gnetum* fibers, one row on each side. Both of these elaborate styles are to be found on figures in varying states of completeness and preservation. It is apparent that carvers liked to improvise with the *abe* form, most conspicuously by increasing its length in relation to the scale of the head and torso. The *abe* in Plate 10 calls for special mention. Its size is not only exaggerated, but it is wrapped with a covering made from a fan-palm frond. Wrapping and packaging valued objects in fan palm is the customary way to protect them,

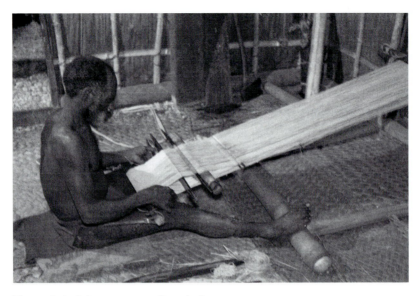

Figure 2.6. Man weaving a breech clout.

and on Plate 10 the fan palm would have kept the *abe* fringe from becoming soiled by the smokey interiors of dwellings. This indicates that when the figure was acquired, the owner either had put it away and was trying to protect the fringe, or in turning the piece over to the collector, he wished to protect the fringe during its journey away from the island.

Other Articles of Clothing

Standing male figures seem always to have been clothed with some type of breech clout. In everyday life on Nendö men once wore breech clouts (Figure 2.6) and women wore short skirts, both of bark cloth (*lepau*). This changed gradually as cotton cloth became available from traders. For special occasions men continue to wear fancy clouts of loom-woven fabric (*neisia*), while women have ceased wearing traditional loom-woven fabric skirts altogether in favor of wraparound skirts of imported calico which they wear on all occasions. On formal occasions, such as a *nela* dance, women feel they must wear not just a clean skirt, but one of new cloth.

The traditional breech clout worn by men was a single length of plain bark cloth (*lepau*) held up by a very wide bark belt, almost a girdle. The bark

20

cloth was long enough to pass through the crotch and under the belt front and back, allowing the remaining portions to hang down as short flaps front and back. The clouts worn by members of the male chorus at a public song and dance fest (the *nela* dance, which will be described in detail in Chapter 3), made of loom-woven fabric (*neisia;* see Koch 1971:99), are extra long so that they may be worn with a double fold in front, and after each use are carefully washed and stored in a sealed bamboo tube until worn again at another *nela* dance (Figure 2.7).

The breech clouts on the male images are not single lengths of fabric that are passed through the crotch of the figure. Rather, the image of a clout is simulated by using two pieces of fabric, one front, one back, both held up with a belt of properly laid cord or merely some strands of coarse fiber. Carvers often have pinched the waists in, sometimes almost to a groove, so the fiber belts will not slip down and take the clouts with them.

Only Plates 24 and 52 have formal dress breech clouts made of the same loom-woven fabric that male choristers wear at the public dances. The

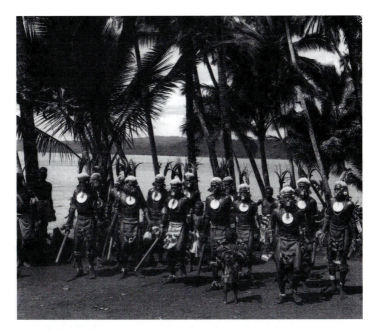

Figure 2.7. Ceremonial breech clouts on nela *dancers.*

dukna are visualized as wearing this type of clout as they sing and dance for their own entertainment off in their part of the island. The cloth for these two miniaturized clouts was specially woven to a reduced width and decorated with a scaled-down band of geometric pattern for use on the sculptures. Plates 3 and 25 have clouts made from scraps of a type of coarse loom-woven cloth that was once used for purposes other than clothing and was no longer woven on Nendö in 1958–59 when I arrived (see Speiser 1916:193, Abb. 38).

Plates 29 and 30 have clouts of bark cloth, and the latter has an inked design to simulate the patterned horizontal band of loom-woven clouts; clouts in Plates 1, 6, 17, and 39 are made of a bast produced by coconut palms, a sort of fabric that resembles bark cloth but is a natural material, never used in clothing; the clout in Plate 41 is also coconut bast with an inked end pattern to simulate weaving. The clout in Plate 30 is of an early type of European trade cloth. No female figure retains a conventional woman's skirt.

What can be derived from these variations in dressing images is that some owners of objects were more particular and willing to go to greater lengths than others even with the basic articles of dress. The same seems to have been true for body ornaments, which will be discussed below.

Carving Details

Quite conspicuously carved on the bodies or held in the hands of two figures are depictions of sharks (Plates 2 and 5). This feature has led some commentators to refer to these figures as representing "shark gods." This is partially correct, but their real significance will be explained below. Some figures grasp a stick or baton (Plates 8 and 9), a fish (Plate 15), and in one instance, a snake (Plate 33). The sharks and the baton (actually a shark-killing club) refer to fishing for this awesome animal; the fish refers to fishing for large species such as tuna and bill fish, both of which were notable economic specializations; the snake represents the form a particular deity (in this case, a deity who resides in the forest) takes when it manifests itself to a worshipper.

Carvers sometimes attached arms and hands to the base or body with a bar (Plates 10, 11, 16, and 22, the right arm of Plate 27, the right arm of the male figure in Plate 26, and the transverse bar of Plate 9). These are structural features intended to reinforce the arms and to keep them from breaking off the figure. When the arms hang down free, the point of attachment to the shoulder is very fragile; a slight blow will detach an arm, as has happened to Plates 3 and 26. When the reinforcing bars are shaped into iconic elements both structure and imagery are enhanced, but when the reinforcing bars are conspicuous (as in Plate 11) it is difficult to determine what the sculptor intended.

22

An obscure but nevertheless significant iconic detail that appears on some specimens are barbs or spurs that stand out from the wrists (Plate 4, possibly Plates 17 and 18), ankles (Plate 5, possibly Plates 6, 8, 9, and 18), knees (Plate 4), feet (Plates 16, 28, and 35), and groin (Plate 18). These barbs, called *nula*, are a characteristic of a subclass of deities associated with shark noosing and fishing for large species such as swordfish and tuna; the fish were and are very saleable to communities with no direct access to the ocean when a wedding or a maturational rite is about to be celebrated. The significance of the *nula* is derived from the function of a barb on an arrow, a hook, or a spear—preventing the targeted animal from slipping off the projectile. Extended into a broad metaphor, the *nula* on a carved image suggests an ability of the deity represented to keep one's objective from slipping away, to secure an objective firmly. (In Nendö speech one can "barb" something, just as in English one can "hook" something.)

The most celebrated of the *dukna* with *nula* are Melake, once again, and Menaopo. In the mythic image of Melake sitting quietly on a sandy beach beneath a low overhanging branch of a great tree, the species of tree has thorns, or sharp twigs, that are also called *nula*. At certain places at dawn and twilight the shallow inshore waters of Graciosa Bay on Nendö may suddenly commence to roil. Fish leap, some so vigorously they land on the dry beach or become impaled on the thorns of the overhanging branch. This phenomenon is caused when schools of carangids, a highly prized fish, come inshore to feed on small fry; sharks then close in to prey on the carangids, causing them to leap out of the water to escape. This phenomenon, while natural, is believed to be precipitated by supernatural intervention, and it produces a plenitude of a highly valued commodity obtained without human effort. It is interpreted as a generic model of how an abundance of any sort of thing of high value can come to a worshipper when a tutelary *dukna* uses his supernatural power to enrich his worshipful follower.

Facial Features and Ornaments

As in many Melanesian sculpture traditions, the face and head of the figure dominate when compared to the depiction of the rest of the body. The size of the head is not only enlarged in scale relative to other parts of the body, but the facial and other features of the head are usually rendered in greater detail. The emphasis on the head and face also involves exaggerating and distorting the shapes of selected features, mainly the nares and earlobes, so that conspicuous ornaments can be attached. Eyes may be accented by inlaying perforated discs of shell (Plate 35), or in one instance inserting a shell

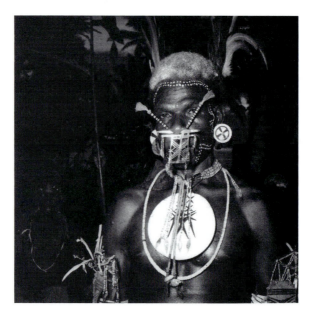

Figure 2.8. Man wearing pearl shell nose pendant (nela) *and other ornaments.*

cat's eye (Plate 41). On some specimens motifs are inked or incised to depict ceremonial face painting. Hair is suggested by carving hair lines (Plates 3 and 12) and creating a sort of smooth cap to the head. This evokes the conventional close-cropped, even-all-over male hairstyle. Darkening the whole surface of the top of the head (Plates 31 and 47) or darkening only half of it represent two types of hair coloration the choristers use at public dance fests.

Earlobes may be exaggerated and bent round so they project outward, but this seems to be not so much a matter of aesthetic taste as it is a way to shape the ears so that earrings can be attached and hang correctly. The nares are often enlarged and flared to accommodate the attachment of rings, and nasal septums are shaped and pierced so that appropriate rings and pendants can be suspended from them.

The most eye-catching facial ornament is supposed to be a pearl shell nose pendant called *nela* (Figure 2.8). This ornament carries a heavy load of cultural significance. Ordinary *nela*, made of sea turtle shell, were once universally worn by men as part of everyday dress, but by 1968–69 they were worn all the time only by a few, mainly elderly men (Coombe:1911, opp. 183; Koch 1971:119,

24

Abb. 96, 97). Fancier nose pendants are made from the nacre of the black species of pearl shell. Since black pearl shell is not found in the seas around Nendö, it must be obtained through trade from other islands and this makes it a rare commodity. Since the nose septums of nearly every figure are perforated, nearly all images probably once had either an ordinary or a fancy pearl shell nose pendant attached. The most common form of *nela* remaining on carvings (Plates 10, 18, 23, 24, and 38) is the plain turtle shell variety.

The fancy *nela* ornament is believed to have been first devised by the supernaturals for their own use, and only by accident did a human see one and make a copy. This prototype had the shape of an inverted teardrop; only Plate 3 has one in this shape. According to myth, the *dukna* created another form of *nela* that is much larger and carved with a filigreed pattern. Again by accident, a human saw one of these and made a copy. Since then humans have been tinkering with the openwork patterns, so now there are many design variations. Of all the fancy personal ornaments, the pearl shell *nela* is the one that is most closely associated with the *dukna* and the mental image of them singing and dancing in elegant clothing and adornments.

One might expect that all the images would have a pearl shell nose pendant of one style or another, but that seems not to have been the case. Miniature copies of the openwork form of nose pendant are not attached to any of the surviving carvings, and no older informant with whom I spoke could recall seeing a *munga dukna* with one. Perhaps it was too difficult to make detailed, scaled-down copies with filigree designs with the tools available.

As for the *nela* themselves, some are singled out on aesthetic grounds as being especially fine specimens; others, both fine and ordinary specimens, can be highly valued as heirlooms because their histories of ownership include important men. *Nela* are fragile, and most of the old and highly valued specimens have been repaired.

Body Adornments

A number of other body ornaments, all worn by humans, are attached to the figures: necklaces, breast ornaments, bead belts, arm bands, anklets, knee and elbow ornaments, and leg rattles attached just above the calves. The ornaments applied to figures are often not nearly as well made as even those worn by men and women with their everyday clothing, not to mention the better-made ornaments that are worn on festive occasions.

The miniature figure in Plate 50 has a string of light blue trade beads draped around it, and Plate 53 has a belt of the same. This kind of bead is an early type of trade item that was much valued when it first appeared about

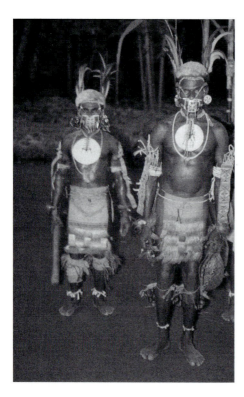

Figure 2.9. Dancers with shell breast ornaments (teima).

the turn of the 20th century. Now these beads are merely a curiosity from an earlier time. The glass trade beads of the post–World War II years are smaller, come in a multitude of colors, and are desired mostly by young girls for bracelets and ear decorations. They do not appear on any of the recently made figurines because they are seen as suitable only for young children and young unmarried women.

The old beads that have great value are the perforated ground shell variety (as in the necklace of Plate 6) that were long ago traded in from Vanikoro and the Reef Islands (where they have not been manufactured for many years). According to oral tradition, strings of ground shell beads, called *ba,* were a type of money used throughout the group before the singular red-feather money was invented.[6] Throughout the Solomon Islands there are several versions of shell beads that function both as currency and as body ornaments.

The leaf and fiber necklaces in Plates 24 and 25 are modeled after similar articles that both men and women sometimes fabricate to wear— along with a flower tucked behind one ear—to indicate their glee at the completion of a day's hard work in their gardens and the pleasant thought of returning home for a sunset bath in the sea and the evening meal.

Another male ornament that is depicted on three figures hangs on the chest, suspended by a cord around the neck (Plates 36, 52, and 53). The three of these, consisting of fragments of shell and a human fingernail, bear no resemblance to the chest ornaments that men wore with both ordinary and formal clothing and which the *dukna* are supposed to wear when they are dancing.

The conspicuous chest ornaments called *teima* are still a necessary element of the full-dress costume that choristers wear at *nela* dances (Figure 2.9). The *teima* breast ornament is a flat circular disc, 5–7″ in diameter, ground down from material obtained from the giant *Tridacna* clam.[7] For obvious reasons it is called a "moon" (*teima*). On some specimens of *teima* a decorative appliqué made of turtle shell, called "the bloom" or "flower," is secured to one face of the disc (see Beasley 1939; Koch 1971:114–16). In former times, all older men of substance wore a *teima* (along with an *abe*) as part of their everyday dress. As with pearl shell nose pendants, some *teima* are heirlooms with detailed histories. Although by the 1950s new *teima* had not been made for many years, their value had greatly diminished because there were so many. The excess *teima* came about from the great depopulation from epidemics of illness suffered at the turn of the last century (Rivers 1922:passim). More *teima* were to be had than there were men of social substance to wear them, and so the fashion of wearing them as status markers declined. Nowadays their only use is as part of the *nela* dance regalia.

The *dukna* are credited with inventing *teima*, which are assumed to be part of their dancing finery. I cannot explain why not one of the surviving figures wears a copy of a genuine *teima*. According to my elder informants it would have been quite appropriate to adorn a male image with a genuine copy made of *Tridacna* shell.

The shells that are tied to some of the images as wrist ornaments (Plates 7, 8, 16, 28, and 52) have a special meaning. Some men of high social standing and substantial wealth in red-feather money wear on one wrist a small shell that may resemble a triton. The shell stands for the large trumpet shells that are blown on important occasions, such as when sharks, turtles, large fish, or pigs are being delivered to a man who has purchased them for consumption at a lavish public affair. Furnishing large amounts of expensive meat is

the part of the sponsorship of such affairs that gives a man prestige. If a man has many of these sponsorships to his credit, he is entitled to wear on his wrist as a badge of honor a small shell, preferably but not inalterably one that resembles a trumpet shell. The adorning of a figurine with a shell wrist ornament acknowledges the power that deities may use to assist their clients in becoming rich, and so to win honor by expending their wealth on celebrations that are judged to be for the public good and enjoyment. That, in brief, is the version of the Melanesian "big man" game as played on Nendö.

There are many more details about the adornment of images that might be added to the above, but to discuss each and every one would be unnecessarily tedious. The underlying convention was to make the image an elegant representation of the deity, a sort of sculptural portrait that flattered the tutelary. This left the exercise of taste in these matters to the owner.

Generalized versus Developed Style

On some figures the eyes and nose are set beneath a strong rendering of a continuous brow ridge that crosses an elongated nasal form. This produces a T-shaped configuration. Conspicuous eyes are set on either side of the vertical, cheeks are flattened, and the mouth may be reduced to a featureless slit. This turns the facial features into a cartoon-like rendering of a human face. Plate 43 illustrates this.

The T composition is enhanced by broadening and squaring off the chin and locating the slit mouth on its underside. This transforms the chin into a canine-like muzzle on both male and female images. From straight on or a slightly downward view the face appears to be chinless (Plates 29, 30, 38, 39, 41, and 52). The heads of male figures that have muzzles as well as an *abe* projecting back present an anthropomorphic depiction that is totally unique in the domain of tribal sculpture.

Some images bear animal and geometric shapes inked on cheeks and body areas. One of these is a chevron signifying the arched body of a porpoise (Plate 15, left upper arm). These markings represent body painting, which is a male cosmetic accessory to the wearing of formal facial ornaments and loom-woven breech clouts (Figure 2.10).

The figures used in domestic rituals were smeared all over with turmeric, and the application of a fresh coat of turmeric was a minor ritual in itself.[8] Plates 1, 2, 3, 8, 9, 18, 20, 24, 33, 36, 48, and 51 still retain traces of turmeric on them.

Figures that have the simplest facial configurations also have the simplest body forms. A very few of these are not merely simple in conception and

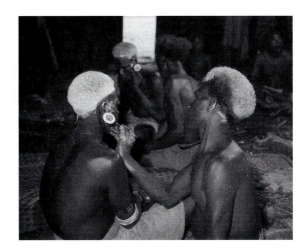

Figure 2.10.
Applying ceremonial
face paint on a nela
dancer.

execution, but they are less well carved than most. Together the group of images having simple facial and body forms constitutes a justifiable subcategory of style as compared with all of the other carvings. To this more simply conceived group I give the stylistic label Generalized type, and I place 14 specimens in it: Plates 14, 17, 19, 20, 23, 37, 39, 40, 41, 42, 43, 44, and 52. Specimens in the Generalized style have been collected from many localities on Nendö, by many different collectors, and over a span of years from 1882 (Plate 23) to 1959 (Plates 39, 40, 41, and 52).

Turning to the other specimens, the style features they share are heavily carved forms, inclusion of more detail, and greater range in size. Altogether they are iconically quite variable but are more sculptural and much more expressive than those of the Generalized type. They appear to have been clothed and adorned in greater detail as well. Aesthetically, the most visually stunning specimens are in this category, and one might surmise that the carvers of these pieces were more accomplished artisans than those who carved the specimens in the Generalized style. I designate this group, consisting of 38 specimens, as having a Developed style.

If one compares images such as Plates 3 and 24 with Plates 42 and 47, the differences between the Generalized and the Developed styles are very apparent. But if one seriates the specimens from the simplest to the most elaborately carved, it is obvious that some pieces (such as Plates 31 and 47) might just as well be placed in either category. One piece (Plate 34) seems not to

fit with the others and has features that suggest it might have come from the western Solomon Islands. The details about its collection are vague, and because I am dubious about its provenance I have left it unclassified.

The most striking variations among pieces in the Developed style occur in treatments of the face—the chin, lips, and mouth. On Plate 46, for example, all three facial features are distinctly rendered; on Plate 5 the chin has all but disappeared and the flattened face ends with a rounded form where one would expect a mouth and chin, but the mouth, reduced to a slit, is on the underside. This occurs on some of the Generalized style figures as well (Plate 17). On Plate 6 the lips are suggested, but the mouth is visible because the head has been tilted back. When the jaws are elongated and the chin is dropped down and squared off, the mouth and chin become transformed into a non-human muzzle. There are enough other examples of this transformation of mouth and chin into a muzzle to regard it as a substyle, mainly within the Developed style but carrying over to the Generalized.

Most of the specimens in the Developed style were collected either from communities located on Temotu Islet or on the nearby shores of Graciosa Bay. That is where the missionary effort was strongest because there were good anchorages for Melanesian Mission ships and Captain Fred Louis Jones's small trading vessel. This region has always had the densest population. It appears that something occurred in this area that provoked a change in carving and aesthetic taste that produced the Developed style. Perhaps it was greater specialization of artisans, perhaps it was due only to the normal process of culture change and evolution. When I discussed this with informants, they could offer no explanations. In fact, most of the experts I relied upon could not understand why I was concerned with such a trivial matter as carving style.

Trivial or not, differences between the Generalized and Developed styles cause an ethnologist such as myself to be curious about the underlying cultural dynamics. I offer a possible explanation of the evolution of the Developed style based upon the well-known cultural phenomenon of diffusion. About 200 miles due west of Graciosa Bay and Temotu Islet lie the outermost of the eastern Solomon Islands, an area well known for its fine sculpture in wood. There are a few short legends and myths on Nendö and on Santa Ana and Santa Catalina Islands about both purposeful and accidental canoe voyages in both directions between these islands (Figure 2.11). From the Nendö perspective the peoples of Santa Ana, Santa Catalina, and neighboring parts of San Cristobal (known on Nendö as Te Motu ni Olra, "Isles of the Women," because the women there were openly friendly and sexually accessible to stranded Nendö voyagers) could be relied upon to offer

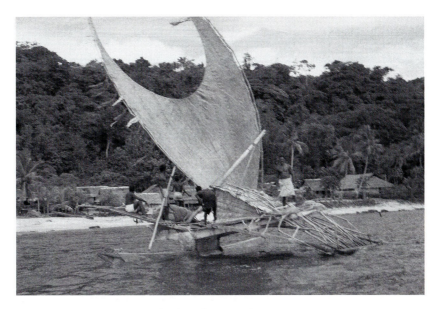

Figure 2.11. Santa Cruz Islands sailing vessel.

succor to the hapless crews of Nendö voyaging canoes (*tepuke*) that acci-
dently drifted onto their shores. Santa Ana and Santa Catalina people
traditionally have called the Nendö people "Those with the Long Bows,"
which is neither imaginary nor deprecatory.

Several features of some Nendö sculpture can be found on eastern
Solomons sculpture, and the most significant of these are rendering anthro-
pomorphic figures in a standing position on a base and the muzzle-like
mouth-chin configuration. In fact, the mouth-chin muzzle is also found in
the central and western Solomons, especially on the well-known figures,
generically called *musumusu*, that are fastened to the bows and sterns of large
canoes. But the squaring off of the muzzle is found mainly in the eastern
Solomon Islands, where carving is also very sculptural, the forms being well
delineated and strongly three dimensional.

It appears then that sculptural ideas diffused from the eastern Solomons
to Nendö, and these influenced the carvers of the Temotu Islet/Graciosa Bay
area, but the new ideas did not secondarily spread to other parts of Nendö.
Put another way, the Developed style emerged out of the Generalized style
as wood workers of the Temotu Islet/Graciosa Bay area began to be influenced

by eastern Solomons sculpture. This is not a far-fetched diffusional idea, because two-way contacts across the separating sea before Europeans appeared on the scene did, according to legend and myth, occur.[9]

Propitiating the Power of the Figures

Returning to the subject of clothing and adornments on Nendö sculpture, we should not assume that the surviving clothing and adornments on images were placed on them by the carvers. Initially, perhaps the carver did clothe and adorn an image he had fashioned, but since images were durable and were inherited along with the ritual responsibilities toward the deities they represented, adornments would be changed and replaced in order to keep images appearing cared for. A shabby-looking image was a sign of ritual neglect and might be interpreted by the deity as a slight that called for some sort of retaliation against his client.

A difficult problem arose during the epidemics that drastically reduced the population of Nendö during the early 1900s and up until the 1940s. As people were dying, images and altars were left unattended and uncared for. Survivors worried about this and feared that neglected *dukna* would cause further disasters. After the worst was over, therefore, many men and some women commenced to look after sacred objects, including images, whose owners had died, even though they did not become worshippers of those deities.

During my first stay on Nendö in 1958–59 I encountered such a situation in the Graciosa Bay village of Balo. The senior man of that village was Tautro, who had been born in the former inland village of Naiavila. Naiavila's population continued to decline even into the 1940s, so the village site was vacated in the 1950s by order of the District Commissioner. It was thought that there was something unhealthy about the locality. Like many men his age Tautro had received baptism, then fallen away from the church and resumed his traditional religious orientation. Tautro was also ill with a chronic respiratory ailment, and he blamed the illness, as well as the continuing population decline of Naiavila, on the anger of the deity Melebaipu (see Chapter 5). Melebaipu was a deity revered for helping a client who was involved in a blood feud, but feared for causing a consumption-like illness. Tautro was the client of another deity, but he took it upon himself to look after some sacred objects associated with Melebaipu that were still among the ruins of the Naiavila men's house.

The abandoned sacred objects that Tautro reluctantly took over included an image, a bundle of special feuding arrows (erroneously called "poisoned

arrows"), and some other talismanic objects. These he kept secreted in the ruins of Naiavila's last men's house, and nearly every day he laboriously trudged to the site of Naiavila to perform a short ritual over them. His wife did not approve of this, nor did a number of Christian neighbors in Balo village. But Tautro was firm in his belief that the sacred objects had to be ritually honored or there would be more trouble.

After my departure from Nendö in 1959, Tautro was arrested on a fabricated charge of practicing sorcery and the possession of "poisoned arrows." Both of these were serious statutory offenses under Protectorate law, because both were interpreted as indicating an intention to harm someone. The objects were seized as evidence by the Protectorate police; Tautro was tried and convicted by a court convened and presided over by an acting District Commissioner who was temporarily standing in for the regular District Commissioner. But before Tautro could be taken away and jailed at Eastern District Headquarters on San Cristobal Island, the acting District Commissioner pardoned him, citing his illness and his advanced age as sufficient reasons not to incarcerate him. The sacred objects, being legal evidence, were kept at the District Office on San Cristobal.

Several years later I talked to Tautro about his ordeal and was surprised to learn that he was not the least bit resentful. In fact he was pleased by the outcome, because the Melebaipu objects had been removed from Nendö and his custodianship, and had become the responsibility of the "Gummit" (the Protectorate government) to look after. Tautro had done what he could to prevent Melebaipu from continuing to cause illness. Moreover his health even improved for a brief time, but this reversal was short lived and he died soon thereafter (see pp. 89–90 for further detail).

3
Worship and Ritual

*T*he sculptures presented in this volume embody a spiritual life in Nendö that has now been largely relinquished. Below is an account of the ceremonies and rituals whereby the *dukna* were once revered.

Traditionally, daily worship of a tutelary deity involves prayer and making food offerings at the evening meal before a household altar. The altar is located in the worshipper's dwelling (*mabau*) or in the men's house (*madai*) or both. The altar itself is a small space, perhaps 3' on each side, on the earth floor of the *mabau* that has been clearly demarcated so children and visitors can keep their distance from it. The *munga dukna* is conspicuously set up within this space, and if there are some other sacred objects that the worshipper wishes to include, such as a forefather's skull, they are placed alongside the image.

Some men, particularly widowers and elderly ones whose children are married and have their own households, will set up their altars in their men's house, because they prefer to take their evening meal (the main meal of the day) and make their prayers in the company of other men. In a few instances a man with small children will not have a household altar, because he is afraid that his children might accidentally disturb the altar and the figure on it and thus offend the deity. The senior man of a *madai* always has an altar in his men's house. Close by and above it a length of bamboo is hung from the rafters like a trapeze (see Figure 2.3). This is used when coils of red-feather money are to be compared and evaluated for an exchange. The comparison bar (*noali*) is also considered to be a sacred object, and when not in use, it is hauled up out of reach and high enough so that no head will bang on it.[1]

The basic ritual is carried out just before a family or man in his men's house begins to eat, shortly after sunset. The head of the household places an offering of food on the altar and makes a short, respectful speech to the deity. The deity is called by name and its attention is directed to the offering.

The manner and tone of speech are the same as if an honored guest were being presented with the first serving of food. If the worshipper has some small request to make of the deity, he will either think it or mutter it softly under his breath. The active verb used for this daily ritual is *kuka*, which covers all kinds of prayer and petitions to a deity.

In a dwelling, the wife of the household commences to serve the food to household members immediately following the prayer. The male head of household will receive the first serving, followed by the children. Most men will be given choice morsels, but usually they will pick out the best portions and add them to the children's servings. The wife will probably postpone eating her meal until after the rest of the family has finished and will select her food from the leftovers. As the meal draws to a close, the head of household will remove the offering from the altar and consume it himself. In effect, this simple ritual acknowledges the deity's presence in the household and his or her superior status with respect to the other members.

There is an early eyewitness account of figurines in a *madai* by the ethnologist Felix Speiser who, after briefly mentioning the conspicuous sacred storehouses (*madukna*) in every village, continued with this brief observation: "In a few of the men's houses, in small niches on the wall, I saw wooden statuettes (only one in each case) similar to [the figure he collected, Plate 47]…which were regarded as sacred and which even I was not permitted to touch" (Speiser 1916:205–206; Buhler and Kaufmann 1980).

When a man wishes to have a more private interaction with his *dukna*, especially when he is pleading for something and promising to sponsor a public ritual honoring the deity if the latter does as requested, he will take a portable image to the privacy of a *madukna*. There he will go through his ritual, surrounded by sacred paraphernalia that are used in certain public ceremonies (see below). The worshipper might even sleep in the *madukna* for a night or two so he can have several intense sessions of *kuka* with his *dukna*.

When a man is engaged in some hazardous endeavor, such as fishing for sharks or visiting a distant men's house in order to conduct some trade, and where he might be physically attacked or become the victim of sorcery,[2] he will carry with him a portable image of his tutelary. With this image always close at hand, he can utter silent prayers to it whenever he wishes.

I asked several of my most religious informants whether or not it would be possible to petition a deity without a concrete representation of it, and all replied that one should have an image (*munga*) that is recognized by the *dukna* or the deity might not be there to hear the request. In other words, the invisible presence of a *dukna* will always be in the vicinity of a figurine or a performance in his or her honor.

It is not just the physical safety and well-being of a worshipper and his household dependents that is under the supernatural protection of a tutelary. Of equal or greater importance is the influence a tutelary deity may have over the success that a man has in the pursuit of wealth through the practice of his economic specialty, his *ngaalue*. Every mature man and some women are expected to have an economic specialty.[3] It is through the successful practice of a specialty that adults gain wealth, that is, accumulate red-feather money (*tevau*). The degree of success or failure in pursuing one's specialty is assumed to be greatly influenced by one's tutelary *dukna*. Even with specialties that require considerable skill, such as weaving, building outrigger canoes, or surgically removing bone points of fighting arrows, the practitioner must have received "power" (*malutu*) from his or her tutelary *dukna* in order to be successful.

As mentioned above, both the soul of a deceased forebear and one's tutelary deity can communicate directly to a person through dreams. And it is firmly believed that during sleep a person's soul wanders around and somehow dreams are caused by experiences of the soul while it is separated from its body. Occasionally, a wandering soul will encounter the soul of a relative, and they will have a short conversation in which an important bit of information is contained that will be revealed through a dream, but not with precision. The dream may have some troubling content or there may be some emotional element in it that does not match up with the bit of information. This calls for going to a female medium or seeking out a woman who, although not classified as a genuine medium, has a reputation for being able to interpret dreams. These women often have other special powers derived from their tutelaries to cure specific illnesses. *Dukna* usually communicate to their clients not through language or dreams but by causing a client to have a strange experience which causes the client either to ponder about what his deity is trying to communicate or, as a last resort, to hire a female medium to use her familiar to seek out the answer. One must pay quite dearly for these services, but only if they work.

The area the *dukna* habituate and in which they maintain their secluded places to sing and dance is in the extreme western part of Nendö where humans never seem to have lived and generally avoid visiting for any purpose. This is the area mentioned where some of the important formation myths occurred far in the past. It is also firmly understood that, after death, souls of humans also go somewhere in this vicinity. Some informants say that souls and *dukna* communicate easily and freely; some informants insist this is not possible. *Dukna* are never, by the way, created from souls of dead humans.

However, in times past, a male forebear was often honored by exhuming his skull,[4] cleaning it, sometimes plugging the eye sockets and nasal aperture with wooden plugs, painting it with turmeric, and displaying it on one's personal altar alongside a *munga dukna*. An eyewitness account of this juxtaposition is in the quotation from van den Broek (1939) cited in Chapter 1 and the sketch notes by Mme. Regina van den Broek of a personal altar in the village of Nonia on which was displayed not only turmeric-smeared skulls but also coils of red-feather currency (Girard 1971).

My interpretation of this is that ancestral skull(s) on the altar alongside the *munga dukna* honor an ancestor who was very likely the senior relative through whom the worshipper received the rights and obligation to carry on the veneration of the deity whose image is on the altar. Moreover, the skulls were sacralized, so to speak, by being smeared with turmeric. The coils of feather currency displayed with the *munga dukna* and skull(s) represent a kind of non-food offering, a ritual statement of thanks (or hope) for bringing wealth to the worshipper. I cannot account for the wooden bungs in the eye sockets and nasal aperture. By itself, a decorated skull is an object through which one communicates directly with the soul of the ancestor whose skull it is.

I have referred to the unique currency used on Nendö as "money," and, indeed it is a fine example of a "primitive money" (see Davenport 1996). But Nendö red-feather currency carries more than monetary value. It is supposed to have (or some specimens of it, anyway) a mystical power that attracts and dazzles a seller so he will accept what is offered. (There is no such thing as bartering or haggling over prices in a Nendö economic transaction.) In short, some coils of currency contain a mystical property that helps the buyer (Figure 3.1). This power is not fabricated into the object by the three specialists who are involved in its manufacture. That special power gets into the money by placing charms in the protective bundles in which each piece of money is stored. The coils of currency placed on a private altar are a form of offering to the tutelary and are usually of very low economic value.

Returning to Neo village during my years of field work on Nendö, I observed that several skulls belonging to important ancestors were kept in the men's houses, and from time to time they were redecorated by smearing them with a fresh coat of turmeric (just as formerly turmeric was smeared on *munga dukna* from time to time as part of efforts to refurbish them). As part of the preparations for the closing ceremony at Neo in 1973 the turmeric on these skulls had been renewed and the skulls remained on conspicuous display inside a men's house during the celebration, almost as

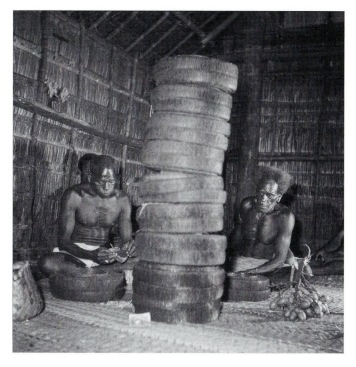

Figure 3.1. Feather money transaction.

if the skulls had been brought out to be present at the closing. This was a holdover from earlier times when one communicated to a forebear or ancestor via his skull.

Public Ceremonies

It is not enough for an ambitious man to worship his deity through daily rituals alone. At some time he must be the sponsor or cosponsor of a public event that honors his deity with song, dancing, and, formerly, with entertaining dramatizations as well. Such events are not single celebrations, but are an intermittent series of celebrations that may last for a number of years. Launching such a series is a major economic undertaking, hence it is usually jointly sponsored by a small group of men, one of whom is the principal coor-

dinator and leader. This is one of the ways a person becomes respected and influential—by using accumulated wealth in ways that enrich peoples' lives. Others include enabling young men to obtain wives and holding maturation ceremonies for children.

People from neighboring villages are always invited to any public event such as those mentioned above. As many as a hundred persons may attend, coming from many villages, some of which may be far away. In former times when warfare and feuding were rife, obviously only friends would be invited. Making such a visit could still be dangerous, because a group of men, women, and children from one village going to another on foot could be ambushed by enemies. Friends and enemies were usually determined by who was feuding with whom, and who was allied with whom to carry on the vendetta. Nevertheless, people were always very eager to attend such events, because they were the largest and most enjoyable celebrations in Nendö life.

An important secular and sociological aspect of commencing a public dance series is the reciprocity that enters into the effort. Whenever a community sends out an invitation to another community to attend a song and dance event of this kind, an acceptance entails an obligation to recip-rocate in like manner at some future date. This also applies to wedding cere-monies and maturation rites for children. The results are reciprocal networks throughout the island, touching the lives of everyone, even the *dukna*. These thick social and ritual interrelationships, together with economic trade and exchange, traditionally enmeshed all Nendö communities into a kind of polity that had neither social class nor hereditary chiefs or other public officials.[5]

Such a ritual series is undertaken when it is thought that a tutelary deity is displeased or downright angry, or when a man finding himself in a perilous situation promises his tutelary that he will honor him with a series of public celebrations if only the deity will see him safely through a present crisis.

A *dukna*'s indifference or displeasure with his client can be communi-cated to the latter in several ways: the worshipper might have a strange and terrifying dream or a run of bad luck, or several sudden and inexplicable deaths might occur in the immediate community. To confirm or disconfirm that a displeased *dukna* is the cause of these events, a female spirit medium[6] has to be consulted. She is supposed to go into trance and send her familiar into the supernatural domain to mingle with *dukna* and souls of the dead and find out the cause. Sometimes a medium might receive a warning commu-nication directly from a disgruntled deity. Obviously, the medium receiving such a communication will pass the information along to those persons

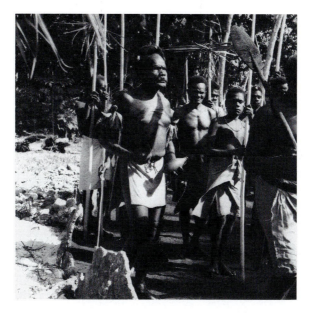

Figure 3.2. Neighbors joining the ceremonial nela
dance.

most concerned who can decide what course of action to take. Female
mediums are highly paid for their services, but only for as long as people have
confidence in them.

Participants at Public Events: Visitors, Locals, Choristers, and Duknas

The participants at a public singing and dancing event fall into three
categories: first are the visitors from other villages most of whom will be
carrying small tree limbs, stripped except for a cluster of branches and leaves
at the top (Figure 3.2). The tree limbs signify that these people have trav-
eled overland and through the forest to get to the celebration.

Another group of participants is made up of the local people, most of
whom will have in some way contributed directly or indirectly to the festiv-
ities. Some of them, particularly elderly men and women, may carry short
walking sticks on which they lean as they bend forward to stamp out the beat

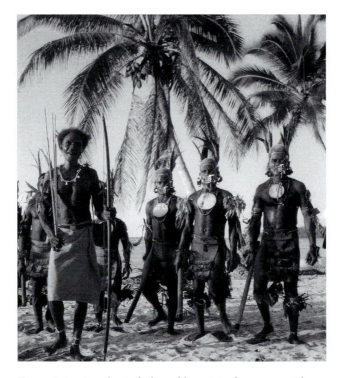

Figure 3.3. Locals, including elders, join the ceremonial
nela *dance, carrying implements representing men's work.*

of singing. Some of the vigorous men of this group carry a tool or implement associated with men's work on land and sea, such as canoe paddles, bows and arrows, and fishing gear (Figure 3.3).

The third and perhaps most important category of participants is a chorus of six to ten (three to five pairs) young men (*obla*). These choristers are specially selected for their handsome bodies and their powers of endurance to sing and dance for several days without sleeping, and are spectacularly dressed in their finest formal clothing and body ornaments. Such clothing is worn only at these singing and dancing events (Figure 3.4). The chorus is the centerpiece of the dance and is supposed to be the head and leader of the participants as they sing and slowly circle the dance ring. The responsibility of keeping a vigorous beat and maintaining heightened enthusiasm in the singing rests with

the chorus. Members of the male chorus are actually playing double roles: one as chorus members and leaders of the dancing and singing, the other as impersonators of the *dukna* engaged in their favorite leisure activity, singing and dancing in their finest formal clothing and accessories.

Unseen in this gathering of participants and observers are those *dukna* who are being honored by the event. They are, in effect, the guests of honor and are accompanied by other *dukna* who are merely curious and drop by to watch the entertainment. The presence of *dukna* casts an aura over the event that some people say they can sense, and transforms it into a sacred occasion. But this does not suppress the merriment and enjoyment the human participants feel and freely express at these ceremonies.

The Choristers' Attire

The clothing and ornamentation worn by members of the chorus are copies of garments and body decoration the *dukna* supposedly wear as they

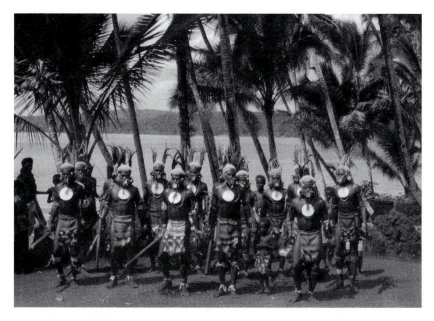

Figure 3.4. Choristers/dancers in nela *dance.*

dance in their remote abode. (The clothing and ornamentation that the *munga dukna* wear should be nearly the same.) So, in veneration of the deities, the appropriately attired choristers lead the participants in the outdoor dance ring as if they were *dukna* who had been invited to attend the celebration as honored guests.

As mentioned earlier, the most significant body ornament that the choristers wear is a pearl shell nose pendant. This style of pendant was first worn by the *dukna* and not known until a man chanced to witness some *dukna* dancing with them. He copied the ornament and showed it to other humans who commenced making them to be worn at their ceremonials. Another myth states that the *dukna* invented them, but then a *dukna* accidentally dropped his while crossing the passage that separates Temotu Islet from Nendö. A short time later a human spotted the nose ornament under the water and retrieved it. The name of the nose ornament, *nela,* is also used for pearl shell and to signify the type of dance (e.g., a *nela* dance) in which they are worn, and sometimes used to designate a member of a chorus in place of the word, *obla,* "a young man."

Singing and Stomping

The lyrics that are sung at *nela* dances have been composed just for these occasions. Some are old and beloved; some are very old and their meanings obscure; some are fairly new but not yet known to everyone on the island; and some are brand new, composed specially for the launching of a new series of dances (see Davenport 1975 and 1998). There are only two melodies, one for day and one for night, and there is no dancing step other than stomping on the ground in unison to establish the rhythm, with stress placed on every other beat. A song begins when any participant calls it out by singing its first line. As soon as it is recognized the chorus will pick it up, followed by the rest of the participants. Lyrics are three lines long; the first line usually states the subject of the lyric, the second line poses a question or suggests an enigma, and the third line is a resolution.

As a song catches on, the chorus will sing only the first line, then pause as the other participants answer with the second line, at which time the chorus comes in again with the third line, which is answered with a repeat of the first line and so on, turning the song into a round. As a song progresses the entire gathering slowly wheels counterclockwise in the dance ring, with the chorus close to the hub. One song may last for only a few minutes, or if the singing remains spirited, for twenty minutes or so. During the moments when the entire group catches the spirit, the two-beat rhythm and the call and answer singing will subtly shift in and out of syncopation. At a peak of high enthu-

siasm the forward movement of the crowd will all but stop, and the partici-
pants will bend slightly forward on their sticks or whatever supports they carry
and bear down on the stomping. With only brief pauses at the changing of a
lyric the singing and stomping continue all night and past sunrise.

During the day only the chorus and a few others carry on. Food is served
more or less continuously all day long, but most people do not eat their fill
until sundown. The festival continues for one, two, and occasionally three
days, depending on the enthusiasm of the crowd and the amount of food that
can be served. As the singing and dancing continues through the dawn and
the melody of songs shifts to the daylight mode, everyone gathers around
the outside of the dance ring rather than inside it, where the chorus keeps
singing and slowly moving counterclockwise. The chorus must be able to
sing and dance continuously without sleep, taking only brief time-outs to
drink water, eat, have a smoke or a chew of betel, and relieve themselves.
When a member of the chorus wishes to drop out for a break, he must be
accompanied by another member of the chorus or one of the older partici-
pating men, because it is believed that a certain changeling female super-
natural might seduce him in the dark which could cause him great harm. The
name of the female *dukna* who is most frequently mentioned in this respect
is Inelua, who can disguise herself and appear as a familiar young woman.
Inelua is one of the very few female deities who is the equal of the active male
tutelaries.

The Dance Ring (*Nue*)

The singing and dancing take place within a walled ring (*nue*), the floor
of which has been specially prepared to reverberate as the dancers stomp on
it. Dancing rings vary from about 20′ to 30′ in diameter, and the tone the
earth floors emit under the impact of the stomping varies according to the
care that went into its construction and how long it has been used. Good
sounding dance floors must be constructed in a certain way,[7] and a good-
sounding floor always heightens the enthusiasm of the participants when
their singing and stomping reach peaks of excitement.

In every village of Nendö there are the remains of old dance rings
located in among the dwelling sites. And in abandoned village sites if one
brushes aside the surface debris that covers them, one will find the remains
of old *nue* walls. This is because a closed *nue* is never deliberately disman-
tled or its building materials used again. The old *nue* remains as a commem-
orative marker of the dance series that was once celebrated in it. In relatively

large villages an old dance ring is sometimes apt to be partially dismantled as the former sponsors die off and residents make room for new dwelling sites. New *nue* must always be built from new materials. Part of the ritual value of initiating a new *nela* series comes from expending a lot of labor in building the new dancing ring from scratch.

The circular *nue* is usually enclosed by a wall of large coral discs (3–4' in diameter) set into earth on their edges. (The discs are the heads of a species of large coral that grows only in calm shallow waters.) The dancing progresses in a circular motion and the singing is in the repetitive circularity of a round. This theme of circularity is consciously considered to be the underlying aesthetic principle of the event,[8] but otherwise there is no symbolism in it. The event is rendered sacred because *dukna* come to observe and possibly to join in, and because it is a performance dedicated to pleasing and flattering the tutelary deities of all the persons who sponsored it. The sacredness of the event is not diminished because the human participants openly enjoy themselves.

Obviously the resources that must be committed to a *nue* series are great. Extra gardens will have to have been planted some months before, pigs must be fattened, and the herds increased for consumption. Just before an event is to take place, fishing parties must go to sea to catch high-quality fish. The productive economy of a community reaches its highest level when it is involved in maintaining one or more dancing series.

The organization of a *nue* series requires good leadership and more of it than a single individual can provide. For this reason several senior men will have formed a loose support group around the principal sponsor, and each will oversee some of the preparations. All these men, who can be thought of as community leaders, must also persuade their wives and mature daughters to participate because so much of the work falls to women. Some of the men in the support group will contribute money in the names of their tutelaries instead of actually doing some of the arduous preparatory work, and their deities will, of course, be fully informed of this and, the contributors hope, be appreciative. Therefore, while a *nue* series is primarily dedicated to the principal sponsor's *dukna*, it is secondarily dedicated to the tutelaries of all the men who contribute something substantial. In this sense it appears to be a community-wide endeavor, because in the end nearly every adult of the community has contributed something.

Both government and Mission officials have always spoken out strongly against *nue* celebrations, not only because they are part of the traditional religion but also because they are judged to be a great squandering of labor and resources that might better be directed toward community projects such as building churches, improving the paths that interconnect settlements,

looking after council meeting houses, and maintaining small medical dispensaries. But to most Nendö adults, work on government and Mission projects has traditionally been viewed as an unnecessary waste of their time and energies.[9] To the devout the *dukna* come first, and if all's right with them, then all's right with life.

As long as a *nue* series is under way, the dance ring is considered sacred ground, set apart, and not to be used for secular entertainments or profaned by the intrusions of children, dogs, and pigs. When a series is finally declared finished by its principal sponsors, the ring must be officially "closed" or shut down for further *nela* dances, and only then does it cease being sacred and restricted space. The closing of a ring calls for a special ceremony in which all of the women who have worked hard to keep the series going receive praise and payments in red-feather currency for their labors. This is done on the morning following the final night of dancing.

When it appears that everyone has gathered, the organizers begin calling out the names of the women they consider deserving of special acclaim and reward. As her name is called, each woman steps close to the wall of the ring where a roll of red-feather currency is balanced on her head, and she steps into the ring and commences to dance around the ring to the lively daylight beat. As the women make several rounds inside the *nue* those gathered outside shout out praises for the women and the organizers. In short order one of the organizers will step onto a high point where he can be seen and heard and call a halt to the singing and dancing. Without further ado the event is over, and everybody present knows the series is finished and that the *nue* is closed to further *nela* events.

The closing just described is based upon one I witnessed at Neo village, Temotu Islet, in October 1973. That *nue* series had begun in 1963, following the sudden death of a child the year before. Seeking an explanation, a female medium was consulted, and after she sent her familiar into the spirit domain, she reported that the *dukna* who had once been the tutelary of the deceased child's paternal grandfather reported that the soul of the grandfather was hurt and unhappy because, since his death, he had not been honored in any way. No action was taken as a result of this information, but several months later, five other men of Neo, each with a deceased relative they wished to honor, joined with the father of the deceased child to sponsor a *nue* series. Of course, it was the respective tutelaries of these sponsors who were being honored and petitioned.

In 1972 that same medium informed the sponsors that her familiar had been informed by a *dukna* in a dream that it would be all right if they closed the *nue*. As the sponsors were considering this, word came that a young student had

suddenly died at a Mission boarding school in the Solomons; then the medium herself suddenly died. The sponsors were truly in a dilemma over these events, with no one at hand to interpret them. Eventually they concluded that the recent student's death was not connected to the first child's death, and since there was another *nue* at Neo still involved in a dance series, they could safely hold a closing ceremony for this series. And that was the one that I witnessed.

When the men responsible for a *nue* fail to hold a *nela* dance for a long time, while members of the village continue to attend other *nela* dances in other villages, there emerges a strong feeling that the commonly understood rules of social reciprocity are not being followed. One response has been for the leaders of a village some distance away to organize the young adults of their community for a kind of unannounced raid on the dance ring in the laggard village. Conspicuously traveling as a group, the raiders burst into the offending village without warning and commence singing and dancing in the *nue*. Such a raid is called "stealing the *nue*."

The rules of hospitality require that visitors from other villages receive food, betel ingredients and tobacco, and a place to sleep. This can usually be provided for a few unexpected visitors, but when a horde of young adults appears and "steals the *nue*," the women are caught in an awkward position. They rush around trying to put together something for the visitors, but what is finally offered is not adequate. The women of the community are embarrassed, and this is supposed to shame their menfolk who have caused the problem by their carelessness in not maintaining a balance between attending dances in other villages and hosting *nela* dances in their own.

Tradition and Change: Opening and Closing *Nue*

At the time the pacification of Nendö commenced (see Chapter 1), *nue* dances were celebrated in a slightly different way than they are at the present time. The start of a new dance series and the inauguration of a new dance ring had to be marked with a spectacular opening performance of some kind. There was no set convention for an opening performance, except that it should be directly relevant to the principal *dukna* being honored and have some surprises in it for the onlookers. New song lyrics were not enough. The opening event had to be a performance and had to present some element that had never been done before, one startling enough to give observers and participants something to talk about for some time to come.

A routine part of the opening was to have as large a chorus of costumed dancers as could be assembled. The first performance in the ring was usually

the chorus dancing by themselves with special batons or dance clubs called *napa*. Dancing with *napa* was always vigorous and involved intricate footwork and routines that required rehearsals; yet it had to be a surprise, so the rehearsals had to be carried out secretly in some place removed from a village. A popular routine with dance clubs involved two lines of young men facing each other, each opposed pair engaged in dueling, one swinging his club at the other's head, the other checking the blow with his club.[10] Then the other partner tried to strike a blow to his partner's head, but either that blow was checked or the recipient ducked. Then both partners whirled around or changed positions and the blows were repeated. All this was performed in time to the rhythm of a conventional daytime song.

The opening might also commence with a parade around the inside of the new dance ring followed by another group that encircles the first in a counter direction. This led to many variations of the two lines weaving in and around each other, again all in time with the tempo of the chorus's singing.

Lrepe Ceremony

In the Graciosa Bay villages one of the best-remembered opening stunts was celebrated at the village of Lrepe and dedicated to the deity Noelebu sometime in the 1930s. The event began with a parade of five pairs of male dancers, each carrying a large python—its head bound to its tail—looped over one shoulder and hanging off the opposite hip. The snake-wearing dancers marched from behind the village to the beach and then in front of the *madai*. There, a single male dancer impersonated Noelebu while he carried coils of red-feather money and led the snake carriers into the dance ring. As the snake carriers paraded and danced in the ring they sang songs that were directly or indirectly relevant to Noelebu. The line of dancers circled the ring ten times and with each circling the lyrics changed, all having been composed for this opening event. They danced until dark, then stopped the ritual to share a sumptuous meal of pork and fish with everyone present. After that, all assembled continued dancing for the rest of the night, just as is done now.

In a second act, many live snakes were turned loose on the floor of the ring, and the men carrying snakes danced and sang among them. Some men picked up snakes and danced with them in their mouths. This was a shocking performance because most people, especially women, are frightened of these pythons, even though they encounter them often in the gardens and know they are non-poisonous. Following the snake stunt, one of the sponsors of

the dance series, in an impersonation of Noelebu, entered the *nue* holding a coil of red-feather money above his head, followed by a pair of costumed choristers doing the same. The other members of the chorus followed, two carrying images of Noelebu, the rest carrying branches of *nonūlū* over their right shoulders. The *nonūlū* species of tree bears flowers to which red honey creepers (Myzomela cardinalis) are attracted, and it is the downy feathers of this scarlet bird that go into making the red-feather money (see Davenport 1962a). This double reference to red-feather money in a procession invoking the deity Noelebu constituted a propitiatory message to him to assist his followers in getting rich.

About sunset a *nela* chorus entered the *nue* and was joined by a horde of dancers who sang and stomped as described above. But this *nela* dance continued for only a few hours when the sponsors called a halt to the singing and dancing. The tradition of dancing all night and for several days developed later as participants came to regard these dances to be as much entertainment as they were public religious rites.

Even with the new dance ring at Lrepe, things still did not go well there or in other villages with followers of Noelebu. The most senior follower of Noelebu, a man named Menongu, became very ill, and it became clear that he had to be replaced with someone else. Several Noelebu followers were asked to learn all they could from Menongu and replace him, but no one would accept the burden of leading the worship and being close to the awesome powers that Noelebu could summon. Finally, the leadership position came to rest with the woman, Ibonga. This is one of the exceptional instances when a women became the senior person in a cult of tutelaries.

From the beginning Ibonga was ambivalent about receiving the supernatural powers associated with Noelebu. She was afraid they would backfire and cause harm to her and her relatives. So, Ibonga began to organize a closing ceremony for the just-built *nue* at Lrepe. No harmful or mysterious events followed the closing, indicating that Noelebu was not displeased. The remaining followers of Noelebu at Lrepe switched to worshipping the deity Opla who had become strong in the nearby village of Banua and was on the way to becoming the most popular tutelary in the Temotu Islet/Graciosa Bay area.[11]

Banua Ceremony

The beginning of the remaining *nue* in Banua village goes back to the late 1930s when Banua had a few Christian residents but not enough to build and support a church. There were two open *nue* in Banua then, and a conspicuous *madukna* stood at the edge of the village (exactly where the Banua church

now stands). At this time the late Siede was having sexual affairs with two unmarried women, Katienau and another woman whose name could not be recalled. Not surprisingly, the two women got into a nasty row with each other, and Katienau fled to nearby Uta village. The men there allowed her to stay temporarily in their men's house, where she would be shielded from the verbal abuse and physical threats of her antagonist. The other woman did come to the men's house several times and each time made a scene, calling Katienau all kinds of names and threatening to harm her, all the while pounding the outside leaf walls of the *madai* with a heavy stick. At that time the *munga dukna* and other sacred paraphernalia representing Opla were kept inside the men's house, because the cult leader took his meals and slept there every night. There was much concern among the men of the *madai* that Opla might take offense at the disturbances caused by Katienau's adversary.

Over the next weeks several young children in Banua suddenly sickened and died, and several prize pigs also took sick and expired. And then still another untoward event occurred after a large shark was delivered to a rich Banua man who intended to cook and distribute it at a nose-piercing ceremony he was cosponsoring for an infant named Matabau. As the young residents of the *madai* were butchering the shark and making it ready for cooking, it was noticed that its liver did not look just right, so it was tossed aside with other unwanted cuts and scraps. Shark and pig livers are considered a delicacy and are usually distributed only to notable persons or special friends and relatives of the person making the distribution. When the owner of the shark noticed the liver lying among the unwanted scraps, he became furious and ordered his helpers to retrieve all of it, cook it separately, and distribute it among all the residents of the *madai*. His wishes were complied with, but all those who ate pieces of the liver became very ill; two young men died.

A female medium was consulted and she reported back that, as feared, the deity Opla was upset about the incidents between the two squabbling women that had occurred outside the *madai* where his icons were kept. This diagnosis of Banua's trouble prompted the leading men of Banua to build a new dance ring and sponsor a dance series in honor of Opla. As all this was going on, missionaries were having success in Banua and its adjacent communities. The Banua dance series to Opla was never completed, nor was a closing ritual celebrated.

By 1958–59 the senior men of the Opla cult had become Christian and were not interested in formally closing the ring. So, the *nue* remained open but uncared for, and it began to deteriorate physically. Young boys often played a kind of kickball game in it, and although many adults grumbled

51

about the situation (including my good friend and informant Alu), no senior man of influence would move to do something about closing it.

Napu Ceremony

In 1959 a similar situation existed in the village of Napu, where a *nue* remained ritually open but unused. It had been built and dedicated to the deity Menaopo by Menaplo and his brother Mekope about a decade before. While both men, who were in their 60s, were still active and in relatively good health, neither was economically well off, and they knew they could not get support from their fellow villagers to sponsor a regular closing ceremony, with *nela* dancers and feasting for visitors.

Menaplo was deeply concerned, both about the consequences that might come from an angered Menaopo and for his personal reputation as a leader and a person who was always aware of social protocol. Quietly, Menaplo purchased two large pigs. He and his wife cooked them in a large earth pit dug behind their dwelling. The pork was cut up according to the complicated rules governing butchering pork for distributions to other persons. After all the portions had been neatly wrapped into leaf-covered packets (see Koch 1971:157, Abb. 129), each packet containing a high-value cut of pork was paired with a coil of red-feather money of the appropriate value, and the presentations were discreetly delivered to all of the women, or their heirs, to whom Menaplo and Mekope were indebted for assisting them so far with the *nue* dedicated to Menaopo. Then, Menaplo sent word for me to come to his men's house.

With very few words of explanation Menaplo, by himself and holding a sprouted coconut seedling, escorted me to the dance ring, stepped into it, and crossed to its center. There he murmured a lengthy *kuka* and planted the seedling where he stood. Later, he explained that he had felt compelled to close the ring in this way, because he had been having difficulty preventing the young children of Napu from playing in it and dogs and chickens from defecating in it, and nobody had offered to assist him with a proper closing ceremony.

Economically, Menaplo and his brother had been in the position of creditors to all the communities from which guests had come to participate in *nela* dances at Napu. And they owed nothing to their cosponsors who had helped construct the *nue* in the first place. But as leader of the sponsoring group it was Menaplo's responsibility to see it through to a proper end. His main reward for making this stripped-down closing ceremony was that his peerless reputation as a *noblo kaetu*—"a first person," "a premier personage"— was not tarnished by having failed to finish off a *nue* series properly.[12]

Andrew Letade's Nue *at Malo and Its Unprecedented Outcome*

A *nue* situation of a quite different sort commenced in 1974 when Andrew Letade of Malo village on Temotu Islet decided to open a new dance ring that he alone would sponsor and pay for. His motives had very little to do with traditional religion. Most of the time Letade resided in Honiara, where he had a good job with the BSIP government. Actually, Letade had grown up in a hamlet on Nendö located just across the channel that separates Temotu Islet from the main island, and he owned land where that hamlet had once been located. This area is generally referred to as Luova and has become the location of a post office, administrative office with radiotelephone, Nendö council house, a guest house, a dispensary, and most recently, the landing strip and a jail.

On one of Letade's visits back to Nendö in the early 1970s, he found that someone had built a substantial house on his land at Luova. He was furious and, without trying to find out who the trespasser was, he burned the house down. The District Commissioner was touring Nendö at this time, and when he heard of Letade's actions, he arrested him on several charges. Since Letade worked in Honiara, the District Commissioner sent the charges there for further prosecution. Soon after Letade returned to Honiara he was tried in a municipal court, found guilty, and sentenced to three years imprisonment. He appealed, and the case was sent to a higher court for review in Suva, Fiji Islands. This was the normal appeals procedure for criminal cases and it could take a year or two for the appeal to be heard. The appellate judge in Fiji dismissed the main charges, reduced others, suspended the penalties, and ordered Letade released from jail in Honiara. This was 1972, and at the first opportunity Letade returned home for a visit with his family at Malo. While there some of his friends urged him to celebrate his court victory with some kind of public event, for example, a feast like the annual saint's day celebrations that each church held.

Letade had always been an enthusiastic *nela* dancer, so he decided to construct a *nue* on his property at Luova and to invite a large group of people to celebrate its completion. He spared no expense in constructing the finest floor that could be built: not too soft, not too hard, and producing a deep resonance when it was pounded. No *nue* floor like this one had been built for many years. He set the opening date and sent out the invitations in a traditional way to all the adjacent communities. The date he chose to open the *nue* just happened to coincide with the saint's day of St. Andrew's church at Malo, Letade's own church and, fittingly, the first church to become established on Nendö. Letade was permitted to integrate his *nue* opening with

Malo's celebrations, and after the church ceremonies were finished, the Reverend Caspar blessed the *nue* and the piles of feast foods and other amenities that Letade had provided (four pigs, a goodly amount of fish, heaps of staples, and mounds of feast puddings, as well as pepper leaf for betel, tobacco, and cigarettes). The *nela* dance started immediately following a brief evening church service. It had a chorus of five pairs of fully costumed *nela* dancers, and the dancing lasted all night.

Letade's *nue* opening was, indeed, a personal victory. It was also judged by participants to be a notable success because he had spared no expense on the accompanying feast, and the dance floor fulfilled all his expectations and was an eye-opener to many Nendö people who had forgotten what a high-quality dance floor was like. There can be no doubt that Letede had set a new precedent for *nela* dancing. The irony of all this was that for years missionary teachers and like-minded government officials had sought to eradicate *nue* dances altogether.[13] Now Letade, a single-minded individual not known for his religious zeal, traditional or Christian, had sponsored a lavish dance that received the blessing of a priest. He had managed to bring the sacred *nela* dancing, complete with impersonations and songs of praise to traditional deities, into an annual celebration honoring a Christian patron saint, and he had done it without repercussions from the higher clergy of the Mission.

4

The Santa Cruz Island World View: Cultural Assumptions and Mythology

This chapter provides cultural materials to convey insight into the Santa Cruz Island (Nendö) world view as it was when the first Anglican teachers began to spread Christianity during the last half of the 19th century. By "cultural assumptions" I mean those indigenous ideas and orientations that filtered and conditioned everything the people of Nendö knew about the world (*nulā*) around them. These myths and cultural assumptions are the foundation from and for which Nendö figurative sculpture was developed. The 55 figures bear in them the weight and spirit of this traditional Nendö, before the changes wrought by Europeans.

In the most extensive sense, their geography was a universe of different kinds of tropical islands and reefs, some of which were to be found within the Santa Cruz Islands and others they knew about through voyaging in their large canoes, called *tepuke* (see Davenport 1964b).

Within the known sector of the Nendö world there are two domains—one, the natural three-dimensional world of the human senses; the other which, for the lack of a specific linguistic term, I call the "spiritual domain." The big difference between humans and supernatural beings is that *dukna* mainly exist in the spiritual domain, while humans (*lepula*) live primarily in the other. Humans cannot sense directly what goes on in the spiritual domain, but *dukna* can and do monitor the empirical domain and can and do influence the outcomes of human affairs. For humans it is very important to communicate with the *dukna* and that is the primary function of religious rituals, the secondary function being enjoyment and celebration.

Essential to understanding Nendö religious behavior is an assumption that the soul (*munga*) of a human being is rather loosely coupled to its body and can detach itself in many situations, the most common of which is during sleep. Dreams are the mind's registration of the soul's experiences as it moves about when detached. A common illness, particularly among young children, is brought on by waking up an individual suddenly. The mind comes awake, but the soul is left outside of consciousness. The same sickness can be caused by startling someone as they are daydreaming. It is not easy to discuss these topics with Nendö adults, partly because of a paucity of specific terms for "mind" and "consciousness," and partly because when ordinary persons are in need of "mentalistic" expertise they consult spirit mediums, called *olra-ni-kemlao*, most of whom are women who have lost a child recently and become possessed by the child's soul which death has released from its body. The explanation of this is that the dead child's soul is frightened and wants to be reunited with his or her mother.

The mediums who are consulted to diagnose this sort of illness when it is suspected are also the therapists who treat the illness. The treatment usually results in the patient's being trained to become a medium. Female mediums are also sought out when there is a dire need to penetrate the spiritual domain of the *dukna*. The medium goes into a trance and sends her familiar to scout around and determine what *dukna* are causing problems for humans and why. The medium reports back while she is in trance, and her report must be interpreted by another or by several other mediums.

In modern Nendö beliefs about *dukna*, the concept of *doppelganger* is very clearly understood. Remarkably, the Nendö concept is a characteristic they share with Europeans, especially the clergy of the Mission. An example that I heard many times was one about Dr. Charles E. Fox, a scholar/missionary most of whose life was spent in the Eastern District of the Solomons, i.e., in and around the Santa Cruz Islands. During my years of active field work, Dr. Fox held several positions in the Mission, but to the few young men who had gone to the Mission school at Pawa, he was classroom teacher and sometimes headmaster, and he was also conspicuous as the Archdeacon who traveled incessantly with the Bishop on the Mission's yacht, *Southern Cross*. In the minds of those who knew him at Pawa, Dr. Fox held both positions simultaneously, transporting himself instantaneously across hundreds of miles of sea as his work demanded.

I was also paid such a compliment by my neighbors in Banua who insisted that during the brief periods that I was away visiting other villages in other parts of Nendö, I came back to my house in the middle of the night to use my typewriter for an hour or two. Apparently they were often awakened by the clatter of typing coming from my dark and empty house. Actu-

ally, reminding me of my habit was really a complaint, very politely coupled with an unspoken request that I do something about it so their sleep would no longer be interrupted. It was a hard request for me to grant, and all that I could do was to deny having such power and pass out sticks of tobacco with the sincere hope that the tobacco might help the complainants sleep better.

In Nendö mythology historical time from the present backwards is usually expressed not in years or decades but in generations, or in "*begots.*" Such reckoning produces what is technically called a "line" or in Nendö language, *nui.* In the Santa Cruz Islands, as well as in most Solomon Island societies, genealogical records rarely go back more than four to five generations or kinship jargon not beyond the grandparental generation of one's grandparents. Always of interest to folklorists and social anthropologists alike is the way in which actual historical events (as Europeans think of these) become integrated into traditional mythic time. And was the nature of this time different before and after initial contact between the people of Nendö and Europeans? In Nendö reckoning of historical time there is a conflict not so much between the arrival of Europeans and after as between the period before humans were around and there were only *dukna,* almost by definition not mortal, and after humans settled on the islands.

European Contacts as Reported in Nendö

By European reckoning, the initial contact with Europeans is datable: it was made by the Spanish explorer Alvaro de Mendana on his second voyage to the southwest Pacific in 1595. From the historical records of his expedition, the objectives were first, to locate the Solomon Islands, and second, to establish a colony somewhere with the Spaniards who were carried aboard for just that purpose. Mendana sailed his vessel into the large and inviting bay that he named Graciosa in thanks to the Almighty for the successful completion of the arduous trans-Pacific crossing. The supply ship that followed Mendana's flag failed to see that maneuver and continued sailing west into oblivion (and was later discovered to have been shipwrecked on San Cristobal).

Mendana decided to stay in Graciosa Bay and commenced building a fort to protect his compatriots. Even though the Mendana party thought they were exercising restraint in their dealings with the local people, there were difficulties resulting in firearms being used to chastise and coerce the locals. Illnesses broke out among the Spaniards, and Mendana fell sick and died. Without his leadership and with dubious judgment, it was decided to sail on with Mendana's widow as titular head of the expedition.

There is no way of knowing how the people of Graciosa Bay perceived what was going on and what caused the strangers to sail on, because they have no memory of the Spanish debacle. The mere fact that Nendö people were injured and killed in this encounter would not necessarily be sufficient cause for marking this unprecedented event, because Nendö was a violent place right up until a peace was imposed by the British at the end of the 19th century. But there is a short story of an encounter with strange people who arrived on a great ship. It is a historical myth, not a religious one. I recorded two versions that report essentially the same data. The version I present here is the longer:

One day in the very distant past [after humans had appeared and spread out to occupy villages all over the island, and after Nendö people had acquired their customs and material culture but definitely before the first missionaries appeared and long before any foreign traders appeared and also before the BSIP government began to suppress feuding, raiding, and enforcing "the law"] a large sailing ship appeared in Graciosa Bay and anchored off shore at Na-ba-ka-enga. [An archaelogical survey located artifacts and pottery sherds at the very head of the bay, known locally as Lue Nebo, "Nebo Stream."] The ship was the largest the local people had ever seen, so large that gardens producing edible foodstuffs were planted aboard. Only a few crewmen showed themselves on deck at one time, and although large numbers of local people gathered around the ship in their small paddling canoes and fishing rafts, since neither side could understand the other's speech they had no success in communicating with the strangers aboard.

Nothing odd about the physical appearance of the ship's crew is mentioned in the brief mythical account, which may indicate the people aboard were remarkable only in that there were communication problems. None of the local men tried to climb aboard, because they were afraid, but some of them shot arrows and hurled verbal threats at the strangers. No one from the ship came ashore and there is but the brief report of the visit, in Spanish. In this story, after a few days the ship weighed anchor and sailed off. The interpretation of the ship's abrupt departure and the fact that no one aboard tried to buy or barter for anything seemed to indicate to local observers that the strangers were frightened away by the longbows and "poison-tipped" arrows that Nendö men carried (not a reality, but Nendö men think their feuding arrows carry a deadly poison).

There is no historical record by Europeans of another contact with Nendö until the English ship *Swallow*, under the command of Philip Carteret, passed through the group in 1768 without putting anyone ashore. He named the Reef (Swallow) Islands after his ship. The next encounter was in 1875

when Commodore James G. Goodenough went ashore at Carlisle Bay near the village of Noka in 1875. He was attacked without provocation and wounded by an arrow. Unfortunately, he contracted tetanus and died on his ship as it was hurrying south toward the Banks Islands where it had been hoped there would be a Mission dispensary that might save his life.

Nendö Record of Contact: Shipwreck at Ebo

This was told to me by Olu of Banua not as a myth, but as an unadorned account of a fairly recent historical event that happened just before or during the period when British law and order was being established, in the 1920s or early 1930s. It recalls the going aground of a small ship on the reef off a strip of shore named Ebo on the south coast of Nendö. Several Europeans got ashore, but all but two persons, a man and a women, were immediately killed by the local people. The two survivors escaped into a nearby dwelling for shelter. They had a rifle and managed to kill many of their attackers, but in the course of the skirmish, the man with the gun accidentally set fire to the leaf roof. When the flaming roof came down it trapped the man, and he burned to death. Somehow, the woman was dragged out of the burning house, still alive but badly burned all over. The local women looked at the European woman and noted that she looked like a pig does just after it has been singed and all the hair scraped off the skin. The local women did what the fire didn't quite do; they killed her.

There is no official record of such a shipwreck on the south coast of Nendö. Olu of Banua clearly indicated that he thought of the incident as a lost opportunity for the local people who would have benefited in some way had the outsiders been received in a kindly way.

Pre-contact Nendö Knowledge of the Wider World

Before the coming of missionaries, administrators, and traders, there was some vague knowledge on the part of the Nendö people of a very large island off to the southeast. They called the island Matangi (*ma* = "place"; *-tangi* = "the name of a seasonal wind"). The name Lematangi literally means "People of Tangi" and came to be the generalized name for all Europeans. During World War II Nendö men who volunteered to work at the Allied base on Guadalcanal soon learned that their ideas about Europeans were much too

simplistic, and the single linguistic reference of Lematangi had to be changed in order to take account of national identities such as Melika (American), Aussi, Yapani (Japanese), as well as Pomi and Limey for Englishmen, who formerly were thought to be the only foreigners to come into their islands. After hearing more about Matangi, they began calling it only by the Pidgin English names "Big Place" and "Cold Place."

Nendö Myth of the Birth of Technology: The Underwater Workshop of the *Dukna* at Ela

From a technological perspective, there is a general belief that all of Nendö traditional technology, knowledge, and skills came to them by way of the *dukna*. The short myth that is the charter for this belief is as follows:

A human (whose name is now forgotten) was poking around the reef shallows just off the eastern shore of Graciosa Bay, an area known as Naba-kaenga, and when he came to a place called Ela (no one now knows exactly where Ela is located) the man happened on to the entrance of an underwater cavern. He swam inside it just to find out where the underwater tunnel led, and a short distance along it, he came to the entrance of a vast dry chamber where dozens of individuals were working at every known technological skill that the Nendö knew about, until the Europeans brought others. (The latter skills do not include all the new material culture that came with the Melika during the war [or *taemfait;* see Davenport 1989].)

Even though the individuals in the cave all appeared to be humans, in point of fact they were *dukna.* When the man was told this, he was dumb-founded. He just could not understand what these strange beings were doing and just what was going on before his eyes. A friendly *dukna* came up to him and commenced explaining what this individual was doing and what that individual over there was about to do, and so forth. As the man and his friendly guide moved from one skill to another the guide kept urging the man to pay close attention to what he was seeing and to what he, the unnamed *dukna,* was trying to explain, but at the same time as he was explaining, the *dukna* also kept urging the man to hurry along, because there was not much time. The observer tried as best he could to take in all that he was seeing and hearing, but gradually darkness overtook them and the cavern began to fill up again with sea water. As the man became frightened again, the friendly *dukna* vanished as suddenly as he had appeared.

Before the *dukna* vanished, he presented to the human observer samples of the objects that he had watched being fabricated. Later, the man began

to tell other humans about his experience and showed around the sample objects. In due course Nendö men and women learned the skills, and the prototypic objects became widely dispersed around the island of Nendö and treated as sacred archeotypes. (I purchased one of these prototypes, a turtle shell fishhook with snood attached, which is in the Santa Cruz Islands collections of the Bernice P. Bishop Museum in Honolulu.)

Because the time allowed for the nameless observer to look was so limited, he learned only a few skills well enough to pass the new knowledge on to others. Thereafter, many important technologies were learned at different times from other *dukna*.

Red-feather Money in Nendö Mythology

A pair of short stories that I think of as mini-myths account for the invention of red-feather money (*tevau*) for which Nendö society is ethnographically famous. One story states that originally the only currency used on Nendö was the fire tongs used for handling hot stones that heat small household earth ovens. These are made of a strip of the fibrous material removed from the central stalk or branch of a coconut frond (the branch portion to which the leaflets are attached) bent over upon itself. A listener is supposed to chuckle at the naiveté of this monetary experiment, because tongs are so simple and have no purely economic value whatsoever. Obviously, this simple artifact did not serve well as currency and it was replaced with halves of coconut shells (*teipu*), objects that have uses as containers, substitute cups, and so on, but as currency they are no better than tongs. Then someone got the idea of manufacturing something special, and they commenced using swatches of a coarsely woven fabric (similar to the cloth woven for burial shrouds). This did work for a while, and some of these swatches were still kept as curiosities in the 1960s (and I purchased them for the collection now at the Bishop Museum). Then someone got a better idea: use the strings of perforated *Conus* shell discs called *ba* that were manufactured on Vanikoro Island. This worked fairly well until *ba* became so valuable and hard to obtain that they had to be given up as currency (however, this type of ground shell disc survives as a valuable type of belt called *ba*, worn only for ritual *nela* dancing). Finally, red-feather money (*tevau*) was invented.

The second story or mini-myth is directed at the actual invention of feather money, and I recorded several versions of this, all of which are bare of technical details.

A man watched the branches of a *nulu* tree rubbing together and the sap gradually collecting during a storm. He then saw a red honey creeper fly up and get caught in the sap, and remembered that red honey creepers were attracted to the flower of the *nulu* tree. Then the idea suddenly came to him: catch the birds, pluck the red down from them, and fashion this beautiful material into a new kind of currency. Little by little he worked out the technology of actually making *tevau*. (It is here where the several versions differ, but only in the way the unnamed central character tried various ways to create something that would serve as a currency. All narrative variants ended the same way.) Eventually, this unnamed human worked it out, and he became very rich.

Some *dukna* were watching this trial and error approach to making *tevau*. The *dukna* Opla was particularly fascinated. In due course three occupational specializations developed out of making *tevau*: catching the birds, making constituent web coils, and binding them into belt-like double coils (see Davenport 1962a). Because Opla and other *dukna* liked the appearance of *tevau*, they gave to the initial makers certain protective powers and spells to keep all but a few persons from making the currency. This association of currency making with *dukna* Opla imbued currency with the possibility of being endowed with a special supernatural power of attraction, an attraction based on an analogy with the flower of the *nonūlū* tree that attracts the red honey creepers. As a result, some individual pieces of *tevau* attracted persons and hence influenced the transactions in which they were involved, sometimes in favor of the purchaser, sometimes in favor of the seller. This mystical component has been celebrated in many song lyrics that are favorites at the *nela* dances described in Chapter 3.

This power was most apparent when it came to paying *wergild* and when *tevau* was used to "buy off" attackers threatening to raid a community. Such power is what makes litigants in a serious legal case feel recompensed or requited after they have come to an agreement on the settlement. In former days, litigants might settle their dispute, but after payments were made, one party might have second thoughts, that is his emotions (verbally expressed as his "stomach" or seat of the emotions) still troubled him, and the dispute had to be reopened. This sort of dissatisfaction was explained to me as due to the absence or deficit of that invisible power of attraction within the currency. The same applied to bride price negotiations long after internal violence was ended by the Protectorate.

Valuable pieces of currency were always protected with charms (*nobue*) that were bundled together with the double coils (see Koch 1971:161–3),

and some of these charms were also believed to help maintain or recharge a specimen with the power described above. And it is relevant to note here the bamboo bar (*noali*) that hangs in every *madai* on which pieces of currency are hung when being compared with each other (see Figure 2.3). Such comparisons are rituals in themselves, and their outcomes are uncertain. By association they transform the *noali*, a simple length of bamboo, into a sacred object that is always treated as such.

The Origin of Human Beings in Nendö

The origin of human beings is accounted for in brief mini-myths that describe how the the first humans emerged out of shallow caverns and natural recesses in the limestone portion of Nendö. This occurred at several localities around the island within the same mythic time frame. As a progenitor, usually a female, emerged she was named either Bu or Bebla, and thus became the founder of the matrilineal descent categories bearing those two generic names. These two names are also the names of two large genera of ocean fish, each of which occupies a broad ecological niche. And associated with each fish genus there is also a genus of trees that occupies a distinctive niche in the rainforest.

Along the north and east coasts the two descent categories have varying food taboos. Individuals who associate food taboos with both parents tend to observe those taboos strictly and religiously; others observe them only casually. Failure to observe food avoidances is supposed to cause illnesses of several sorts, usually a skin disorder around the mouth accompanied by severe swelling and discomfort.

At Bumalu on the north coast a Bebla woman was washing the earth off some *pana* (a species of yam) for the evening meal. She was squatting in a narrow passage through the fringing reef, and in swam a single fish of the *bu* species which she deftly caught by using her skirt as a dip net. The fish may have been attracted toward her by a scent from her vagina. That evening she cooked the fish over the hot coals of her cooking hearth but refused to let anyone eat any. One child kept nagging her for some of the fish until, finally, she relented. The child ate a bit and in a short time died. The other brothers and sisters declared henceforth that *bu*-fish were taboo to eat. From that incident her descendants formed the Bu descent category that regarded that species as a food taboo. This assumes a patrilineal rule of descent at Bumalu then, the mother being Bebla, her husband a Bu.

Descent Categories

The number of descent categories (*nou*) recognized is variable across the island (see Davenport 1964a). While a matrilineal moiety system is observed in most of the Graciosa Bay villages, in some northern communities Bebla is understood as being a segment of Bu, and a third *nou* with several names is thought to have come to Nendö from somewhere outside the group, its progenitor having drifted ashore on or inside a large log. Some people give this *nou* a sort of nonsense-sounding name such as Tulaleka as if it were a derivation from a very different language. Within part of the area that recognizes dual moieties, the original pair is named Kio (a species of bird) and Bebla. Kio is associated with "the bush" or forest and sometimes called Bona ("pigeon"), while Bebla is of the sea, with Bu coming out of Bebla according to this short myth:

A Bebla woman was searching for shellfish along the reef at low tide. She squatted down to probe under some coral stone, and a small eel (*navu*) entered her vagina. Her husband and his younger brother both were killed by having their penises bitten off. Sex with a husband's younger brother was acceptable because, traditionally, a younger brother "inherited" his elder brother's widow. Then another husband's younger brother tried to lure the *navu* out of her by dangling some bait and a string noose outside her vagina just as freshwater eels (*tuna*) are caught in streams for food. He caught the *navu* and took the woman as his wife, which was proper, but he found that she was pregnant from the *navu*. When that child was born it was a female, and she became the progenitor of the Navu descent category, considered to be a branch of Bebla.

In another myth a fatherless daughter of an ogress (Blaepuano) was taken and reared by a man from the village of Bania, and she became the progenitor of the Bu moiety in that eastern sector of Nendö. In several Nendö communities, however, no descent categories are present, and in two communities along the west shore of Graciosa Bay, descent is ideally supposed to be reckoned patrilineally. In fact, few individuals can name their own *nou*.

Throughout Nendö, genealogies linking progenitors with living descendants are shallow, rarely more than four or five generations deep. Each *nou* is supposed to be indicated by a distinctive pattern of creases on the palms of the hands of its affiliates. And while there is little correspondence between individuals' asserted affiliations and their palm patterns, still the fictive convention does serve a purpose when two men from different islands within the Solomons are trying to work out how they should interact with one another. If the two have palm prints that match, then they are of the same

descent category, and if their ages are similar, they are "brothers." If their palms do not match, then they think of each other as either in-laws or possibly related through a patrilineal connection.

Even though at first glance Nendö society appears to have a segmentary lineage structure, closer analysis does not support such a classification. Traditional Nendö society provided no category for incorporating outsiders in any way other than those provided by the kinship system or their limited inventory of government and Mission officials (such as District Officer, Bishop, and Priest), the latter always being called "Mama" (this term means "father" in Pidgin English). Traditionally there was no sociological category such as "friend." When Nendö men find themselves in situations that require close cooperation and trust, they will seek to create, by ritual, fictive reciprocal kin relationships. Usually, these are "brother" or "brother-in-law," both of which are characterized by great trust.

In thinking of Nendö as a society knitted together by one common institution, kinship is that institution. But it is a unique system of kinship that is largely fictive, in the sense that the way people interact is not determined by strict, closely kept pedigrees. Rather, it is by establishing interactive relationships first, then categorizing such relationships by kinship terms.

My own sociological identity was a problem when I first arrived on the island. Initially, I was just Lematangi—"foreigner" or "European"—but after some months an elder in the village came to me and suggested that they treat me as if I were his "son," and brother of his son Meneisia, with whom I had already become friendly. From then on there were no more problems. My personal name became Melika (for American) and I learned too from my "brother" how and why he acted as he did with individuals and did as he did. Since my dwelling was always open to many persons of all sorts, it became classified as an equivalent to a *madai*, a men's house, in Banua village.

5
Myths of the Santa Cruz Island Dukna

Most of the figures in the catalogue presumably represent named tutelary deities, or *dukna*. The particular names of these deities and the myths surrounding them have now, however, become disassociated from the figures. The myths recounted below, upon which the religious life of traditional Santa Cruz Island (Nendö) society was based, are, nonetheless, instructive in the context of this catalogue, because they demonstrate the extraordinary and widespread powers that these figures must have been imbued with at the time of their making and use as ritual objects.

Kamatiboi and His Son Be

A man from Tanga, one of the villages of Nifiloli in the main Reef Islands, isolated his daughter in the bush as part of an initiation ritual called *guau* and got an older woman to stay with her and look after her needs. This form of initiation for both girls and boys was observed on Nendö and in the main Reef Islands for a brief period, probably in the 1920s, then abandoned. It appears to have been a cultural borrowing of a male initiation rite from the eastern Solomon Islands (see Davenport 1981). One day shortly after the girl was placed in isolation the people of Malobo held a dance to which people from all over the main Reef Islands came, including the attendant to the young lady who was undergoing the *guau* rite. In the middle of the night an ogress (Blaepuano) carried the girl off and hid her in a deep pit in order to fatten her up before eating her. Knowing the ways of Blaepuano, the young lady refused to eat anything her captor offered so she would lose weight and become less appetizing to the ogress. Soon she became thin and emaciated.

One day while Blaepuano was away collecting firewood, a tutelary deity (*dukna*) of the captive girl's maternal uncle appeared and told her this was her opportunity to escape. However, the girl claimed that she was too weak to walk, so the *dukna* carried her as far as the sandy beach and put her down. Shortly after this a *dukna* from Utupua Island named Kamatiboi came flying by and saw the girl lying on the sand, nearly dead from hunger and exhaustion. Being a genuine *dukna*, he already knew about her abduction by the ogress, so he kept close watch over her for two days and nights, during which the girl slept. As soon as she awoke Kamatiboi brought her two coconuts with soft meat (one of the foods used in weaning infants) and instructed her to eat the soft coconut slowly. Soon she felt better, but refused to go away with Kamatiboi as he was asking her to do because she still felt weak and wished to sleep. So, Kamatiboi stayed with her, bringing more coconuts and bananas each day. Soon she was strong enough to leave with Kamatiboi, who took her to his house that was located atop Utupua's highest hill. By taking up residence together, Kamatiboi and the young lady became husband and wife.

Every morning, Kamatiboi arose early and disappeared for the remainder of the day. He gave his wife strict instructions never to attempt to follow him when he left their house. And when Kamatiboi returned in the evening he brought one coconut, one corm of taro (*Colocasia* sp.), and enough firewood to cook the latter for their evening meal. The couple could not eat all of that food, so there were leftovers for a morning meal as well. This amount of food is much less than two adult humans would normally eat, but the small amount indicates that the couple was not an ordinary human husband and wife.

Since Kamatiboi had saved her life, the young lady did not question him about the strange instructions and behavior. After a few months, she became pregnant, and Kamatiboi asked her if she were homesick for her relations in the Reef Islands. But she always replied that she was quite content with things the way they were. But then Kamatiboi began to be troubled because he had actually stolen the girl without seeking any permission to do so and without even negotiating a bride price with her close relatives.

Without informing his wife about his uneasiness, Kamatiboi set about assembling a large amount of red-feather currency and stores for making a canoe trip to the Reef Islands to see her parents. On a day that the weather looked fair, he loaded up his canoe and set off for the Reef Islands.

Arriving at the canoe passage near the house of his wife's parents just before daylight, Kamatiboi instructed his wife to go on ahead of him, and that he would follow soon. She refused, insisting they go together as a

husband and wife should. So, they waited until daylight and went together. Her mother met them and right away told them that her husband had died some time back. Kamatiboi asked his mother-in-law to call all her friends and neighbors together to help pull his canoe up onto the beach, and to come to her house, because he had something very important to do.

She did as he asked. And Kamatiboi proceeded to hand out rolls of feather currency to all assembled. This was an odd situation for he was short-circuiting the whole process of negotiation, but not being human, he could and did as he felt right. Eventually Kamatiboi gave out much more than would have been a normal bride price; everyone was pleased and no one considered making any trouble because of the irregularity of the marriage. Immediately after Kamatiboi completed making his distribution, the couple set off for Utupua.

Life went on as before until she gave birth to a son whom they named Be ("Beginning"). The boy matured very rapidly, and Kamatiboi celebrated every stage of Be's maturation with an appropriate feast and distribution of enough cooked pork to reach every villager on Utupua. Be continued to mature very fast and soon began to question his father about where he went every day after he left their house. But Be's mother managed to keep her son from asking these questions directly to Kamatiboi, and informed him of Kamatiboi's orders not to question him about where he went each day.

Be's breech clout ceremony marked his transition from a child who showed no genital modesty to a young man who not only must keep his genitals covered but also is old enough to begin sleeping and taking his meals in a men's house (*madai*) instead of eating with his mother and sisters in the dwelling. The ceremony also celebrated Be's social maturity, his ability to understand the complex rules of behavior, particularly the avoidances, that governed the domain of interpersonal behavior. At this time, Kamatiboi promised that he would make a bow and arrow set for Be to play with.

Time went on, but Be never received his bow and arrows. He became very angry at his father for not fulfilling a promise, so Be decided to spy on his father to see what he did during the day. For several mornings Be did not wake up until after his father had gone, so he decided to stay up all night feigning sleep. He managed to do this, and one morning he watched his father leave the house through a tunnel kept hidden under floor mats. Be waited while his mother woke up and went out to urinate. Then Be picked up his father's bow and arrows and went into the hidden tunnel. After a long distance, the tunnel opened on a garden scene. There Kamatiboi sat in the shade of a great tree watching over his garden tools that were working in a taro garden by themselves, except that Kamatiboi occasionally spoke

instructions to them about what to do next and so on. Be watched all morning, and then picked up his father's bow and shot an arrow toward where his father still sat, just to attract his father's attention. The arrow struck the tree above where Kamatiboi sat and passed right through the trunk. Startled, Kametiboi jumped up, and the garden tools fell to the ground motionless. In a rage Kamatiboi jumped up shouting at his son, "Now you will be sorry for not obeying my orders. From now on you will have to come with me every morning and help with growing the taro and all the other food that you eat."

Thereafter Kamatiboi and Be went together to their garden and worked without a break until it was time to return to their house for the evening meal. So it went, every evening as soon as the evening meal was eaten, Be fell asleep. One morning Be failed to wake up, and his father went off without him. Be thought a long time before he got out of bed, and came to a plan of action. He went outside and collected fibrous materials for making a rope. Everyday he did this, and he asked his mother to lay (-*nui*) the strands into a very strong fishing line. Before many days passed his mother had produced a line strong enough to use for catching sharks. And Be then found a crotch on a small tree out of which he fashioned a large fish hook.

Taking his hook and line, Be launched his father's outrigger canoe, and he paddled northward without stopping until the sun was directly overhead. There Be commenced fishing. Shortly after the hook was on the bottom, he got a strike and commenced to pull the line in. He pulled and pulled, and finally a entire island began to emerge. Then Be went ashore on his island to study the landscape. The hook had fouled on a mountain top at a place now called Mt. Nodabu. After ascending the mountains, he descended to the shore and began to inspect it.

Soon there appeared another supernatural (*dukna*) in a canoe who ordered Be to get off the island, because it was not his. They argued fiercely, and finally Be suggested they settle the matter by a contest. Be would troll for fish along the northern shore, while the other *dukna* would troll off the southern shore, and they would meet at Note ka Mate (Cape Death), the western tip of Nendö. The one who had caught the most fish would be the winner and could take the whole island as his. And so they commenced their contest. When they compared their catches, Be, of course, was the winner. But the other *dukna* would not accept the result, saying that Be knew where all the good fishing places were before they started to compete, and so it was not a fair contest. Be realized the only way to get rid of the competitor was to kill him. Be had no difficulty in dispatching his opponent. And so Be became the sole proprietor of Nendö.

Be got his father's canoe ready and paddled back to Utupua, arriving off his parent's old house during the night. Be did not wish to wake up his parents, so he slept the rest of the night in the canoe. When daylight came Be climbed the mountain where his parents' dwelling stood, and looking northward he could make out the outlines of Nendö, his own island. Be then woke up his parents and began telling them about all that had happened since he had gone away. And he showed them the outline of Nendö in the north, and he informed them that they would go there to live, because everything would be easier and better there.

And so, the first *dukna* came to reside on Nendö.

Be and His Son Melata

This myth introduces the best-known *dukna*, Melata (or sometimes just Lata), about whom there are many tales in which he plays several roles. From a folkloric perspective, Melata is a culture hero and he is also a trickster, in the tradition of Maui of Hawai'i and Qat of Vanuatu (or the New Hebrides). Some Melata tales clearly establish him as a supernatural being worthy of veneration, which he was in the northeastern villages of Vaenga and Neba, as well as former villages on Temotu. But Melata stories, particularly the trickster tales, are also told in purely secular contexts as humorous folktales and "just-so stories."

When there was only Be residing with his parents somewhere on some unknown island, the sea was covered with a sticky substance that made it difficult to go far out to sea to fish. Nevertheless Be managed to go out far enough to fish for his and his parents' food. One time Be let his hand line down and it got snagged. He pulled and pulled with all his supernatural might, and land began to emerge. Melata had snagged his hook in an underwater tree on the peak of Mt. Nodabu (Mount Dabu Tree). Standing on the dry land, Be could look down on all of Nendö and to the south just make out the profiles of Utupua and Vanikoro. As Nendö had emerged from the ocean depths, it pulled the Reef Islands and the Taumako group (Duff Islands) up at the same time. The Dabu tree was later transformed into a pillar-like stone that is a reminder to the humans who came later to live in the islands of Be's great effort.

Be came down from Mt. Nodabu to live at the mouth of Lue Nilu, the largest river on Nendö, not far from Note-ka-Nego (Point Nego or Cape Byron), the northwest tip of Nendö. Not long after Be had settled there, the ogress Blaepuano from Taumako came swimming ashore. A stone there, visible only at low tide, marks the spot on which she landed. She sensed Be was there

and marched up to him and demanded to know on whose or what authority he was living there, because it was her island! Be countered with the claim that it was his island, because he had fished it along with all the others. After many hours of fruitless argument, Be suggested they settle their differences with a contest, the winner of which would be the owner of the islands. Blaepuano stupidly thought Be was not as powerful as she. And she agreed with the rules of the contest as Be outlined them: each would swing the other by the legs and let go. The individual who landed on his or her feet would be the winner. Be swung Blaepuano and she went sprawling on the ground; Blaepuano swung Be and he landed gracefully on his feet and kept standing.

As Blaepuano was leaving, Be said, "You have no place to go, so why don't you stay here with me?" She assented (which signified they would live as a married couple).

Before the year was over, Blaepuano gave birth to a boy, and they named him Melata. As would be expected, Melata began to mature very rapidly, and soon Be was taking him out each day in his canoe while he fished for the family's supper. But this turned out not to be such a good idea, because Melata needed a lot of attention. So Be began to consider leaving Melata behind each day, but first he had to devise a way to hide Melata from his ogress mother, who, following her ogress instincts, might devour him. Be first turned over a very large wooden bowl under which he could hide Melata with a large cooked tuber of *Cyrtosperma* taro for his day's food. But Melata would eat the tuber up before Be got very far away in his canoe and would start calling his father back to prepare more food. Be then decided to modify the food so Melata ate more slowly and still remained hidden from the boy's ogress mother. He cooked a large tuber and then stuffed it full of coir fiber, the same as the fiber used for canoe lashings, and that slowed up Melata's eating so a single tuber lasted until he came back from fishing. And this is how the *Cyrtosperma* taro, sweetest of all, got the fibers in it.

As a boy, Melata was fascinated with canoes, which at that time were a very clumsy craft. First Melata made a toy canoe with a leaf hull and another larger leaf set vertically for a sail. This toy would skim over the water very fast, but only if the surface were perfectly smooth. Such toys are still made and are truly extraordinary sailers. Melata studied this toy intently, then made a larger model with a dugout hull. It worked but needed improvements. So Melata made another, then another, and finally he developed a new style of outrigger canoe in which he could sail far out to sea.

While Melata was experimenting with canoes, a stupid *dukna* named Biale was watching him closely. Biale came right up to Melata and asked him to show him how to make a proper sailing outrigger canoe. Melata was not about to show

this dunce of a *dukna* how to make a canoe like the one he had been developing. But Melata did not show his annoyance and acted as though he would be pleased to show Biale how to build his new style of canoe. He gave Biale a long list of materials he would need, and Biale set out to collect them all.

Melata explained that they would build two canoes, one for himself, while he instructed Biale to build another just like it for himself. As they commenced Melata seemed to be giving Biale all the correct instructions; every thing he explained to Biale was intended to make Biale's canoe look like his own, but not actually be equivalent. And so they worked long and hard, and finally Melata said they would launch their canoes the next day. Melata launched first and sailed smoothly right out to sea. Then, Biale launched his canoe, and with the first swell it encountered the hull broke up and left Biale floundering in the surf.

Melata returned to his mother's house as usual and told her about tricking Biale. She realized that very soon Melata would just sail away and not return. So she commenced to warn him about all the supernatural hazards that existed out on the ocean, such as the giant grouper, the treacherous garfish, the giant octopus, Besila the whale, and others. There are stories about how Melata went about encountering each of these hazards, and after overcoming each, how he returned to his mother's house, told her about his victory, presented her with a portion of meat cut from each monster, and asked her to cook it for their evening meal.

All over Nendö there are marks and features in the landscape that are linked to an incredible feat of skill or audaciousness by Melata. Some of these feats are humorous, some not, but all reveal Melata's supreme skills and unique abilities.

Eventually, Melata invented the *tepuke*, the large cargo-carrying outrigggger canoe, as well as the smaller version of it called *nuatupma*, upon which the overseas trade network, linking all the Santa Cruz Islands, depended (see Davenport 1962a; Koch 1971:164–7). Melata even sailed a *tepuke* to Matangi, the home island of the Europeans, and there he invented the steamship and motor-ship. Melata returned to the Santa Cruz Islands to show off his ships, but since no one could appreciate the significance of these inventions, Melata went off and never returned again as a human. But as a *dukna,* Melata lived on and became the dominant tutelary deity in Vaenga and Neba villages, and possibly in former villages on Temotu Islet as well. On the other hand, Lematangi ("foreigners") did see the importance of all of Melata's inventions, hence their technical superiority.

Melata apparently had followers in the Reef Islands and at Taumako as well. Appropriately, in the 1990s a cultural revival, in the manner of the

Hōkūle'a of Hawai'i, was organized by outsiders with the goal of building and sailing *tepuke* to distant islands.

Melata, Memitewa, and Besila

An old man named Memitewa and his wife were sailing in their *tepuke* (not explained is how Memitewa acquired his *tepuke*) to the small islands of the Outer Reef Islands. They encountered the great whale Besila, who swallowed them up.

At this same time Melata was also at sea in his *tepuke* on his search and destroy mission to rid the sea of its great hazards. Inside Besila, Memitewa and his wife were starving and had already eaten each other's hair, even their pubic hair.

Melata, in his cavalier manner, asked Memitewa what he and his wife would like to eat. All they could utter was "food," meaning, of course, staple foods such as yams, taro, and sweet potato. Melata took his bush knife out of his belt and cut off a piece of Besila's liver. He broke up the pole (used for propulsion over shallow reefs) in his *tepuke* and built a fire to cook the liver. Besila was writhing in pain, and Memitewa shouted at him, "Take us ashore or die from being hacked up and burned from inside." A tsunami tidal wave suddenly came and washed the great hulk of Besila up on the shore at a place called Mang on Temotu, and there Besila died.

Melata propped open Besila's mouth with another pole and all the "passengers" walked out on the sandy beach. Besila rotted away at that spot. Memitewa told all the people who had gathered there at Mang that they should commence to venerate Melata, and they should build a *madukna* there for housing sacred objects (such as *napa*) used in the public worship of Melata. The *madukna* was named Palisi-ka-Neo, and that name was carried on until Neo villagers destroyed its several *madukna* when the villages of Temotu Islet became Christian just after World War II. The village name, Neo, is thought to have been part of the name of a *dukna* that was being worshipped at the time Besila was stranded, before the villagers switched to Melata.

Temami

The next story can be thought of as a complete myth in itself or one episode in the lengthy saga of Melata. However, this story, one that Neo village on Temotu regards as its "charter" for the veneration of Melata there,

raises question about borrowing and adapting stories from the Old Testament; is this such an instance or not?

The following three stories are about the volcano on Nendö called Temami, which appears on most charts as Tenakula. It has active periods when fire, smoke, and lava spew out, and it has quiescent periods when from a distance it appears to be extinct.[1] When Temami is active it is an awesome sight. Smoke, flames, and great boulders hurl out of the crater, and streams of molten lava run down the slopes into the sea, causing great clouds of rising steam.

The people who know the volcano best are those of Noka village on Temotu Islet and Vaenga at the northwest corner of Nendö and the people of Nupani atoll. Not only is Temami in full view from these communities, but some men from each have been close to it while on extended fishing trips. The attitude toward the volcano in Neo and Vaenga is much less fearful than in the Graciosa Bay villages, whose people think of the volcano as a super-natural phenomenon closely associated with *dukna*, something to be regarded with caution and wonder.

I have two versions of the myth, both of which read as if they were children's folktales. The version below was recorded at Neo, in full view of the volcano that was inactive at that time:

(A) A woman named Oriela and her husband lived at Taumako and they had a son named Temami (in some versions he is named Mega). As a child Temami showed an interest in chewing betel, and he especially liked to chew on a wild variety of the areca nut (one ingredient of betel) which everyone knows makes one fart. Temami would not heed his mother's warnings about wild areca. One morning she noted Temami's sleeping mat and bark cloth coverlet had been burned during the night, with ashes strewn all around the floor where Temami normally slept. She asked him about it, but Temami could not give a clear explanation. So Oriela gave him another sleeping mat and coverlet, but the same thing occurred on the very next night. Temami's father was deeply concerned and decided to stay awake and watch closely in order to see what really was happening. Late that night he heard Temami fart, and as he got up to take a closer look, Temami's bedding burst into flames.

Now Temami's parents understood what was going on, and they realized that Temami was a danger not only to their household but also to the whole village. So they decided to take Temami away, and the father got their small sailing canoe (*nuatupma*) ready. He set sail to the southwest, past the Reef Islands and into the open sea beyond. There, Temami asked his father to stop, so he could dive down and inspect the bottom. Coming back up, he told his father to sail on some more until they reached the location where the

volcano now stands, to the north of Nendö. Again, Temami dove down to have a look at the bottom, and when he came back to the surface, he told his parents he would remain there, and when the sea commenced to boil and smoke, not to worry, for that would just be he, Temami.

And so after many episodes of boiling and smoking and fire coming out of the sea, an island began to emerge. It kept right on growing until it became the cone-shaped island that it is today, rising up conspicuously off the north coast of Nendö.

(B) According to the men of Neo, after a dormant period and a return of activity, they say that Temami, the supernatural boy, is trying to get rid of something irritating on his body. For example, the crew of a fishing canoe may have gone ashore there to get fresh water and done something, such as defecating or urinating, that the spirit Temami does not like. So, Temami comes to life, so to speak, first with earthquakes, then emitting fire, smoke, and lava.

In addition, the same informants at Neo on Temotu Islet who related the Temami story to me have a supplemental idea about the geology: beneath the mountain and in the sea, there is a great dry chamber in which a fire burns. An eruptive phase commences when the fire roars to life and melts hard lava, which goes off into the air as smoke and flame, and molten lava slides down the slopes and back into the great fire box. There, the lava is reheated and the cycle starts over again. In other words, it is a closed system with no new material entering it. This belief, certainly not widespread and probably confined to Neo village alone, is backed up by the following logical argument: over the generations that people have lived in Neo, the volcano has held its shape (a classic cone) and position relative to the shoreline of Nendö. If more volcanic materials were feeding into the subterranean chamber at each eruptive phase, the lava would have brought the visible base closer to the shoreline of Nendö, and that is not the case.

The people who live closest to the volcano island of Tenakula (Temami), and especially the people of Nupani atoll in the Outer Reef Islands, often made camp on Temami while they fished offshore and smoke-dried the catch ashore (there is enough brush growing on the shores of Tenakula to make fires). Over the years Nupanians had planted coconuts on the island, so there would always be something to drink. Some of the smoked fish was brought over to Nendö to trade for staples that were brought back to Nupani to relieve a chronic food shortage there. There was nearly always a group of Nupanians camping out on Tenakula during the 1960s, as the amount of dry land on their atoll was diminishing due to erosion. The District Commissioner of the Eastern District managed to

arrange a purchase of a sizeable acreage of unused land on Temotu Islet for any Nupani household that wished to relocate there. In a very short period the majority of Nupanians made the move, leaving only the very old people on the diminishing atoll (see Davenport 1970).

Medauea and Tenakula

Medauea is often cited as a powerful deity who was once venerated by people who lived on the southeast corner of Nendö at a village called Naggu and on the small off-lying islet named Temotu Noi. Shortly after Medauea was born, his father took off, leaving his wife and child to fend for themselves. Medauea (his name means Mr. Tidal Wave, and Dauea was a fairly common personal name among men of both Nendö and the Reef Islands) was a very beautiful child, and his mother decided she never wanted her husband back. In several episodes of this myth, people become envious of Medauea and his mother, because he was such a beautiful child and his mother so independent and capable. Their envy turned to anger, and the Naggu people commenced treating mother and son very badly. But she never complained or talked back. Then, without telling anyone, the mother and son left Naggu and crossed the narrow channel to live on Temotu Noi. But there, as at Naggu, the people tried to harm them with sorcery and by asking their tutelary *dukna* to do the pair in. Always, the mother quietly outmaneuvered her enemies by being kind and doing considerate things for others.

Medauea continued to mature rapidly (as *dukna* born of human mothers always do), and their only friend was an old and inconspicuous lady whom Medauea's mother called "grandmother," although they were not related by kinship. Although still appearing to be a child, Medauea fully understood how badly the community treated his mother, and he asked the grandmother what he should do about it. She told him to go to a certain locality where a large tree grew, to cut the tree down and hollow it out. Then Medauea was instructed how to fill the hollowed-out inside of the tree trunk with dried coconut leaflets and wait until a crowd of curious villagers had gathered to see what he was up to. When the crowd had collected and were hurling insults, Medauea set the tree afire and commenced dancing around it, jumping up and down and singing, "Many times you have tried to kill us; now it is my turn." Over and over, Medauea sang this refrain, and with each repetition of his song, the tree flamed up and spread. Soon the whole village on Temotu Noi was burned down, and all but two individuals were burned to death. These two survivors then revealed themselves to be

dukna, like Medauea, and they advised Medauea to quit Temotu Noi and go far away. Medauea took their advice, stole a canoe, and taking his flaming tree with him as a torch, he paddled off. After awhile he stopped and asked the two *dukna* who were ashore and watching them, if he had gone far enough. "No," the answer came back, and Medauea moved several miles farther away. Still he received instructions to move farther along and, finally, he rounded the western tip of Nendö (Note-ka-Nenggo). The two *dukna* finally signaled that he had gone far enough. There Medauea's great torch was transformed into the volcano island of Tenakula, and from this miraculous event Medauea earned the reputation of being a powerful *dukna*, respected by other *dukna* and venerated by many humans who lived in the small communities that were located along the shore from Naggu and Temotu Noi to Note-ka-Nenggo.

Two Sisters from Taumako

There were two sisters and a brother who lived in a village of Taumako (one of the Duff Islands, north of the Santa Cruz Islands). Every day the brother went to a particular rock to feed two sharks who were spiritually associated with him. (Calling and feeding sharks is a ritual in many localities of the eastern Solomons, but in the western islands it was practiced only at Taumako, following an epidemic that had hit the area.)

One day a stranger from Takula, one of the Taumako Islands, came up unnoticed behind the person who was calling the sharks and so startled him that he lost his balance and fell into the sea. In an instant, the man was consumed by the very sharks he was calling. The stranger immediately went to the man's house in order to explain the accident so that he would not be suspected of causing the disappearance of the man.

He also told the sisters that in an unexplained way their brother had told him that he wished them to go with the stranger from Takula and live with him. The sisters were very suspicious of this, their brother's final wish, but they packed their few belongings and went along toward Takula.

Arriving there, the sisters told him to go first to his dwelling; they would follow after bathing and changing their bark-cloth skirts. Instead, they called out to their brother's two familiar sharks, who appeared right away. They asked if it were true that they had eaten their brother, and added that if untrue they should swim away. If true, they should swim in close and open their jaws. This is what the sharks did, and the sisters saw shreds of flesh between their teeth and their brother's breech clout still caught by one tooth.

Having had the fate of their brother corroborated, the sisters decided to run away from Takula by swimming across to the nearby islet of Ka. At Ka they cut lengths of bamboo and made a fishing raft (used throughout the group by persons who did not own outrigger canoes). They succeeded in poling the raft all the way back to their dwelling on the main island of Taumako. There they gathered up their personal belongings, borrowed an outrigger, and headed south for the Great Barrier Reef that stretches westward from the main Reef Islands. They poled their way across the shallows of the Great Barrier Reef, just as people do today, and as they wore down the bamboo poles, they cast the shortened poles overboard and each length was transformed into a patch of the Great Barrier Reef that remains dry even at high tide.

The sea was calm and the sisters made good time drifting southward from the Great Reef toward Tenakula which was not active at that time. Reaching Tenakula, the sisters climbed straight to the summit of the volcano. One sister went to the northwest rim, while the other went to the eastern rim. The sister standing on the northwest rim removed her skirt and shouted out,

"You people out there over the horizon [the entire Solomon Islands, which had no collective name then] shall never become civilized, never know genital modesty, never wear proper clothing, never learn to cook your food, never eat regular meals."

The sister who faced southwestward looked out at Nendö on the horizon and shouted,

"You over there shall always wear clothing, never show your genitals, shall cook your food and eat two regular meals, morning and evening, every day."

Cultural anthropologists and folklorists will recognize this myth as one of "The Raw and the Cooked" type as classified by Levi-Strauss, which gives justification to the people of Nendö for feeling culturally superior to those of the Solomon Islands, including Aoriki and Santa Ana Island. The latter two were locally called Temotu-ni-Ora, "Islands of Women." There, traditionally, women wore no clothing until married, and only a perineal fringe after marriage. Boys wore nothing until put through a maturation rite, and then only a minimal pubic covering.

Meboku

Meboku is a shark/human changeling, and versions of Meboku myths are told as widely as myths about Melata. Meboku is important also because of the imagery of several carvings where sharks appear in strong relief on the

bodies of the standing anthropomorphic figures, causing commentators to name them "shark gods."

All versions of Meboku myths commence on the sandy islet of Naba located in the mangrove swamps of western Nendö. There are two other islets, Gaito and Nibamau, and at various times during the 20th century all have had temporary human settlements on them. Overlooking this extensive swamp is the uninhabited area called Matapapa where *dukna* live and dance every night in their finery and also where souls of the human dead comingle.

At Naba lived a man and his wife who kept mostly to themselves. The woman became pregnant and shortly after, her husband suddenly died. Before her pregnancy came to term, she miscarried. Although weak she placed the aborted fetus in a basket and threw the afterbirth into a pool of salt water. The pool turned murky and the basket with the fetus floated around. In time, the fetus developed into Meboku.

Yam-planting time was soon upon the community, and people commenced traveling from Naba to the shore where they began making new gardens. Because she did not have a canoe, the widow could not start new gardens; neither could she cross over to glean the old gardens. Thus she was out of food. During the day the only other person who remained in the village was an old man without family who lived in the men's house (*madai*). She began to scrounge around Naba for something to eat, and to her surprise found the vine of a forest yam (*Numularia* sp.) growing up the trunk of a tree in the village area. She dug around the corm and cut off a piece for cooking, but before she ate any took a piece over to the *madai* for the old man.

Then one day she set her portion of the yam aside while she delivered the other part to the old man. When she returned to her house her part of the cooked yam was gone. The next day the same thing happened, and then again the following day. But on the next day, after taking the food to the old man, she returned to find a young man in the act of stealing her food.

The young man commenced to explain, "I am Meboku, your son, and I am angry because of the way the people here are treating you. It was I who saw to it that you discovered the forest yam in back of your house."

From then on, after the villagers went across to tend their gardens Meboku appeared in his shark transformation and ferried his mother across to the garden lands. But she continued to cut off parts of the corm of the forest yam for herself and the old man to eat as their evening meal. Day after day, Meboku ferried her across in the morning and back in the afternoon. The neighbors were very puzzled about how she always got to her new garden site late, and they left early before she did. They were really angry because she

seemed to have food to eat and also she did not work as hard or as long as they did. So, in order to find out what was going on, one villager stayed back after the others had left. In this way they discovered that a shark/man changeling was assisting her.

When Meboku dropped his mother off each morning, he came back to the village and took off his shark body and hung it up on a limb and then went among the single female villagers to seduce them, one by one. In a short time he had seduced them all and they were pregnant. All alone in the *madai*, the old man saw and understood all that was going on. As the time came for each of the single women to give birth, each bore a mixed species monster—part lizard, part snake, part rodent, and so on. This was Meboku's first revenge on the villagers for treating his mother so badly. Then Meboku caused all the mangroves to grow up almost instantaneously, completely surrounding and entangling the villagers' canoes, making it impossible to launch them in order to return to their village. Still not satisfied with his revenge, Meboku put a curse on the sharks that were swimming in the channels of the swamp, making it easy to catch them. But the shark meat would not cook. At this time the old man in the *madai* broke his silence and instructed the villagers to wrap the shark meat in *Barringtonia* leaves before putting the leaf-wrapped packets of shark meat into their earth ovens. To this day, everyone on Nendö is aware that *Barringtonia* leaves spoil the taste of any staple or meat cooked in them.

Meboku kept up his harassment, and the villagers fought back by summoning all the supernatural powers belonging to their tutelary *dukna*. They also consulted a spirit medium on what to do. She instructed them to summon a fish-deity named Pna, a red shark who boasted that he had greater powers than Meboku, and to summon the great supernatural whale Besila, and the giant eel named Kuli-ka-Nego ("The Dog of Nego"). Only Kuli-ka-Nego had the courage to confront Meboku, but in the course of their violent combat, Meboku cut a new labyrinth of channels through the swamp.

Not far away, where the Lue Maoda (Tridacna Clam River) empties into the sea, a storm surf came up and eroded all the sand away from the shore-line. Now when a storm comes up any place along the shores of Nendö, people say, "This is Meboku fighting with other deities." Omitted here are other confrontations Meboku has with different *dukna,* all of which, of course, he wins.

Now the old man decided to get into the fray from the other side, and he stole Meboku's shark body from where he had hung it up. Somehow, Meboku sensed what was going on, so he caused the old man to stumble and fall into the sea, but Meboku in his human form dragged him to the bottom

until he was nearly dead before releasing him to surface for air. Four times he did this, and then lectured to the old man,

"I will let you go now in spite of the fact that you opposed me. I do this because I like the woman who gave you food. She is a very caring person. Now, you tell the other villagers to build a shrine where all can venerate me as the most powerful *dukna* of this part of Nendö. When you need my help again, make a feast [meaning, dancing in the *nue* and feasting and singing songs of praise] in my honor, and I will return to help you."

Metakioneipi

At Bapnenge village, a woman had a miscarriage and she wrapped the aborted fetus in a piece of bark cloth and threw it into the sea. Meboku, in his shark form, found it and carried it to Nupani Island in the outer Reef Islands (see Davenport 1971). Going ashore at Nupani in his human form, Meboku decided to rear the aborted fetus, a male, there. The fetus matured very rapidly and developed into a handsome boy. Meboku decided to take the boy back to Bapnenge so he could learn about his mother. Meboku transported the boy by carrying him in his mouth, and by surfacing after short intervals so the boy could breathe fresh air.

When they arrived at Bapnenge there was no one in the village, and the boy was very hungry. So the boy just entered a house and helped himself to some cooked food that was in a basket hanging down from a rat guard [the conventional way leftovers are kept to be eaten later]. Soon the man of the household returned and he went to the hanging basket to get a snack.

Now it just happened that the house from which the boy stole the food was his mother's and the man was his mother's new husband. The mother and her husband were so puzzled by the disappearance of the leftovers, it was decided that she should not go to the garden the next day and keep watch while her husband went about his daily business.

The boy came back the next day and found the lady at work plaiting a new mat. He explained to her what his situation was and why he was there. His mother realized this fine-looking boy was her own son, who she believed had died by the miscarriage. When he went back to the shore and called Meboku, she went along. Meboku soon arrived and swam right up to the water's edge, opened his great mouth, and the boy stepped inside. That evening she told her husband all about the meeting, and next morning the three of them went to the canoe landing place to wait for Meboku's return. Meboku arrived, and as the boy was stepping into his cavernous mouth she told them that he

had been born abnormally, and his name was to be Metakioneipi, "Place of the Rising Sun." There is an outcrop of rocks at Bapnenge also called Takioneipi (without the prefix *me-*, which signifies "male").

Next morning, Metakioneipi sent Meboku off and asked his father to provide him with a good, stable outrigger canoe with which he could go out to catch sharks, in the Nendö style, with a noose. Meboku had taught Metakioneipi the skill of noosing sharks, and this is apparently the origin of that skill as practiced in the Santa Cruz Islands (see Koch 1971:31–33). Metakioneipi was the first to make shark catching an economic specialty (*ngaalue*). In a short time Metakioneipi became a *bonia* (rich and famous person) through his shark fishing.

Meanwhile, at Naggu village a young woman had provoked bad feelings for refusing to marry several young men who had been selected for her. Finally, an old woman told her that she thought too highly of herself, and then added, "There is no man on this island you would accept as a husband except this man named Metakioneipi." The young woman was deeply hurt by this comment, and after talking things over with her parents they agreed that it would be better for everyone if she left Naggu and searched for this man called Metakioneipi, about whom people were always saying such good things. As she was preparing to leave Naggu, her parents smeared her hair with turmeric, and gave her a new skirt of bark cloth as if she were preparing for her wedding. First she paddled to Nonia, which is situated on the south coast of Nendö, east of Naggu, and arriving there she went straight to the sacred *madukna*, even though *madukna* are usually off-limits to women. There she spoke out to any *dukna* who might be listening,

"Where can I find Metakioneipi?"

Back came instructions from one of the *dukna* associated with this spirit house,

"Go further to Monan Monan" [a small village located high up on a steep slope with its canoe landing and canoe sheds located on an outcropping of rock, a very difficult place to make a canoe landing under the best of conditions, impossible when the sea is rough].

There she enquired again about the whereabouts of Metakioneipi, and she was instructed to go further westward to Note-ka-Matiu, an area of the sea and coast frequented only by *dukna* and men fishing for sharks. There she noticed a very handsome young man who was working on his shark-fishing gear. She wondered if this could be Metakioneipi, and prettied herself up with fresh turmeric in her hair and retied and smoothed out her new skirt. As she was making herself as attractive as she could, the young man noticed her and was immediately struck with desire for her. As soon as she made her

canoe landing, she went off with the young man to his parents' dwelling, and that night they slept on the same sleeping mat.

Next morning, before the couple had awakened, the young man's father noted them sharing a sleeping mat and he became very alarmed, because some relatives of the young woman might have noted they had slept together and demand a damage payment for allowing his son to sleep with this young lady before they were married. The father was especially worried because he did not have enough feather money on hand to meet the demands. Furthermore, the parents of this young woman might also make a legal fuss over this violation of sexual laws and threaten to start a feud. As the father was worrying over this severe violation of the law against premarital sex, the couple woke up, and the father informed them of what was on his mind. The young woman tried to assure Metakioneipi's father that such legal actions would never be taken against him by her relatives.

Still concerned, Metakioneipi's father went down to the landing and called out to Meboku, whom he venerated as his tutelary *dukna*. Meboku appeared immediately and the father summarized the situation. Meboku agreed that they had a serious problem here, and they should commence negotiating a bride price right away. If a satisfactory negotiation were agreed upon, they should make all the arrangements for the obligatory wedding celebration, the *kai kolra* (the "betel feast"). Fortunately, everything went smoothly, and the couple returned to Note-ka-Matiu to live and commenced to worship Meboku as their principal *dukna*.

In time Metakioneipi came to be regarded as a powerful man with special powers, and after he died a cult emerged to venerate him as deity. Actually, the veneration of Metakioneipi as a deity seems to have been regarded as an offshoot or derivative of the Meboku cult that was associated with the two communities of Monan and Madiebalo only, both on the eastern part of Nendö. The main body of Meboku worshippers continued to live in the communities of western Nendö.

Ikaban and Buakamanula, *Dukna* Brother and Sister

This myth is about one of the few female *dukna*, Ikaban, whose name means "Woman of Kaban" (*kaban* being the word for "inlet" but also the proper name of the passage that separates Temotu Islet from the main island), and her brother Buakamanula ("Shark Fighter of Manula"). Both were important deities for the peoples of Malo and Uia villages of Temotu Islet. Uia ceased to be a village during the first decades of the 20th century

following the massive depopulation at that time (Rivers 1922:passim), the last residents merging with Malo village, which has had several localities along the inner, swampy shores of Temotu.

The first Nendö community to accept Christianity and build a church was Malo, and in many ways Malo has been more receptive to outside ideas than any other community. In the 1950s Malo also led in the number of children attending Mission boarding schools and the first to have young men go on for post-secondary school training at a special medical school in Fiji to become medical assistants.

Ikaban lived and died at Uia, and as she lay dying, she informed the people of Uia that she would come back to life when her brother Buakamanula passed away so that she could be among the mourners who keened over his corpse. In life Ikaban was odd in appearance, because she had one red eye and one all white, and when she slept sometimes her head would become detached from her body. All of this suggested to other humans that Ikaban was like a *dukna* in some ways. When her head detached from her body people would gather around and stare in awe at this strange phenomenon. One time when such a group was gathered around her, the people made so much noise they woke her up. Her head quickly rejoined itself to the rest of her body, but she awoke very angry at the people of Uia for their inconsiderate treatment of her. In a tantrum she vowed,

"Now I shall die for good and take with me my special power to return to life from death. Until now, I had intended to give this power to you the people of Uia, but you have angered me, and I change my mind."

Buakamanula was a notable shark fisherman, and he died while visiting one of the villages that once were located on the western side of Graciosa Bay. Two groups of people of Temotu Islet, one from Uia and the other from Neo, commenced to argue over which should receive Buakamanula's corpse and look after the burial and associated rites. The group from Uia took possession before the argument was settled. As the canoe with Buakamanula's corpse passed along the shores headed for Uia, at each stream mouth and point of land there stood an incarnation of Ikaban, holding a branch of *Barringtonia* as she cried and danced her mourning for her brother. When the canoe reached the Uia landing place, Ikaban was already waiting for them on shore, crying and singing. The people in the canoe marveled at her appearance, because they realized that she would have to have flown or been transported by some supernatural means in order to have reached each place she appeared before the canoe with her brother's corpse reached that place. And they recalled her mismatched eyes, which could never have been a human characteristic. The only explanation was that she was a true *dukna* and worthy of veneration.

No one knows what happened to Ikaban after she died except that her skull did not stay buried, and as a *dukna* she would reappear as a fruit bat flying about at dusk in an unusual way. Her appearance as a fruit bat signaled that she was displeased because her followers failed to honor her with rituals. It was feared that she would send an epidemic of a flu-like sickness that could decimate a community.

In the *madukna* at Uia there were two sacred relics associated with Ikaban. One was her own skull, signifying her habit of detaching her head as she slept. The other relic was a skull of a fruit bat, signifying the transformation she took in order to attract the attention of her followers.

As Uia became Christian and the people moved away to live with the Malo people, the Ikaban relics remained in the *madukna* as it fell into disrepair. Finally, some concerned persons asked Melanesian Mission workers to dispose of the Ikaban relics.

Inelua

The only other female *dukna* that I heard about quite often was Inelua ("Woman from Nelua"), but I was never able to elicit a narrative or myth about her. She had the uncanny power to appear to men as a woman whom they knew well, even as a wife. And she was a seductress who lured men to sleep with her (knowing that they were committing an illicit act), and not realizing it until they came down with a serious and often fatal illness. The symptoms of the Inelua illness was a very high fever, delirium and periods of unconsciousness, and the exhibition of marked paranoid delusions, often with violent behavior.

The Mengalu

As with Inelua, no one seemed to know a myth about Mengalu, but women all were aware of a fatal illness caused by him or, as some informants insisted, by a group of male supernatural personages one of whom always appeared to a victim not in Mengalu's crippled and misshaped form but as an attractive man and someone with whom a sexual relationship would be acceptable, even desirable. In the case of a young married woman, the Mengalu might have attracted his victim by assuming the appearance of her husband. The first symptoms of the Mengalu sickness do not appear until a few days after the victim has been seduced in this deceptive manner.

Usually, a Mengalu attracts his victim by conspicuously appearing where one would least expect to have such an encounter with a familiar person, such as on a point of land that juts out into the sea or just around a sharp bend in a path that zig-zags through the dense rainforest. The name Mengalu means "The Bent One" or "The Crooked One," which refers to their distinctive, misshaped bodies that recall persons badly deformed from paralytic poliomyelitis. The symptoms of the Mengalu sickness are similar to those of the Inelua sickness.

It is pertinent to note that in Nendö culture and society of the 1950s and 1960s interpersonal sexual relations were of deep concern to everyone; hence violations of sexual norms brought forth strong and often violent reactions. Formerly, before feuding and vendettas were controlled by the protectorate, sexual offenses, along with murder and inflicting bodily harm on other persons, were considered the most serious crimes. Hence they were very disruptive. One can even say that sex was a loaded topic, both as a highly valued and a tightly regulated domain of interpersonal behavior (see Davenport 1965). From a juridical point of view, sexual offenses, both pre- and postmarital, were considered to be serious offenses that called for equally severe damage payments to those offended, when violations came to public notice.

Noelebu

The place of origin of the deity Noelebu was somewhere in the interior of Nendö. The veneration of Noelebu in the villages of the Nabakaenga (the eastern shore) of Graciosa Bay was widespread after a man named Menongu from Pileni Island in the outer Reef Islands wrecked his *tepuke* while negotiating the canoe passage in front of Lrepe village (some say it was at Nule).

Menongu salvaged what he could from his canoe and began to reside in the men's house named Madai-ka-manabe. He was carrying some sacred paraphernalia in his *tepuke* when it was wrecked, which he salvaged and kept with him in the men's house. His tutelary *dukna* was named Noelebu, and people of Lrepe were very upset at Menongu's introduction of this deity into their community. The other men of Madai-ka-manabe, including Lono, the senior man among them, were so afraid of this deity they refused to enter the men's house now that Menongu was ensconced and carried out his ritual obligations there. Then Nepla (father of Mebuna and associated with another men's house in Lrepe) invited Menongu to come live in his men's house, but

the same thing occurred again. So some friends of Menongu helped him build a separate structure, actually a *madukna*, just for Noelebu, and shortly after they built a dance ring in which public events and entertainments dedicated to Noelebu could be celebrated. Nepla became the head of the Noelebu cult as it spread out from Lrepe. When he died, his son, Mebuna, took over the leadership, but with his death the cult ceased to exist.

Noelebu is remembered for the several powers he controlled, which were wielded by a few of his last followers: the power to stop late rains that delayed the preparation of new gardens, to heal arrow wounds, to cure a severe sickness, the symptoms of which included coughing up blood. The fee (*dabo*) paid for these services was exceptionally large and negotiated as a *naaduka* (a stack of red-feather currency of descending values) the same as that negotiated for a bride price. This made the followers of Noelebu rich, and they used this wealth to celebrate public rituals in their dance ring with snakes.

Mebuna, the last leader of the Noelebu cult, slept often in the sacred house in Lrepe. No one was ever allowed to see the *munga dukna* of Noelebu, which were a pair of figurines, one of which was actually an image of a Mengalu, the associated deity. (For reasons not remembered there was a close association between the deity Mengalu, "the bent one," and Noelebu.) In Lrepe there was another shrine consisting of a low stone wall surrounding a fan-palm tree, and a third enclosure on top of the bluff behind the village where fowl were kept. Leaves of that palm and fowl from that pen were used in the final closing ritual of those honoring Noelebu.

The end of the Noelebu cult came suddenly when Mepuke, brother of Mebuna, went mad. He took the two wood images out of the *madukna* where Mebuna carried out his private worship, and set fire to them on the sand in front of the village. This was in the morning just after most Lrepe women and their husbands had gone off to work in their gardens. Even though a light breeze was blowing, a thick column of black smoke rose straight up from the blazing figures, as if the air were perfectly still. Seeing the column of smoke, many people rushed back to the village to see what was going on. Mebuna and others interpreted this anomalous column of smoke as a sign from Noelebu, but they could not reach an agreement as to what the sign signified and so did nothing. Shortly thereafter Mebuna decided to give up worship of Noelebu and become a Christian. The Mission was already beginning to make converts in the Graciosa Bay area and news was spreading through the Graciosa Bay villages of a new and more powerful *dukna* named Opla.

For the closing of a public ceremony for Noelebu another unique ritual was performed. The images of Noelebu and Mengalu were placed on a

dried fan-palm leaf that had come from the sacred enclosure in the village, and cooked fowl from birds reared in the sacred pen were distributed to the dancers to eat. This was intended to be a ritual payment for their services as dancers. Later, the dancers would be paid again in feather currency for their participation, and, finally, the sponsor of the rite spoke to Noelebu, informing him that the ceremony in his honor had ended and he hoped it had pleased him. The structure of the rituals in the 1960s in the villages of Nabakaenga essentially followed this plan of an opening parade of dancers through the village and into the dance ring, many hours of dancing and singing led by several pairs of fully costumed male dancers, a pause for eating breakfast as the sun rose, and a short final period of dancing ending when all the persons involved in the production of the ceremony were paid off in feather currency.

Melebaipu

Melebaipu was a human who was shot and killed at Bwelo, an inland village of Nendö. He was an important man there, but he was killed because he had been having illicit sexual relations with a woman at Bwelo. Melebaipu did not die immediately after being hit with an arrow, and he got all the way across the island to Menau before he expired, which suggests he had some supernatural power that had kept him alive after being hit.

After death his soul went to Naiavila where a cult was formed to appeal to him for help during feuds and raids. When he assisted someone, Melebaipu would cause an adversary to freeze and become an easy target. He also had power to cure a mental disorder we might think of as paranoia, a truly aggressive and dangerous disorder. Appropriately, the image used in rituals directed to Melebaipu was not a carving but a bundle of fighting arrows (*nipla*). The arrows still existed and were still hidden in the ruins of a men's house or spirit house at the site of Naiavila.

At the time I did my first field research on Nendö, Tautro had become by default keeper of the arrows. Every few days he went up to the site of Naiavila and performed a ritual he referred to as "feeding" the arrows. Tautro was more frightened of Melebaipu than respectful toward him. He was frightened that if no one looked after the representations, Melebaipu would become angry and inflict some harm. Only Tautro's father had been a follower of Melebaipu. I went with him once as he climbed up the bluff behind his village, Balo, to perform the ritual. I asked him then why he did not bring the arrows to his village so he would not have to make the short

trip to Naiavila. He answered that there were small children and dogs in Balo who might disturb the arrows and cause Melebaipu to bring harm to the whole village.

Tautro had a long-standing enemy, who I shall call only by his first name, Gabriel. I do not know the basis of their enmity, but the bad blood between them had a long history. Gabriel was a Christian zealot who had no tolerance for the non-Christian holdouts who were still involved in traditional worship.

During one of my periods of absence from Nendö Gabriel lodged a formal complaint with the District Commissioner, claiming that Tautro had threatened him with his bow and arrow. The weapon was of the kind that every man on Nendö owned and used for hunting, not the kind of bow used for fighting with special arrows that were thought to be poison-tipped. The District Commissioner talked with Tautro, who was so frightened he could not think straight. Despite Tautro's obvious illness, the District Commissioner decided to arrest Tautro on a lesser charge of disturbing the peace rather than for making a threat with a potentially dangerous weapon. Tautro was taken into custody and transported to Kira Kira for trial in a special court for serious offenses, such as that of threatening with a bush knife.

I returned to the Solomons some months after the events described above, and while I passed through Kira Kira the District Commissioner briefed me on the Tautro affair. By then Tautro had been convicted and sentenced to several years in jail. Also, there in Kira Kira was the bundle of fighting arrows that were found in Tautro's house when it was searched, but the bundle had not been used in the trial as evidence of anything relevant to the trial. In jail Tautro explained to me that he had brought them down from old Naiavila during a spell of illness so that he would not have to climb the bluff to get to them. Further conversations revealed that Gabriel had made up the formal accusation, and what offended Gabriel so much was, really, what appeared to be Tautro's veneration of the *dukna* Melebaipu. Later when I talked to Gabriel about the affair, he said he thought Tautro was working sorcery (*noblo-ka-aio*) with the arrows, but because it was "sumting blong kastom," he did not think the District Commissioner would have understood how serious a crime sorcery was and would not have done anything to stop Tautro's actions.

The District Commissioner agreed to let Tautro out of jail and return to Nendö because he was so sick. Because the arrows had not been used as evidence, they were of no further use to the case, and so the Commissioner gave them to me for the collection I was making for the Bishop Museum.

Be-ka-Neba and Mekwaluli

Be-ka-Neba ("Be, Founder of Neba") was an almost cultureless human who spent months, possibly years, clearing a canoe passage through the reef at Neba on Temotu Islet (not the present-day Neba that is located on the northeast shore of Nendö). At this time, too, a young woman of Temotu Noi, located off the southern coast of Nendö, was married but was soon widowed after her husband angered Meboku and was killed by him. The father of this young widow was a renowned builder of outrigger canoes. The father also owned an adz that had mystical powers, and some of that power went into each canoe that the father built.

The young widow decided to leave Temotu Noi, and her father gave her his great canoe adz and told her to use it if she could in order to get another husband. Soon after she left Temotu Noi she encountered Mepwa, a changeling *dukna* who could transform itself into a snake with precious gems in his head. Not understanding that the appearance of Mepwa could bring wealth, the local people killed him as if he were just another bush snake. In the 1960s there was a strong belief that Mepwa would bring great wealth to some lucky person. When a Mepwa appears to someone, he intends to bestow wealth on him or her. If one can secure one of the stones out of the head of Mepwa and keep it secretly as a charm, it will bring the bearer success in all of his economic undertakings.

Now the young widow began to feel both unfortunate and unwanted, and she thought the only man who would take her as a wife was that ugly and cultureless man Be-ka-Neba. She found him and settled in as his wife, but she found that she must teach him about sex, about modesty, and clothing. As he mastered the basic social skills she celebrated each of his achievements with a maturation celebration, just as all male children are put through a series of maturation observances each of which is an open feast at which food and the ingredients of betel are distributed.

Lastly, she taught Be about noosing sharks so that he would have a specialty (*ngaalue*) with which he could gain wealth. (Omitted here is an episode with a stupid person named Mekwaluli who wished to learn how to noose sharks, but is duped by a smarter Be.)

A daughter was born to Be and his wife. He later married her, and they settled in Neo on the northern shore of Temotu Islet. (In another version of this tale, the nearly cultureless Mekwaluli was the husband of Be's daughter, and this is how Neo became a notable center for canoe making and catching sharks. And many men from Neo became rich from the practice of these specialties.)

This short myth is pertinent to this study because Neo is the general area where many of the finest specimens of *munga dukna* were collected by Captain Jones and the Reverend West. And it is possible that because many Neo men were specialists in building outrigger canoes, they would have been expert users of the tools used to make wood sculpture.

Opla

In the two decades before World War II which turned the Solomon Islands into an insular battleground, the *dukna* named Opla was gaining popularity and prestige all along the northern districts of Nendö. Put another way, Opla was eclipsing other *dukna* in traditional worship. During the same period, missionaries of the Melanesian Mission were also beginning to have success in making conversions.

The word *opla* means "wealth" as measured in terms of red-feather currency (*tevau*). But in more poetic speech *opla* was the word used for "wealth." It is also a fitting proper name for persons, with a prefix *i-* for females and the prefix *me-* for males. *Opla* as "wealth" is also the topic of many lyrics for the songs that are sung at the public dances. And *opla* as "wealth" was a theme to which songs on related topics, such as ones about the birds from which the down for feather currency comes, and ones about the men out in the rainforest catching birds for *tevau*, as well as other lyrics, could be associated.

There seemed to be no lengthy single myth about *dukna* Opla, such as there is for Meboku. But there are snippets of history and short reports of incidents that in sum constitute a kind of mythic character for Opla, who in a temporal sense was the most recent powerful tutelary deity to come on the scene of traditional worship in the Santa Cruz Islands.

Menopulu and Opla

Opla's mother was Edunga of Maebu, formerly a village just north of where Uta is now located. She was of the Bebla descent category. Thus, in this strong matrilineal area her son Opla was a Bebla. Opla's father's name has been forgotten, but it is recalled that he was a rich man, a *bonia*. Opla was named to honor another rich man called Opla who had lived only two to three generations before [this mythic fragment was recorded]. This rich man probably assisted with Opla's father's bride price. As a child, anything Opla wanted, he got. He was a spoiled child.

One day Edunga left Opla in their dwelling while she went to the water's edge to wash out the shawl in which she carried him. The *dukna* Menopulu was watching, and he used the opportunity of Edunga's absence to kidnap Opla. He took him to the area in the west called Note-ka-Nego where the *dukna* lived. And from then on Menopulu becomes Opla's father. (In another version of this kidnapping, Opla was the second human boy that Menopulu had taken from his parents. The first boy's name was Suvea, and two elderly men of Uta village told me they had known Suvea when they were young.)

When Edunga returned to her house and found Opla missing she nearly collapsed with fear for his well-being. Soon she sought out a spirit medium and hired her to find out where Opla was. The medium accepted the commission and proceeded to get ready for going into trance. While Edunga was trying to come to terms with her situation, she was further troubled by the behavior of the medium. The medium called out to Edunga as she was entering the medium's house, "Careful, don't bang the child's head on the door lintel." Edunga could not understand why the medium had said this, and wondered if there was something meaningful in this odd greeting.

At that moment at Note-ka-Nego the *dukna* were preparing for a ritual dance of the sort humans copied for their own entertainment and to honor specified deities. The *dukna* were making the objects used at these celebrations, such as the special articles of clothing and adornment worn by the participants. Opla begged to watch, but Menopulu refused him and kept saying "no" when Opla asked again and again. Opla was not accustomed to being denied anything, and he was furious in his frustration. Over and over, Opla asked to watch, and at every request Menopulu denied him. Opla then refused to eat and cried and cried. So, Menopulu agreed to make Opla a set of the dancing props used by the *dukna* for their dances, but not until they returned to Maebu. (In another version Opla demanded that Menopulu buy a set of the props the *dukna* used.)

When Menopulu and Opla returned to Maebu, Opla was instructed to build a *madukna* in which the objects used in public ritual dancing could be kept safely, so that neither small children nor dogs would disturb them. The materials they brought back to Maebu were two carvings—one of a pig, the other of a dog. Both had geometric motifs painted on them, bamboo poles with rattles at one end used to beat out the rhythm of the melodies, and a special food bowl of the type used only on special occasions.

And this is the extent of the oral tradition of *dukna* Opla. During the 1950s Opla reached the pinnacle of popularity, and thereafter the ritual dances began to take on the partially secular aspect that characterized them during the 1960s.

Notes

Chapter 1

1. The local name for Santa Cruz Island is variously rendered on maps and charts as Nidu, Nendö, Nitende, and Ndeni. These variants represent different pronunciations of the island's name in different local dialects.

Santa Cruz Island (Lat. 10° 45′ S., Long. 166° E.) is the largest in the group of islands called by the same name. The Christian name was given to Nendö and the group by the Spanish explorer Alvaro de Mendana. After Mendana died on Santa Cruz Island, his expedition, under the command of Pedro Fernandez De Quiros, left the area and returned to Acapulco in 1596 (see Buck 1953:7–8; Quiros 1904). The island group slipped into obscurity for nearly two centuries until the English explorer Philip Carteret relocated them in 1768.

2. Four closely related languages are spoken on Santa Cruz Island, and a fifth is spoken in the main Reef Islands just to the north of Nendö. In addition, dialects of Polynesian are spoken in the outer Reef Islands and further north in Taumako, one of the Duff Islands). All the four indigenous Nendö languages and the language of the main Reef Islands constitute a small independent language family that linguists have judged to be non-Austronesian (NAN) and without any other related languages anywhere. Sometimes this family is referred to as the Santa Cruz–Reef Islands family (Davenport 1962b).

The construction *munga dukna* that I use here to designate the images comes from the Nendö language that is spoken as a first language by the people living along the north and west coasts, who make up more than one-half of the Nendö population.

3. This change in the representation of Opla occurred in the 1920s and 1930s, just as the British were bringing the Santa Cruz Islands under govern-

ment control and putting an end to warfare, feuding, and some other customary practices that were judged to be against British concepts of law and order. See Chapter 5 for more about the *dukna* Opla.

4. It is not clear how the collector got this specimen out of the Solomon Islands. At that time there were regulations against removing genuine sacred objects from the country without special permits and waivers, which in this instance would seem to have been impossible to obtain. The image has since been sold and its current owner and whereabouts are unknown to this writer.

5. Captain Jones was not the ordinary sort of European trader. He had a common-law wife in Taumako (Duff Islands), and he fully recognized his children by her, as well as his wife's relatives who lived on other islands in the group. He put all his children through secondary school in Australia and later set them up in businesses in the New Hebrides (now Vanuatu). He always cooperated with officials of the British Solomon Islands government by making his small trading ship available for charter when there was no government ship for the Eastern District Officer to use. Captain Jones was directly involved in one of the crucial incidents of violence (the Mamuli affair—see note 7 below) during the pacification of Nendö, but he was not an undeviating loyal supporter of government policy and actions, and he would protest strongly when he felt some of the local people had not been treated fairly by a District Officer. Jones never "went native" nor did he maintain the chasm of social distance between himself and the local people that was all too common with Europeans in the southwest Pacific. Jones wrote letters to his overseas clients that were full of ethnographic information about the artifacts they were purchasing. He even co-authored an early article on the unique red-feather currency that was heavily in use all the time he was trading in the group. Captain Jones sold his trading business in 1956 or 1958 and retired to Sydney, Australia. The business soon failed under the new ownership.

I take this opportunity to express my gratitude to Captain Jones for his interest in my field research and for the many informative letters he wrote to me while I was living at Graciosa Bay, Nendö.

6. It was customary practice in those days for missions to operate trade stores, even small coconut plantations, to help pay operating costs. Waite (1983:98) and Stöhr (1987:242) published a 1913 Beattie photograph of Forrest/Mebuano at Nelua village with a group of local people posing with a very large display of red-feather currency.

7. It is hard to understand why Wilson acted as he did. He must have known that he was going beyond his authority, and there is no known reason for him to have had a personal grudge against the people of Graciosa Bay.

96

Two other violent incidents took place in this short and turbulent period during which the British were trying to establish a *pax Britannica*. One occurred in the village of Noole on the south coast of Nendö in which a villager named Meningale was killed while he pursued and harassed a government patrol as it was returning to the northern shore. There was no District Officer personally in charge of that patrol, which precipitated a long investigation. The other incident occurred at Noka on the north coast of Nendö when Captain Jones and his vessel were being used by the district to carry out a delicate mission of repatriating some Reef Islands women, against their wishes, back to their home villages. Many Nendö men were also strongly opposed to the repatriation. (See note 1 for Chapter 3 for further clarification of what exactly was involved in this action.)

A man named Mamuli had been employed by the District Officer to act as an interpreter for Jones. Mamuli was a Polynesian speaker from the Reef Islands, but he resided on the north coast of Nendö, and he had a local reputation for being a scoundrel. Again, for unknown reasons the District Officer was not aboard Jones's ship, and it is apparent that he had not been aware of Mamuli's reputation when he secured his services to assist Jones. As Mamuli was trying to explain to a crowd what the District Officer had ordered, some of Mamuli's personal enemies threatened to attack him with clubs and bows and arrows.

Just as Jones set sail Mamuli deftly slipped away, and he stole a canoe and paddled off on his own to the Reef Islands. How Mamuli evaded his enemies on Nendö is not known. Sometime later an armed patrol under the command of acting District Officer Campbell was sent out from Kira Kira on San Cristobal Island to take Mamuli and some other Reef Islands men into custody. All the men, including Mamuli, were rounded up, and as the government ship was at anchor in Mohawk Bay, Reef Islands, Mamuli seized one of the police constable's rifles, took a shot at Campbell, and dived overboard. Mamuli's shot missed Campbell's head but went through his hat; in the ensuing confusion aboard the ship all of the other Reef Islands men likewise jumped overboard and escaped.

The next time Mamuli was seen, he was back on Nendö, but then he vanished and nothing was ever heard of him again. The speculation on Nendö was that his enemies finally got to him, and they said nothing about it, because they could have been charged with revenge killing. In the late 1950s the Mamuli story was still being told on Nendö as a humorous tale, and were it not for the fact that his name and parts of the incident are recorded in government archives, one might think the tale was a trickster myth.

From the angle of the establishment of law and order the British Solomon Islands Protectorate (BSIP) was declared in 1898–99 and the Santa Cruz Islands group was included in it, even though this small archipelago lies a good distance to the east of the Solomon Islands. The first capital of the BSIP was at Tulagi, one of the Nggela or Florida Island group in the central Solomons. Up until this time this region was outside any European political jurisdiction. It was a true frontier, well beyond the reach of law and justice as European nations define those concepts. As a result of this absence of an outside political jurisdiction and authority, the area was preyed upon by outlaw ships that came to poach *Trochus* and green snail shell and pick up labor for work on sugar plantations in Australia and the Fiji Islands. The operators of these outlaw ships came to be called "blackbirders," and their trade was declared to be a form of enslavement because they obtained laborers by force and more often than not failed to repatriate laborers to their home islands.

Nendö was one of the islands that the blackbirders hit time and again until the people became suspicious of any and all European vessels that touched their shores. And because of this there were several incidents: in 1864 a party from the Melanesian Mission ship was attacked from the village of Matu near the entrance to Graciosa Bay, and several missionaries were killed. Both were Norfolk Islanders, descendants of the *Bounty* mutineers. Seven years later Bishop John Coleridge Patteson of the Melanesian Mission was murdered while he was ashore on Nukapu Island in the Reef Islands, and Stephen Taroaniara, a Solomon Islander teacher for the Mission, was also killed in the fracas that followed the Bishop's killing. Ever since the Mission has revered Patteson and Taroaniara as martyrs in the long struggle to establish Christianity in the islands of the southwestern Pacific.

Other violent incidents took place against legitimate European commercial ships seeking to buy shell and, in 1874, against a shore party from HMS *Sandfly* at Carlisle Bay on the north coast of Nendö. The next year Commodore J. G. Goodenough of HMS *Pearl* was attacked while on shore at Carlisle Bay to investigate the *Sandfly* incident. Goodenough died at sea five days later of tetanus. The irony of the *Sandfly* and *Pearl* incidents is that both ships had been dispatched to these waters to track down blackbirders and protect the islanders from their outrageous predatory practices.

During my first stint of field research in 1958–59 the island was certainly tranquil and law abiding. Superficially, it appeared to be fully Christian, but few individuals attended Sunday church services, and large crowds always

attended the *nela* dances which were both the favorite public entertainment and public religious rituals (see Chapter 3).

Chapter 2

1. I did some of my research on the sculptures by showing informants photographs of objects from several European museums and asking them to identify the deity represented and tell me all they knew about that deity. In 1958–59 a common response to the photographs was one of awe and a reluctance to hold the photograph when I handed it to them for close inspection. Children shrank away from the photographs, and adults would lower their voices or speak in whispers as they studied the pictures. After a few such sessions, my neighbors in Banua village asked me privately not to show the photographs to just anyone, and especially not to the children. They were openly frightened that the children might suffer harm from pawing over the prints.

In one memorable instance at Neo village on Temotu Islet, an elderly man broke into tears of joy as he studied one of the photographs. He was certain that the sculpture pictured was one he had once owned. He had inherited that figure and the obligation to worship the deity depicted from his maternal uncle. Over the years that he had owned and used it in domestic rituals, he had refurbished the sculpture several times by changing its garments and body ornaments and recoating it with turmeric. In the 1920s he turned it over to one of the European missionaries whose name he could not recall (very likely the Reverend West).

All but one, or possibly two, of the patient and generous informants who struggled to help me understand the traditional religion are deceased at the time of this writing. And, as is the case in small traditional societies undergoing rapid culture change and inundation by outside influences, these informants died without transmitting their religious knowledge and experiences to their descendants. During my revisits to Nendö in the 1970s some of the offspring of deceased informants came to me and asked me to tell them about the traditional religion. Sometimes I could even read to them from my field notes in which were summarized some of the conversations I had had with their fathers.

2. It is firmly believed that if one passes along the shores of this area in a canoe, especially at night, one can hear the supernaturals singing in the distance.

3. So persuasive were the descriptions and stories about *leimuba* that some government officials who had served for short periods on Nendö asked me to actually search the interior for a pygmy race, analogous to the

misnamed "Pygmy peoples" of interior New Guinea. Specialists in Oceanian folklore are very familiar with semi-supernatural small people in the folklore of several island groups (e.g., the Menehune in Hawai'i).

Clement Dana of Nule village told me of a *leimuba* encounter he had about 1950. Dana was walking alone in the vicinity of Maebu in Graciosa Bay. Suddenly he was frozen with fear, and then he saw a *leimuba* standing just a short distance away. The *leimuba* was holding out his right hand as if he wanted to give Dana something. Dana could not move, and he and the *leimuba* stood motionless and silent, just staring at each other. Finally, the *leimuba* just vanished, and Dana's fear gradually subsided. Because he could not reach out to the *leimuba*, Dana had missed his chance to receive something valuable.

4. These fancy food baskets—reserved for serving honored persons— were scarce in the 1950s and 60s. Most of them were made in the Polynesian-speaking Reef Islands (see Koch 1971: table 9, a–e).

5. In some eastern Solomon Islands figurative sculpture the back of the head is extended downward and tapered over the back (see Waite 1983:56, and carved detail of pl. 26). It is similar to the treatment of the *abe*, and it is easy to assume that it represents some relationship between the two genres of sculpture. From a historical and diffusional point of view it may very well be a related form, but in the eastern Solomons it refers to an old style of coiffure, whereas in Nendö, as explained, the form represents an *abe*, a headdress.

There are four published depictions of men wearing an *abe*: a drawing in Edge-Partington (1890:154), two photographs in Festetics van Tolna (1903:268), and one in Speiser (1916:161; Abb. 4).

6. In part of a myth about the origin of red-feather money (*tevau*), the people of Nendö first try to use fire tongs as currency, then a type of coarse fabric, then ground shell discs that were made on Vanikoro Island. This myth may have some historical validity, because a kind of woven mat was used as a currency in Vanuatu (formerly the New Hebrides), and strings of ground shell discs of several kinds are currencies in both the eastern and central Solomon Islands, and Nendö people could have used these objects, which diffused into the Santa Cruz group, as currencies until they invented their own unique money.

7. Breast ornaments are a common article of male personal adornment in Melanesia and Papua New Guinea, and every region has its own style. Nendö breast ornaments are well-known objects of aesthetic interest, and many are to be found in museum collections. They are a kind of signature artifact for the Santa Cruz Islands. The Nendö chest ornament is the only

one that is manufactured from the thick and dense portions of shell from the giant *Tridacna* clam. Many societies in the Pacific use this material for basic tools, such as adz blades and scrapers, when volcanic stone is not available in their environments.

8. Turmeric is extracted from the baked roots of *Curcuma longa,* then mixed with coconut oil to form a paste. It is orange in color, but when its pH is altered toward alkaline, it changes to purplish. This is a recognized property of turmeric and interpreted as an indication of some hidden mystical properties within it. Turmeric is always used to help heal a wound. It is used in ceremonies that mark transitions, such as the maturational ceremonies for children and weddings. Applied to images it seems to express the marginal or interstitial place of the figure: an object that exists between the human domain (as a representation) and the supernatural domain (in which the deity it represents is located).

9. That cultural diffusion from the eastern Solomons to northwest Nendö did indeed occur is further supported by other instances of borrowing. Some communities on Nendö and the main Reef Islands borrowed a male initiation ceremony from the eastern Solomons (described in Davenport 1981) and renamed it *guau*. It was abandoned first on Nendö then in the Reef Islands about the time Mission influence began to affect the local cultures. Also, there is a legend that mentions one variety of yam on Nendö as having come from the eastern Solomons Islands. Lastly, there is a type of men's nose pendant in the eastern Solomons that is superficially similar to the Nendö pearl shell *nela*. Although close comparison reveals differences between the two types, stimulus diffusion could be the basis of the similarity.

Chapter 3

1. When a man or group of men acquired a new slave/concubine (*tiela*), her first night with the new owner(s) was spent sleeping under the feather money-changing bar (*noali*) in her owner's *madai*, with his *munga dukna* placed alongside her. The transparent purpose of this ritual was to symbolically give first sexual access to the *tiela* to the *dukna* whose supernatural support made it possible for her owner to become rich enough to purchase her.

The women who were initially selected to become *tiela* all came from poor communities in the Reef Islands. Rich men of Nendö (*bonia*) purchased them outright for enormous sums of red-feather currency, loosely described as ten times the amount of a normal bride price. In no way was a *tiela* similar in rank to a junior, less privileged co-wife in a polygynous marriage. When a *tiela* was purchased from her family, all of her kinship and familial ties were

severed, putting her in the vulnerable position of having no male consanguine relatives to look after her rights and avenge any harm that might befall her. She was given a new name selected from a small set of names used only for *tiela*. She resided mainly in the men's house(s) of her owner(s); she was not permitted to plant gardens as married women were expected to do; her owner(s) could require her to be a prostitute to other men and they then took all remunerations men paid for her services; she could be sold to other men whenever her owner wished; all children she bore became the legitimate offspring of her principal owner and his legitimate wife. She could even be killed by her owner(s)—and occasionally this occurred—and no kinfolk would seek retribution. Owning a *tiela* was the highest personal achievement a rich man could attain.

Obviously, this custom could not be tolerated under the British law of the Protectorate, and the practice was forcefully ended by the first District Officers who learned about it. The women were seized from their owners and repatriated to their home villages in the Reef Islands.

2. What I term "sorcery" in this instance is mainly a form of praying to one's tutelary to cause an enemy to experience misfortune. The most common motivation for wishing harm to come to someone is envy. When a man envies another strongly, he may also wish to bring him down, so to speak, and may request (*upila* = a prayer to harm someone) his tutelary to do just that by making him ill or causing the death of someone close to him—a wife or a child.

There is another form of sorcery in which a spell is whispered into some object (e.g., a husk of betel or food leavings) that was or is intimately associated with the intended victim. This kind of sorcery was always expected by both sides in a feud, and it persists as a disruptive feature in the society. It goes by the same name, *upila*. Some people blame the depopulation of the entire eastern shore of Graciosa Bay on *upila* in which lumps of kauri pine (*notupiti, Agathis* sp.) resin were burned upwind with a spell whispered into the smoke directing it to kill all humans on whom it drifted down. (The verb for this practice is *iaplenge*.) Kauri gum by itself is judged to be harmless and was used in the past for illumination when a household fire went out. The use of smoke from kauri pine resin as the medium for this type of sorcery seems partially derived from the fact that kauri trees grow in pure stands, an anomaly in tropical forests, and nothing will grow beneath them. The common Nendö belief is that kauri trees "poison" the ground all around them, thereby enabling the trees to grow without competition.

The BSIP regarded all forms of sorcery as serious crimes on a par with using physical violence against another person.

3. The word *ngaalue* literally means "head of a stream (or river)." The analogical reasoning here is: fresh water (*lue*) is the source of life and vegetative abundance, and metaphorically it is intended to refer to wealth in red-feather money (*tevau*); the source of a stream is its head (*nga-*). Thus, an economic specialty is a source and flow of wealth in red-feather money to its practitioner.

4. Until the custom was made illegal by BSIP law, the burial of the male head of household was in the earthen floor of his dwelling. After the flesh had completely decomposed, the skull might be disinterred, cleaned, and smeared with turmeric, then placed on the household altar next to the *munga dukna*. The same was done if the altar was maintained in the worshipper's men's house. As far as I know the only village on Nendö to keep skulls after their carved *munga dukna* had been given up was Neo on Temotu Islet, the general location of so many of the finest specimens of carving. Originally, the Melanesian Mission had insisted that converts rebury any skulls they held in the newly established cemeteries that villages had been required by the Protectorate government to prepare. It became illegal to disinter a body from a cemetery in order to deter the making of feuding arrows (so-called poison arrows), the barbed points for which were made from human long bones. But soon the cemeteries were considered to be exclusively Christian burial places, and the Mission did nothing to discourage this belief.

Surreptitiously, people continued to bury in the earthen floors, as before. Neo was among the first villages to build a church and a cemetery, and it alone was given permission by a bishop, no less, to retain skulls of ancestors on the grounds that this was honoring their ancestors, not worshipping them.

5. The other threads of intercommunity integration were those between men's houses. Each men's house had commercial partnerships or reciprocal trade contracts with men's houses in other communities. The more trade contracts a men's house maintained, the more prosperous that men's house was apt to be. But one must never lose sight of the fact that inter-*madai* commerce was always considered to be under the vigilance of the *madai* members' tutelary deities, who could influence the outcomes of their clients' commercial transactions.

6. Only a few women receive the call to become mediums. It often comes after a woman has lost an infant and becomes depressed. She will have a dream in which the soul of her deceased infant appears and cries out to her. She will then consult with another medium who will verify or dismiss the dream as genuine or spurious. If it is judged to be genuine, the woman will make a special kind of dried pandanus leaf necklace and color it with turmeric, just as she would smear turmeric on the head of her infant to protect

it and keep it healthy. The spirit of the infant will then come to reside in the necklace, and the woman will cradle it and talk to it as if it were a live child. After the woman has recovered from her depression, the soul of the child will become, as anthropologists call it, her familiar, a spirit that can be directed to travel about in a supernatural domain. When solicited, a medium is able to enter into a self-induced trance and send her familiar with instructions into the supernatural domain where *dukna* reside in order to discover or verify something and report back to her "mother" via a dream.

7. A good-sounding floor is achieved by excavating the existing earth to a depth of a foot or more. A layer of six or more inches of rotten and water-soaked logs, which have become spongy, is then put down. Finally, the surface is covered with a layer of finely screened black earth. After a rain shower or two and an hour or two of intensive use, the surface gets packed down but the floor as a whole retains a spring from the layer of rotting wood underneath and emits resonance from the impact of many dancers stomping on the surface. After a year or two the earth will become hard and compacted and the floor will lose its valued resonance.

8. In the early part of the 20th century the people in villages of Temotu Islet, the upper western shore of Graciosa Bay, and Vaenga on the western shore of Nendö began to experiment with a circular dwelling. No one I could find could explain anything about them except they were aware of their existence, and circular stone foundations are found in several of the villages located in this area. The rotting remains of one round house still stood by itself behind Vaenga in 1958–59, and its last owner's name was remembered, but the people of Vaenga had little to say about the appearance and disappearance of circular dwellings. The renowned anthropologist W. H. H. Rivers includes a photograph by Beattie of round houses at old Malo village in his celebrated work on Melanesia (Rivers 1914:1, pl. XII, 2). Since Rivers went ashore only at Malo, and he was there for only a few hours, he mistakenly attributed circular houses to all the villages of Nendö.

9. Constructing churches and wide paths connecting villages has from the beginning been accomplished by using volunteer labor, but this is not always forthcoming. Melanesian Mission bishops have often had to resort to shame to bring out labor for building and maintaining their churches, while District Officers, frustrated because Nendö people don't care about connecting paths that are wider than necessary for single-file travel, have had to resort to punishing minor offenders with sentences of so many days working on the paths.

10. Dance clubs are one of the most common artifacts to be found in museum collections of Nendö material culture. The clubs with which I am

familiar have two overall shapes, according to whether the head and body represent a canoe (as all the examples in Koch 1971: Abb. 143, p. 179) or a bird (Waite 1987: pl. 11 nos. 290, 291). They are carefully crafted of strong wood, with shafts that are quadrangular in cross section, and grips long enough for the club to be swung with two hands. The shaft or body of the club is decorated with inked and painted geometric motifs in black, white, and red, the same as the designs appearing large on the sides of *madukna* and painted on bark cloth flags that hang from the arm bands worn by *nela* dancers. All the specimens in the United States I have studied are in perfect condition, meaning they probably had never been used in a dance. After they have been used in a dance routine, the square corners of the midsections are nicked and dented from being smashed by partners' clubs.

After World War II dance routines with clubs began to have separate lives of their own, organized and performed as special entertainment for high-ranking government visitors. There seems always to have been enough men who knew the routines to coach new groups of dancers as needed. I witnessed a *napa* dance in 1976 that had been organized to entertain the High Commissioner on one of the very few visits a head of the BSIP ever made to the Santa Cruz Islands.

11. This information came from Ibonga herself of Lrepe village, and from Menia of Menau-Menau village, with some additional observations and comments from Alu of Banua. Menia had been one of the snake carriers in this performance; Alu, then just a boy, had been among the awe-struck onlookers.

Alu grew up in Banua as the deity Opla was becoming the dominant tutelary throughout the villages of Graciosa Bay and Temotu Islet. He would have become an Opla client had not Christianity begun to take hold in Banua just as a marriage had been arranged for him, and his bride's relatives insisted it be done with a church ceremony.

The Lrepe switch from Noelebu to Opla was thought to be a normal move, because it appeared that Noelebu was not using his powers to assist his followers. All the persons who discussed the traditional religion with me seemed to assume that "setting aside" (*atute*) one *dukna* for another was a relatively common occurrence. This was the reason given to me as to why over relatively long periods of time, the popularity and influence of some deities waxed and waned, a processual interpretation that I was not able to verify by other informants.

12. Menaplo's *ngaalue* was weaving, and even in 1958–59 he was earning a small income from it because handwoven betel bags were in demand among European women in Honiara and the Nendö style was by far the most

popular. Menaplo sold all his woven bags to an agent who came out to Nendö from time to time seeking curios, and paid for his acquisitions in Australian coin.

Menaplo could be a reflective man, although normally he seemed always active and involved. He had a fine reputation for having sponsored many maturation ceremonies and having made contributions to countless bride prices, but he was also remembered as being very quick to anger when he was young and ever ready for a club fight if he felt he had been insulted or slighted by another man. In his wealthier days, he had owned a *tiela* (see note 1, above)—as had his father before him. He was recruited off-island only once to work on a plantation in the New Hebrides (Vanuatu) when contracts were for two or more years. He was not mistreated in any way nor did he have any bad experiences, but he returned to his village of Napu firmly opposed to going out again. He became a classic Nendö "big man" (*kaetu*), the last of the truly influential ones in the Graciosa Bay area. And because he had been such a successful and influential person, he had superb knowledge of and insight into the Nendö culture of two generations earlier. Fortunately for me, he was willing to spend much time with me as an informant. He was very curious about life in the "Big Place," which was what all the countries from whence Europeans came were collectively called, so we both had cultural information the other sought and could swap. I do not think he believed half of what I told him about America, for the same reasons I cannot believe in the truth of the many myths he told me.

Sometime during the 1920s he had presented himself to a missionary yaws infection that had plagued him all his life. He for baptism. He did so in appreciation for receiving medicine for a chronic received the Christian name of Clement, but never became an active Christian, and he never abandoned his inherited commitment to the *dukna* Menaopo. Because he grew up in a time when it was dangerous to venture far away from one's home village, Menaplo was not familiar with all parts of Nendö; yet his name was recognized by every senior man and woman on the island. He strongly disapproved of my traveling all over the island and especially at night by flashlight or lantern. He was always looking for sorcery when someone suffered unexpected misfortune, but he was far from being overly suspicious.

Menaplo died of natural causes after a brief illness in 1961. I was not on Nendö at the time. His death was marked by a traditional memorial feast that lasted three days, during which twelve pigs were cooked and distributed to those who attended. Each pig cooked and distributed at a memorial is a contribution from a man who is deeply indebted to the deceased, and the

total number of pigs given is a kind of numerical index of the deceased's social standing. Twelve is a very high number.

I like to think of Menaplo's soul residing in the western part of Nendö, still working at his loom, weaving fancy breech clouts for the *dukna* (it is not explained in myths and stories how the *dukna* get theirs) to wear as they sing and dance through eternity.

13. In the early days of the Melanesian Mission's efforts to Christianize the Solomons and Santa Cruz Islands, it was the vision of the first bishop, the Right Reverend George Augustus Selwyn, to one day build churches that would embrace local aesthetic traditions in their architecture. As for Nendö's contribution, Bishop Selwyn specifically mentioned the colored geometric patterns that Nendö people used for their sacred houses (*madukna*). This was attempted in only two churches, both located in the Polynesian-speaking communities of the Reef and Duff Islands, but it did not catch on. Bishop Selwyn was one of the new-style liberal missionaries who urged field workers working under him to learn local languages and become familiar with local cultures. (Some Melanesian Mission priests did produce valuable works of ethnography and ethnology, dictionaries, and language studies.) The Bishop's ideas about localizing the architecture of churches was never attempted on Nendö, because just the struggle to maintain a Mission presence on the island and to train a few young students who could be sent away to the boarding schools on other islands was all that could be managed in those difficult early days. Andrew Letade, in having his *nela* dance sanctioned by the church, managed to bring about a measure of religious fusion, although not in the architectural sense Bishop Selwyn had envisaged.

Chapter 5

1. All during the 1950s and most of the 1960s the volcano was quiet, and in 1959 a party headed by the French volcanologist M. Tazieff arrived at Nendö with the intention of hiring some men to assist in making an ascent and collecting samples from inside the crater. Two local men were persuaded to hire on, in spite of strong disapproval from their fellow villagers. The ascent was easy and without incident.

A Catalogue of
Santa Cruz Island Figure
Sculpture

Plate 1

Museum/Collection and Catalogue Number: Museum of Mankind, The British Museum, London; 1939.Oc.10.9.

Type and Style: Miniature; standing male, H. 10.8 cm [4¼"]. Developed style.

Details and Distinctive Features: Head carved with *abe* (headdress); *abe* and plane of face form a smooth arc; *abe* decorated with fiber fringe on both sides; plain cloth aprons front and back representing loom-woven (*neisia*) breech clout; simple fiber arm band; cordage around waist. Face upturned so that it and *abe* are both on horizontal axis, right angle to torso axis; slit mouth and chin merged into muzzle form; no fingers or feet; figure stands on circular base. Traces of turmeric on surfaces.

Ethnographic and Historical Data: Given to the British Museum by the Melanesian Mission with the information "possibly from Mala [*sic*, probably Malo] village on Temotu Island."

Men do not wear aprons with front and/or back flaps; ordinary male garment is a breech clout of plain bark cloth that is passed through the crotch and folded, front and back, over a wide bark belt. For special ceremonies a special breech clout of loom-woven fabric (*neisia*) with decorated borders is worn.

Publication: None.

Photograph: © The Trustees of The British Museum 11597, by permission.

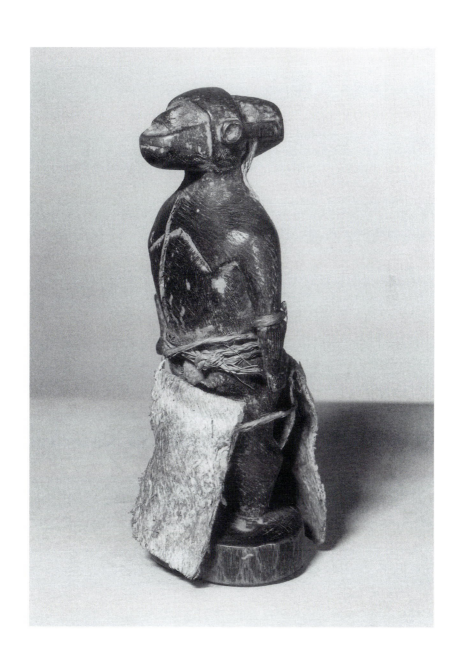

Plate 2

Museum/Collection and Catalogue Number: Museum of Mankind, The British Museum, London; 1944.Oc.2.1168.

Type and Style: Standing male, H. 55.0 cm [21¾"]. Developed style.

Details and Distinctive Features: Head carved with *abe* headdress, *abe* and face at right angles but form an arc; *abe* is decorated with fiber fringe on both sides; top of *abe* and part of raised hair area stained black; earrings attached to ear lobes, other ear details indicated; mouth and chin merged into muzzle; circular eyes accented by inlay; high-relief shark carved on chest and stained black; possible low-relief figure on back; elongated body trunk, pinched waist, genitals indicated; featureless hand and feet; spurs at ankles, stained black; traces of turmeric all over body; figure standing on relatively thick circular base.

Ethnographic and Historical Data: Beasley collection, some of which was at Cranmore Museum until 1944, when it was transferred to the British Museum. Most likely collected by the Reverend H. N. Drummond and/or Mr. Blencowe, a layman, about 1909–10; obtained by Captain Fred L. Jones, who eventually sold it to Beasley. Some of the Beasley collection found its way to the Cambridge University Museum, to the Royal Scottish Museum, and through unknown hands to the New York dealer J. J. Klejman (see Plate 48).

Publication: None.

Photograph: © The Trustees of The British Museum 11598, by permission.

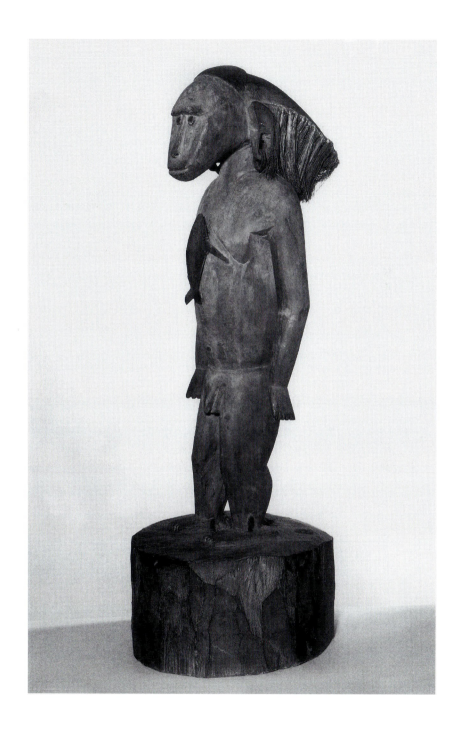

Plate 3

Museum/Collection and Catalogue Number: Museum of Mankind, The British Museum, London; 1944.Oc.2.1169.

Type and Style: Standing male, H. 47.0 cm [18½"]. Developed style.

Details and Distinctive Features: Head carved with *abe*, the latter with perforated flanges to which fiber fringes have been attached; face and *abe* at right angle to each other; mouth and chin shaped into muzzle; low-relief band separating forehead from *abe*; ears with earrings; eyes accented with shell inlay; shell nose pendant in old inverted teardrop style; remnants of shell disc necklace (*ba*); ridges above elbow to prevent arm bands from slipping down; braided arm bands now at wrists (appearing as bracelets); breech clout of undecorated coarse fabric secured with belt of fiber braids; seed-decorated strands with shell pendants, similar to nose pendant, hanging from wrists; shell knee ornaments, kneecaps carved in low relief; simplified feet; spurs pointed upward emerging from feet, fiber anklets; turmeric visible. More intact clothing on this figure than on any other.

Ethnographic and Historical Data: Beasley collection (see Plate 2), identified by collector (probably Jones) as Na-lombla (Duka Nimbe) of Vanikoro. This is unclear. None of my informants ever heard of Nalombla or Duka Nimbe. Identified in 1960 at Neo by elderly man (who claimed to be the former owner) as Menopulu.

Publication: Cranstone 1961 (frontispiece); Gillett 1939 (pl. K1). Davenport 1990:105 (fig. 9.11); Meyer 1966, 2:595 (no. 687).

Photograph: © The Trustees of The British Museum IX 23, by permission.

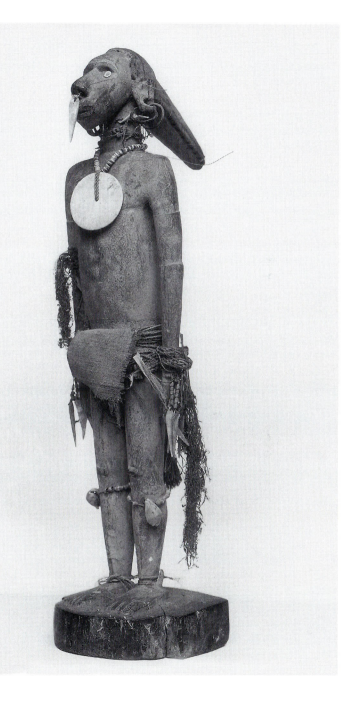

Plate 4

Museum/Collection and Catalogue Number: Museum of Mankind, The British Museum, London; 1944.Oc.2.1170.

Type and Style: Seated male on stool, H. 19.0 cm [7½″]. Developed style.

Details and Distinctive Features: Head carved with *abe;* low-relief band separates forehead from *abe;* elongated nose with large perforation through septum; accentuated brow ridge; mouth and jaw shaped into muzzle; no pendants; perforated flanges on *abe,* but no fiber fringe; eyes inlaid with perforated shell discs; carved arm bands; genitals indicated; squared feet; fiber cords around neck, wrists and right knee; spurs at wrists; figure encrusted with soot, no traces of turmeric; circular disc-like base (but unlike a regular stool). Possibly a capital figure (cf. Plate 14).

Ethnographic and Historical Data: Beasley collection, attached note reads "Figure representing the shark god Men-ar-ta-lu from the village of Nelu [part of the present-day village and district of Neo on Temotu Island], spikes at wrists are said to be used for pulling sharks out of the water and placing them on trees or on shore." Identified from photograph in 1960 as Melake because he is, possibly, "sitting under a tree," per the myth of Melake.

Publication: Gillett 1939 (pl. K3); Girard 1971 (fig. 4).

Photograph: © The Trustees of The British Museum 031300, by permission.

116

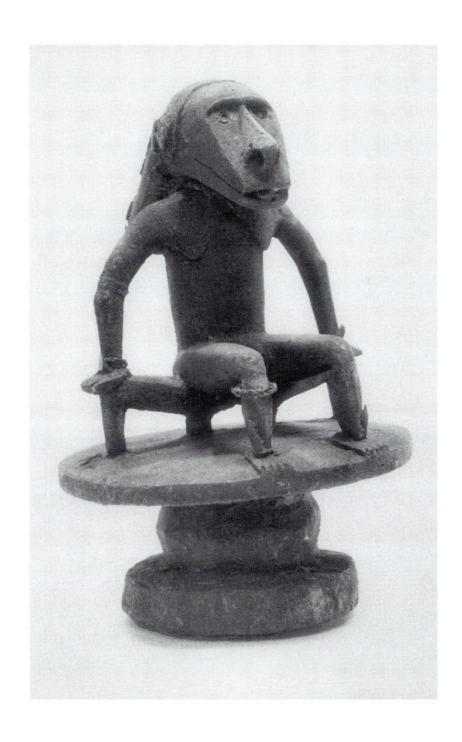

Plate 5

Museum/Collection and Catalogue Number: Museum of Mankind, The British Museum, London; 1944.Oc.2.1171.

Type and Style: Standing figure, H. 48.0 cm [19″]. Developed style.

Details and Distinctive Features: Head carved with *abe,* separated from forehead by a low-relief band; *abe* projects straight back, has linear flanges but no fiber decoration; *abe* forms right angle with face; facial features in usual T composition; mouth and chin fused into muzzle, but not projected strongly forward; enlarged ear lobes with turtle shell earrings; no other clothing or personal adornments; button-like eyes, carved chevron motifs on cheeks; large high-relief shark carved on chest (cf. Plate 2); porpoise motifs in low relief on either side of grooved backbone; knobs for elbows, possibly knobby depictions of wrist bones, hands reduced to ovoid forms, and hands possibly holding something; right hand missing; genitals indicated; pinched-in waist; kneecaps indicated by knobs; legs short with respect to body trunk; feet reduced to rectangular forms, spurs at ankles; circular base. In 1960, from photograph one informant identified *dukna* as Melake, another identified figure as Menaopo.

Ethnographic and Historical Data: Beasley collection (cf. Plate 2).

Publication: None.

Photograph: © The Trustees of The British Museum 30246, by permission.

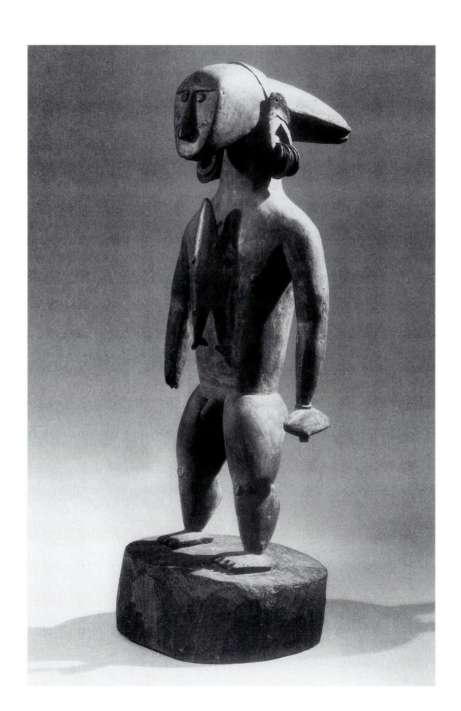

Plate 6

Museum/Collection and Catalogue Number: Museum of Mankind, The British Museum, London; 1944.Oc.2.1172.

Type and Style: Standing male, H. 33.0 cm [13″]. Developed style.

Details and Distinctive Features: Head carved with *abe*; face and axis of headdress at right angle; linear flanges along side of *abe*, but no fringe present; low-relief band separates forehead and lower margin of *abe*; inlaid perforated shell discs for eyes; enlarged ears with turtle shell earrings; mouth and chin shaped into rounded muzzle; naturalistic nose; ground shell beads (*ba*) as choker around neck; coconut bast (stem fiber) breech clout supported by braided fiber belt; moderately pinched-in waist; detailed hands, fingers straight down; knobs at wrists and possible spurs; slightly reduced diameter of upper arms where arm bands should be; right arm band has slipped down to wrist; knobs for kneecaps; large cowrie shells tied above calves where dance rattles would be worn for *nela* dance; spurs at ankles; figure stands on circular block base incised around with inverted angular U motifs.

Ethnographic and Historical Data: Beasley collection. Inherited from his maternal uncle and refurbished; handed over to missionary, probably the Reverend West.

Publication: Cranstone 1961.

Photograph: © The Trustees of The British Museum 11601, by permission.

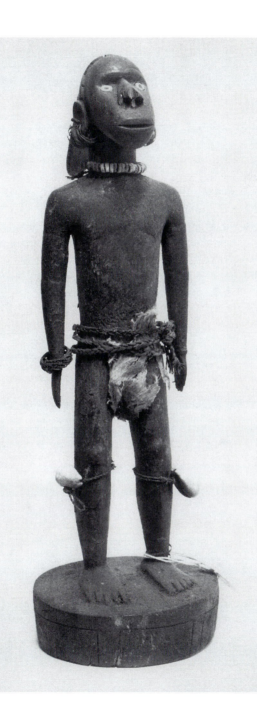

Plate 7

Museum/Collection and Catalogue Number: Museum of Mankind, The British Museum, London; 1944.Oc.2.1173.

Type and Style: Standing male, H. 29.0 cm [11½"]. Developed style.

Details and Distinctive Features: Head carved with tapered *abe*, which forms an acute angle with plane of the face; double flanges at bottom of *abe* for attaching decorative fiber fringe, existing fringe has disintegrated; no eyes, nose elongated with flared nostrils; mouth and chin shaped into squared muzzle angled downwards; ears and ear lobes greatly enlarged and angled outward to accommodate turtle shell hoop earrings, right ear lobe broken off; grooved sternum, pinched and grooved waist; genitals indicated, but no breech clout; arms elongated and jutting out at angle, hands with fingers extending to knee level, auger shell wrist ornament; cowrie ornaments attached at knees; feet squared; former base has disintegrated, so image appears to be standing on its own two feet.

Ethnographic and Historical Data: Beasley collection; identified from photographs in 1960 as both Mengalu and Melake.

Publication: None.

Photograph: © The Trustees of The British Museum 11602, by permission.

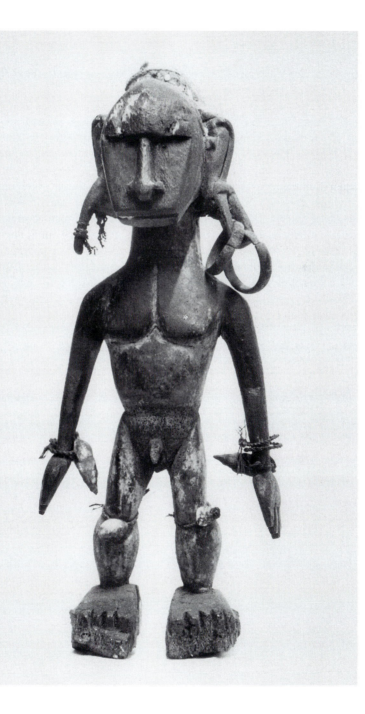

Plate 8

Museum/Collection and Catalogue Number: Museum of Mankind, The
British Museum, London; 1944.Oc.2.1174.

Type and Style: Standing male, H. 58.0 cm [22¾″]. Developed style.

Details and Distinctive Features: Head carved with *abe;* some fiber (prob-
ably *Gnetum* sp.) remains attached to single flange on top of headdress;
abe is tapered and projects straight back from head, forming obtuse angle
with plane of face; face upturned, flattened nose, eyes inlaid with perfo-
rated shell discs; forehead bulbous; chin and mouth shaped into muzzle;
ears not prominent, drilled for earrings, one remains attached to left ear;
low-relief carving of porpoise (?) motif on cheeks; elongated tubular neck;
female-like breasts, male genitals indicated; long body trunk, very
pinched-in waist; legs foreshortened, calves pronounced; upper arms elon-
gated, forearms shortened; right hand holds a baton (possibly a shark-
killing club), left hand holds fish, snail shell wristlet on left; feet
abbreviated, spurs at ankles; traces of turmeric on body; figure stands on
circular block base.

Ethnographic and Historical Data: Beasley collection; identified in 1960
from photograph as Nonalengi.

Publication: None.

Photograph: © The Trustees of The British Museum 11603, by permission.

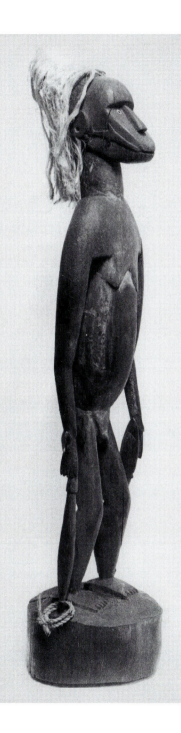

Plate 9

Museum/Collection and Catalogue Number: Museum of Mankind, The British Museum, London; 1944.Oc.2.1175.

Type and Style: Standing male, H. 40.0 cm [14⁷/₈″]. Developed style.

Details and Distinctive Features: Head carved with *abe*, latter forms acute angle with plane of face; much fiber (probably *Gnetum* sp.) still attached, encrusted with lime; long thin nose, no eyes; low-relief horizontal band separates forehead from hair line; short neck, chin close to chest, chin and mouth shaped into squared muzzle; ears project outward with large perforations through the lobes for earrings, turtle shell earrings in both ears; high-relief shark carved on stomach; pinched-in waist, genitals indicated, but no breech clout; lower body and legs greatly shortened; long thin forearms, hands reduced to round forms; right hand holding fish, left hand holding club or baton; transverse strengthening bar joins both hands to underside of buttocks; squared feet with toes; spurs at ankles; traces of turmeric; figure stands on circular base (cf. Plate 8).

Ethnographic and Historical Data: Same as others in Beasley collection.

Publication: None.

Photograph: © The Trustees of The British Museum 11604, by permission.

126

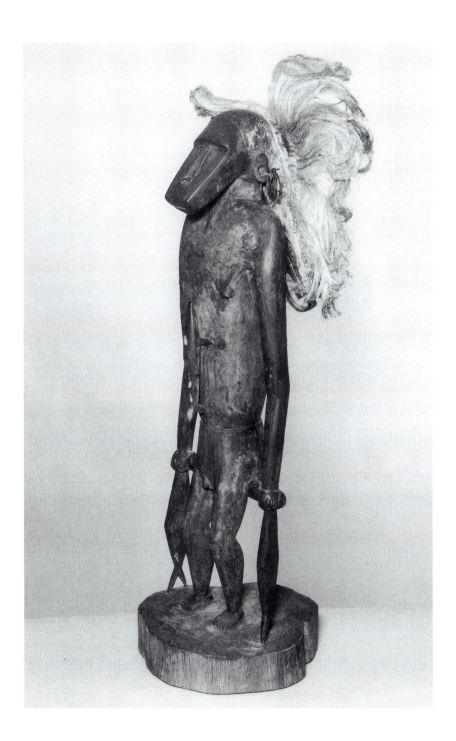

Plate 10

Museum/Collection and Catalogue Number: Museum of Mankind, The British Museum, London; 1944.Oc.2.1176.

Type and Style: Standing male, H. 30.0 cm [11¾″]. Developed style.

Details and Distinctive Features: Head carved with *abe* which is wrapped with fan-palm leaf; head and *abe* form continuous arc; raised surface separates forehead from hairline; perforated shell discs inlaid for eyes; flat turtle shell ornament hanging from nose septum; ears pronounced, lobes projecting outward with large perforations, no earrings; body trunk squared with rounded edges, pronounced belly; upper arms elongated; small wrists compared with hands; hands at knee level, fingers indicated; hands attached to base with reinforcing stanchion; pinched waist, genitals indicated, no clothing remaining; shortened legs with respect to trunk; figure blackened except for sides of head and inside surfaces of reinforcing stanchion; figure stands on thick circular base, no signs of turmeric.

Ethnographic and Historical Data: Beasley collection. Wrapping the *abe* with fan-palm leaf is to protect the fringe and keep it from getting soiled by smoke from household hearth. Identified from photographs in 1960 as a *leimuba* (because of its short legs) (cf. Plate 52).

Publication: Cranstone 1961 (frontispiece); Fraser 1962 (pl. 116); Davenport 1990:104 (fig. 9.10).

Photograph: © The Trustees of The British Museum 11605, by permission.

128

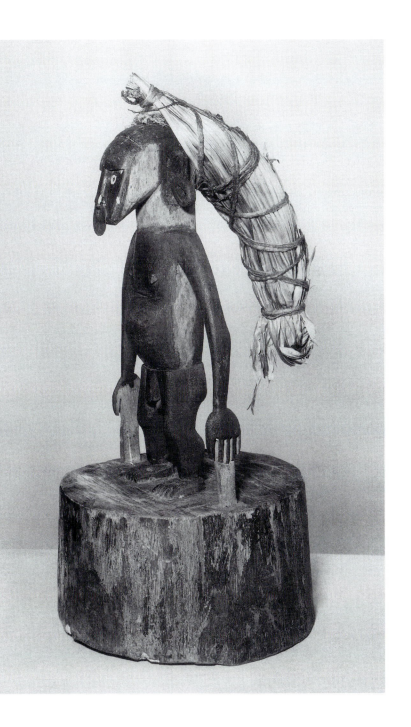

Plate 11

Museum/Collection and Catalogue Number: Museum of Mankind, The British Museum, London; 1944.Oc.2.1177.

Type and Style: Standing male, H. 37.0 cm [14½"]. Developed style.

Details and Distinctive Features: Head carved with *abe;* single flange for attaching fiber on top of *abe;* no or very short fringe remaining with white pigment, possibly lime (cf. Plate 9); face and *abe* form symmetric arc; perforated shell discs inlaid for eyes; long thin nose without flaring nostrils; nares and septum pierced for pendant and nostril ornaments, none present; mouth and chin shaped into extreme muzzle that overhangs chest; no body details indicated, tapered trunk, pinched-in waist; genitals indicated; upper and lower arms in proportionate length to each other and to body; triangular hands; hands and buttocks joined by reinforcing bar, hands joined to base with more reinforcing bars; lower legs shortened, feet as flattened rectangles, toes indicated; wood appears to be harder than that used for most figures, surface burnished; no spurs, no clothing, no body ornamentation, no indications of turmeric; circular block base.

Ethnographic and Historical Data: Beasley collection; identified from photograph in 1960 as Meteteitepu (Meteteipu) because the figure is so "ugly." This is a reference to a myth about a *dukna* of that name who in his visible human condition is especially ugly.

Publication: Starzecka and Cranstone 1974; Davenport 1990:104 (fig. 9.9).

Photograph: © The Trustees of The British Museum 11606, by permission.

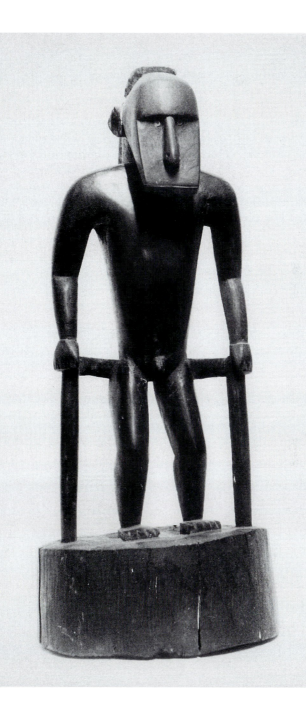

Plate 12

Museum/Collection and Catalogue Number: Museum of Mankind, The British Museum, London; 1944.Oc.2.1178.

Type and Style: Standing female, H. 48.0 cm [19″]. Developed style.

Details and Distinctive Features: Head hair indicated by a raised area; chin and mouth shaped into extreme muzzle; shell inlay eyes set in raised circular forms; earlobes elongated and perforated, with turtle shell hoop earrings attached to left; breasts pointed, with low-relief areas carved below them; waist slightly narrowed with a groove where belt would be attached; single fiber strand around waist; legs shortened, arms hang straight down, hands on thighs, grooves at elbows; figure stands on thick circular base; no clothing, no traces of turmeric.

Ethnographic and Historical Data: Beasley collection.

Publication: Davenport 1990:103 (fig. 9.8).

Photograph: © The Trustees of The British Museum 11607, by permission.

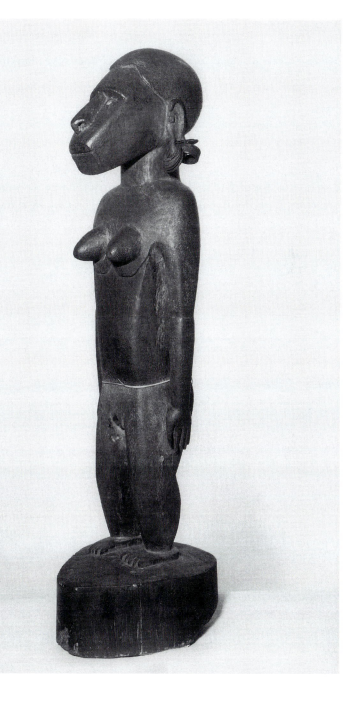

Plate 13

Museum/Collection and Catalogue Number: Museum of Mankind, The British Museum, London; 1944.Oc.2.1179.

Type and Style: Pair of standing males, H. 29.0 cm [11³⁄₈″]. Developed style.

Details and Distinctive Features: Two standing figures seem to be as nearly identical as could be carved; heads with *abe,* tops of which form arcs with plane of faces; sides of *abe* are uniquely flattened, remnants of attached fiber remaining; inlaid shell discs for eyes; noses elongated with some flaring at nostrils; single perforations through nostrils and nares; mouths and chins shaped into muzzles; head of left figure has some reddish color, right figure is blackened; both arms broken off right figure; right arm of left figure broken off at shoulder; left arm missing part of forearm and hand (earlier photograph shows right figure with baton or walking stick in left hand, as well as decorated strips of bark cloth (?) tied around neck of left figure); bodies tapered, narrow waists with belts carved in low relief; genitals well carved, upper and lower legs well shaped; feet simplified; figures stand on thick circular base (other paired set, Plate 26, is male-female).

Ethnographic and Historical Data: Beasley collection; "The two figures are said to be brothers, that on the left named Lemumbla and that on the right Leo Mumbur; their mother's name was Talimba—a legendary personality...I understand from Mr. Jones of Vanicoro [*sic* Vanikoro]—who has kindly supplied much of the information for this article and also the specimens for our collection—that these *dukas* are not exposed to view as formerly, probably owing to the new religion and beliefs, but are partioned off into small shrines" (Gillett 1939:154). "This is a Mana fetish for *manau* [birds for making feather currency] hunters. Image called Meknalneti, because they are twins" (Beasley notes, Cambridge University Museum).

Publication: Gillett 1939 (pl. K2).

Photograph: Douglas Frazer; © The Trustees of The British Museum, by permission.

134

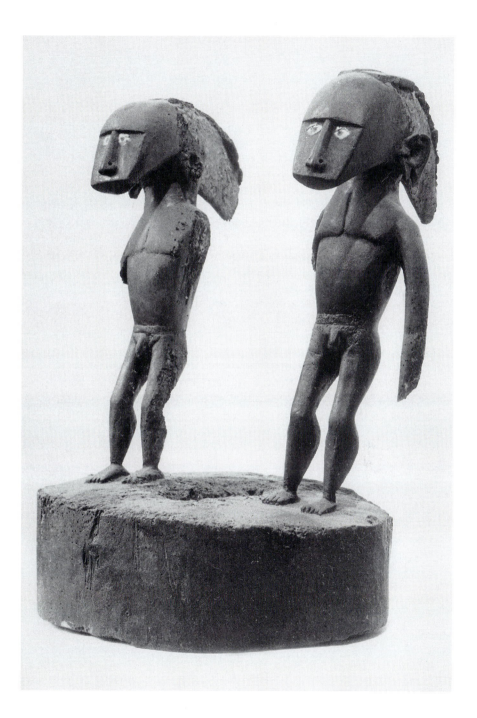

Plate 14

Museum/Collection and Catalogue Number: Museum of Mankind, The British Museum, London; 1944.Oc.2.1182.

Type and Style: Entire specimen H. 84.0 cm [37″]; seated male (?) figure only, H. 31.0 cm [12″]. Figure is capital of a decorated post fragment. Generalized style.

Details and Distinctive Features: A unique piece in that the figure is the terminal decoration of a post, its two pegs probably used to hang fancy baskets with offerings of special food. The figure appears to have a European-style hat on, but such hat-shaped forms are a stylistic device used as ends, terminals, or finials (the same device is used in the eastern Solomon Islands). Thin, elongated, high-bridged nose; upper arms and shoulders form a conspicuous arc; arms hanging down, forearms bearing a stepped flange decoration (iconography unknown); spurs projecting from wrists. Elongated body trunk, figure either is in a sitting position (but no stool) or squatting with lower legs hanging down at right angle to upper legs; feet resting on two blocks and a rectangular base. Unique design in low relief on post in area from which pegs project; below, painted geometric designs very similar to those used on dancing clubs/batons; this is the only example of a post figure from Nidu.

Ethnographic and Historical Data: Beasley collection. Possibly an offering post from a *madukna* or a post associated with the hearth and drying shelf that is in the center of every *mabau* or an offering post used in a *madai*.

Publication: None.

Photograph: © The Trustees of The British Museum 031301, by permission.

136

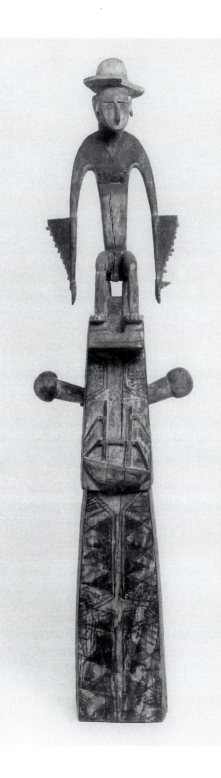

Plate 15

Museum/Collection and Catalogue Number: Cambridge University Museum of Archaeology and Anthropology, Cambridge; 1954.79A.
Type and Style: Standing male H. 45.7 cm [18″]. Developed style.
Details and Distinctive Features: Head carved with *abe* curving down over back, no fringe or means by which fibers could be attached (unique style of *abe*); hairline indicated; ears comparatively small, lobes extended, no earrings; no overhanging brow ridges, chin and mouth not merged into muzzle; long, narrow nose with one ring attached to septum (this ring appears to be the pointed type used to pierce septums and earlobes ceremonially). Two fish carved in high relief over breasts; pinched-in and grooved waist; genitals indicated, but no breech clout; arms hanging down, lightly carved porpoise motif on upper left arm; left hand holds fish, tail down, which is attached to base to form a reinforcing stanchion; figure stands on thick circular base.
Ethnographic and Historical Data: Gift from the Beasley estate in 1954; light impression of a Beasley label on figure, but number not legible.
Publication: None.
Photograph: Cambridge University Museum of Archaeology and Anthropology, by permission.

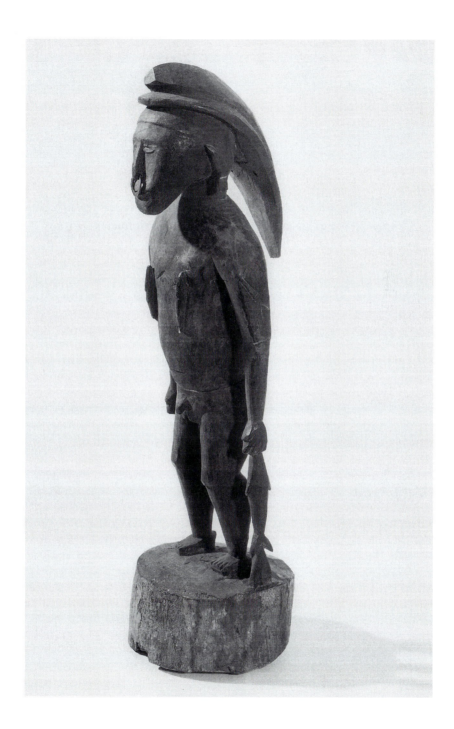

Plate 16

Museum/Collection and Catalogue Number: Cambridge University Museum of Archaeology and Anthropology, Cambridge; 1954.79B.

Type and Style: Standing male, H. 35.5 cm [14″]. Developed style.

Details and Distinctive Features: Head carved with tapered *abe*, perforated flanges along each side for fringe, but no fiber present; plane of face near vertical, *abe* at slightly obtuse angle; discontinuous brow ridges, slit mouth and chin formed into rounded muzzle; ears elongated with enlarged and perforated lobes, turtle shell ornaments on left ear only; tapered body, double cord around waist; genitals indicated, no breech clout; snail shells on left wrist and both knees; squared slabs for feet; reinforcement stanchions extending from hands to circular base on each side; no traces of turmeric.

Ethnographic and Historical Data: Gift from Beasley estate in 1954, no label.

Publication: None.

Photograph: Cambridge University Museum of Archaeology and Anthropology, by permission.

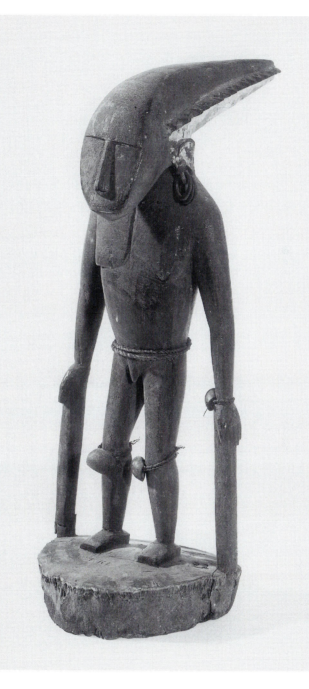

Plate 17

Museum/Collection and Catalogue Number: Cambridge University Museum of Archaeology and Anthropology, Cambridge; Z 5834.

Type and Style: Standing male, H. 62.5 cm [24⅝"]. Generalized style.

Details and Distinctive Features: Head carved with *abe*, human hair attached; face near vertical, *abe* off back of head; flat ovoid face, long thin nose, discontinuous brow ridges; round holes for eyes; painted details around eyes, at temples, cheeks, chest, and stomach; ears represented as circular blocks, pierced but with no earrings; chin and mouth shaped into muzzle; low-relief vertical ridge on forehead; square short neck; quadrangular body tapering to pinched-in waist, transverse groove across chest; fiber cord as belt holding up a breech clout of coconut bast; thin arms hanging straight down, wrists indicated by raised form (that could be spurs), hands squared off, no fingers; calves very thick compared with thighs, pinched in at knees, fiber cord around knees; feet squared with notches for toes; figure standing on thick circular block.

Ethnographic and Historical Data: Ruddock collection (E.1902.213), purchased in 1902 from the Reverend D. Ruddock—a missionary with the Melanesian Mission, ordained Deacon in 1879, Priest in 1883; served during Bishop Selwyn's episcopate; resigned from Melanesian Mission in 1884 because of poor health; died in New Zealand in 1920. Ruddock could have collected this image himself, or it could have been collected by a fellow missionary, such as Lister Kaye who served the Melanesian Mission about the same time (see Plate 23). This was one of the first images to be collected and to find its way back to England.

Publication: None.

Photograph: Cambridge University Museum of Archaeology and Anthropology, by permission.

142

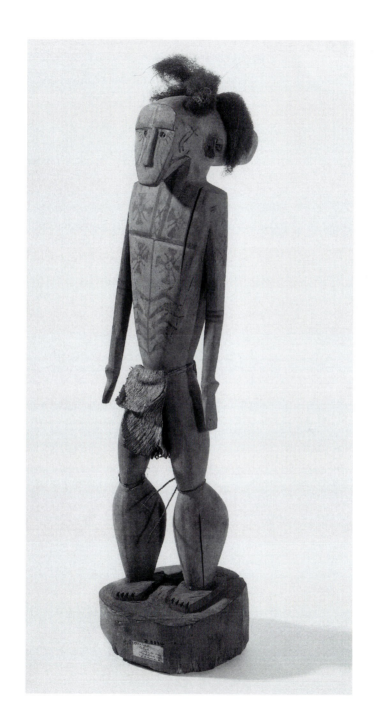

Plate 18

Museum/Collection and Catalogue Number: Cambridge University Museum of Archaeology and Anthropology, Cambridge; Z 31996.
Type and Style: Standing male, H. 58.0 cm [22$^3/_4$"]. Developed style.
Details and Distinctive Features: Head carved with *abe* which has side flanges perforated for attaching fiber fringes, but no fiber remains; ovoid, concave facial area, no brow ridges; low-relief band, from ear to ear, separates forehead from lower edge of *abe*; long thin nose form; holes for eyes, no inlays; ears represented by oblate rings, two heavy turtle shell rings hanging by cord; flat turtle shell septum ring hanging from nose; mouth and chin forms merged into a muzzle with rounded edges; body rounded and tapered down to pinched-in waist; arms hanging down, thickest at elbow area; hands flattened and flared; spurs emerging from wrists; genitals indicated without detail, spurs emerging from groin area; thighs shortened, calves thickened, knees and ankles indicated by small knobs, feet as flattened ovals; figure, painted with turmeric, stands on circular base.
Ethnographic and Historical Data: In 1960 Mekope of Napu village said he recognized this figure as very like one he had once seen in Manoputi village, but he did not know the *dukna* represented; this figure still carries the number D31.92, which could be an Otago Museum number. Very likely it was acquired from H. D. Skinner in an exchange that occurred sometime between 1931 and 1948, but not catalogued by Cambridge University Museum until 1979. However, there are no records of such a transaction at either Otago or Cambridge.

The most likely collector of the piece is Dr. Charles Fox, a New Zealander by birth, who spent most of his life in missionary service with the Melanesian Mission, and most of this service was in the Solomon Islands. It is known that he and Skinner were friends. Fox considered himself to be an ethnographer and linguist. The source could also be Captain Fred L. Jones, who regularly collected artifacts for private collectors in New Zealand, Australia, and England as a part of his trading business. Jones obtained many of the artifacts he sold to others from missionaries in the Melanesian Mission who were working in the villages and with whom Jones seemed always to be on good terms. One of these was the Reverend Deacon George West, who arrived in the Santa Cruz Islands in 1913, first as a carpenter and only later as a Deacon. West collected a wide variety of artifacts, including religious figures, most of which he sold to Fred L. Jones or gave to other members of the Melanesian Mission as curios. The Reverend Charles Fox was one of the latter.
Publication: None.
Photograph: Cambridge University Museum of Archaeology and Anthropology, by permission.

144

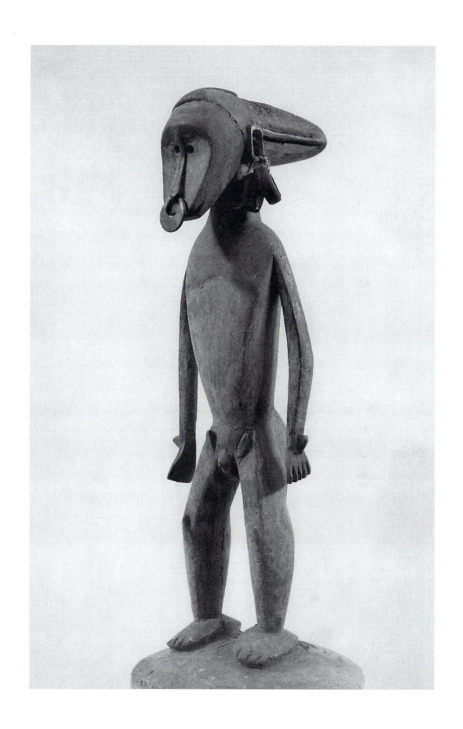

Plate 19

Museum/Collection and Catalogue Number: Sainsbury Centre for the Visual Arts, University of East Anglia, Norwich; UEA 557.

Type and Style: Standing male, H. 29.2 cm [11½″]. Generalized style.

Details and Distinctive Features: Head carved with tapered *abe* off back of head, face at right angles, no ridge or perforations for attaching fringe; ovoid face with long, thin nose, brow ridge broken by nose, but facial features in T composition; eyes inlaid with perforated shell discs; mouth and chin merged, forming rounded muzzle, slit for mouth under the face; ears projected outward, no details, top of right and lobe of left are absent (broken off?); arms down, no elbows; hands slightly lifted back, fingers indicated by notches; no waist, but carved wide belt indicated; no genitals; shortened legs, knees slightly indicated; feet squared, notches to delineate toes; no clothing or ornaments, only a few linear motifs drawn on sides of *abe*, on stomach above waist, side of legs at knees, and on shins; figure stands on round block.

Ethnographic and Historical Data: Nothing beyond the fact that it was purchased by Sir Robert Sainsbury in 1974 from a friend.

Publication: Sir Robert Sainsbury 1978 (152).

Photograph: Sir Robert Sainsbury, by permission.

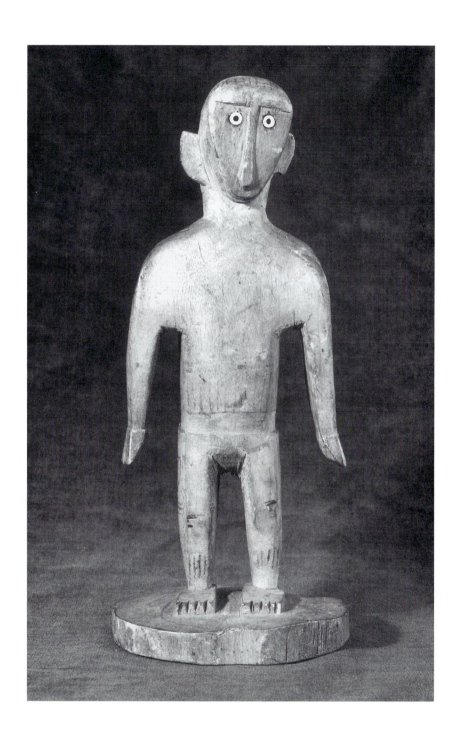

Plate 20

Museum/Collection and Catalogue Number: Brighton Museum & Art Gallery, Brighton; WA503810.

Type and Style: Miniature; male figure seated on disc; cylindrical form, possibly a plug or stopper, under disc. Overall H. 11.2 cm [4⁹⁄₁₆″], H. figure only 7.5 cm [2⁷⁄₈″], disc base Dia. 8.7 cm [3¹⁄₂″]. Generalized style.

Details and Distinctive Features: Tapered *abe* off back of head; head and *abe* fused into single form, no ridge or perforations along side of *abe*; face nearly vertical; inlaid perforated disk for right eye, left missing; short nose, no brow ridge; crescent mouth above rounded chin; short neck, torso not tapered, inlaid disc, as above, for nipples and navel; undifferentiated ear forms, pierced; upper legs quadrangular in cross section, outstretched forward, no lower legs or feet; thin upper arms straight down, no hands; forearms merged with transverse bench-like form; no buttocks. Traces of turmeric. Right back and left front of disc broken off: five concentric rings of linear incised decoration on top of disc; lower cylindrical form slightly tapered at bottom like a stopper.

Ethnographic and Historical Data: Collected by F. N. Ashley, Resident Commissioner BSIP, 1929–39, given by him to the Brighton Museum, January 15, 1953. Object appears to be a stopper, perhaps of a lime container or freshwater bottle. Traditional bottles were gourds, but the large glass Japanese net floats with a drilled hole that often drifted ashore were much prized over gourds or joints of green bamboo for drinking water.

Publication: None.

Photograph: Royal Pavilion, Libraries & Museums, Brighton, by permission.

148

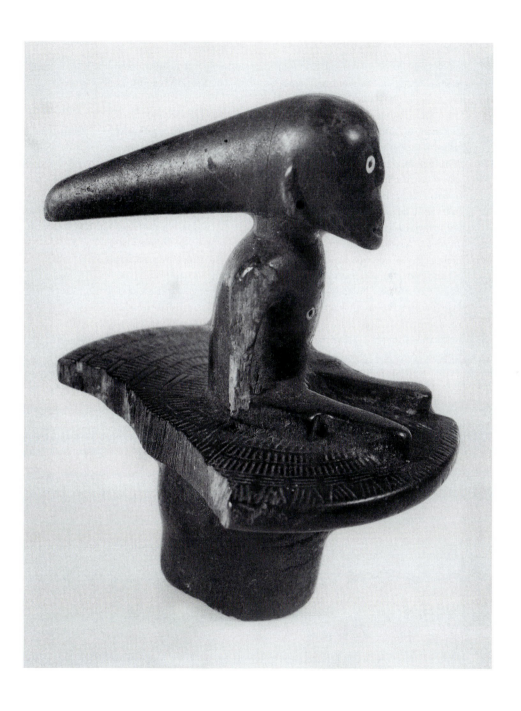

Plate 21

Museum/Collection and Catalogue Number: National Museums of Scotland, Edinburgh; 1954-160.

Type and Style: Standing male, H. 43.3 cm [17″]. Developed style.

Details and Distinctive Features: Head carved with *abe*, no fringe attached; ridge at hair line; long nose triangular in cross section; ovoid eyes under smooth overhanging brow; T facial composition, mouth under chin but not shaped into extreme muzzle; ears with loop lobes hang down, no earrings or nose pendant; long squarish neck, pectoral details in low relief; body squarish in cross section, belly accentuated; waist grooved; genitals well shaped, no belt or clout; knobs at knees, lower legs shortened, thick calves; possible spurs at ankles; thin slab feet, toes indicated by grooves between; figure standing on circular block base; surface polished, may have been stained black.

Ethnographic and Historical Data: Beasley collection, gift of Mrs. I. Beasely.

Publication: None.

Photograph: © The Trustees of the National Museums of Scotland, 3319, by permission.

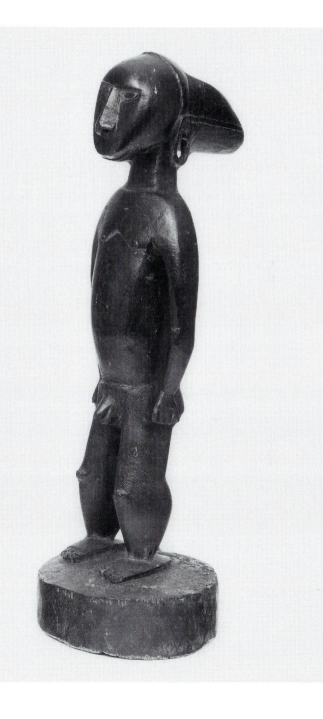

Plate 22

Museum/Collection and Catalogue Number: National Museums of Scotland, Edinburgh; 1954-161.

Type and Style: Standing male, H. 33.0 cm [13″]. Developed style.

Details and Distinctive Features: Head carved with *abe* forming an arc with plane of face; *abe* surface raised above head surfaces but behind natural hairline; long thin nose with flaring nostrils, no pendant; discontinuous brows, eyes inlaid with perforated discs; mouth under chin and shaped into square muzzle; stretched ear lobes with large perforations, no earrings; pectoral areas well defined, grooved waist; genitals indicated, but no belt or clout; thin limbs, arms hanging down with roughly carved hands and fingers; both hands attached to support stanchion extending to circular base; slab feet with toes indicated (cf. Plates 9, 10, and 11).

Ethnographic and Historical Data: Beasley collection, gift of Mrs. I. Beasely.

Publication: None.

Photograph: © The Trustees of the National Museums of Scotland, 3318, by permission.

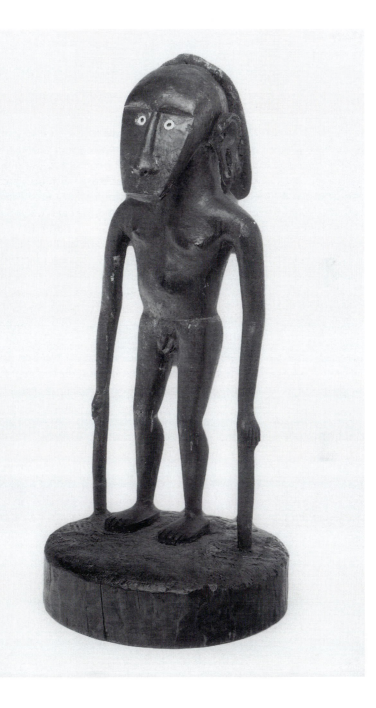

Plate 23

Museum/Collection and Catalogue Number: A. Lister Kaye Collection. Location unknown; no number.

Type and Style: Standing male, H. (approx.) 30.5 cm [12″]. Generalized style.

Details and Distinctive Features: Details not always clear because only record of this figure is a drawing. Head carved with *abe*, face flat, tilted slightly upward, with T composition; fringe on *abe*, earrings, and nose ring; visible neck, squared shoulders, elongated trunk with no waist; long arms with no elbows or demarcation between upper and lower arms; fringe on right arm, but arm band not visible; shortened legs, calves emphasized; no feet; figure stands on circular block.

Ethnographic and Historical Data: This figure was collected by Alan Lister Kaye, Esq., a layman who was with the Melanesian Mission in 1882 and was the first European missionary to reside ashore on Santa Cruz Island. He stayed seven weeks, traveling extensively over the island, and set up the first Bible school on the island. Lister Kaye returned to Santa Cruz Island twice in 1884, the first time for only a few days, the second time long enough to fully explore the coastline around the entire island. He encountered no hostility on Nidu, then went ashore on Nukapu. Bishop Patteson was killed on Nukapu in 1871 in retaliation for the predations of the blackbirders, or slave raiders. Lister Kaye returned to England in 1884 or 1885. A note accompanies the drawing in Edge-Partington: "A spirit (Taluna) [probably the personal name of the spirit, which would also be Metaluna] placed between a sick or wounded man and death; should the man die they say the spirit must have been asleep." It is not known where on Santa Cruz Island it was collected.

Publication: Edge-Partington 1890, 1:163; Davenport 1990:99 (fig. 9.1). This may be the first *munga dukna* to be pictured in a publication.

Photograph: None.

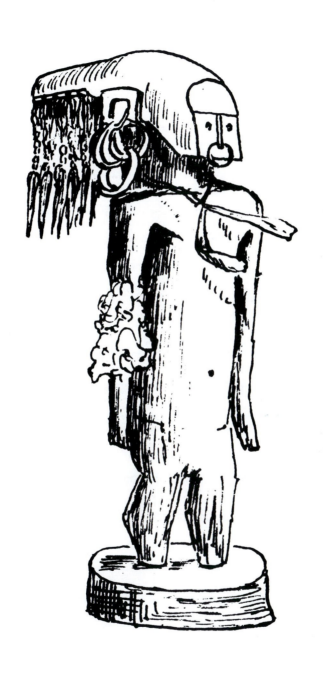

Plate 24

Museum/Collection and Catalogue Number: Otago Museum, Dunedin, New Zealand; 029.131.

Type and Style: Seated male, H. overall 39 cm [15½″], H. figure alone 37.5 cm [14¾″]. Developed style.

Details and Distinctive Features: Head carved with down-pointed *abe* and upturned face forming arc with headdress; fringe attached to *abe;* hairline indicated, continuous brow ridge beneath forehead; enlarged ears with many thin, flat turtle shell earrings hanging from lobes; brow ridges and high thin nose form T facial composition; raised almond eyes, no inlay; septum pierced, one circular turtle shell nose pendant; perforations also through nares (for stick ornaments, but ornaments not present or simulated); chin and mouth in muzzle form; some neck visible, fiber and pandanas leaf necklace hanging down over chest; pectoral shapes lightly defined; trunk slightly tapered to pinched waist; cords around waist supporting a decorated loom-woven fabric breech clout; arm band in place on right arm, slipped to wrist on left arm; cordage bracelet on right wrist, but may be part of arm band; upper and lower arms about equal length, elbow indicated by slight ridge intended to hold arm bands in place; hands flat, fingers roughly indicated by grooves between them; fingers overlap edge of stool on which figure sits; upper and lower legs naturalistic, calves not thickened; leaf ties for knee ornaments remain but no shell; remnants of cordage anklets both legs; no spurs, feet flattened, toes indicated by grooves between them; figure sits on M-shaped stool (similar to Nidu neck rests; possibly Tikopian); base is a circular block. Turmeric all over surface.

Ethnographic and Historical Data: Collected by the Reverend George West probably in 1928 at Mainu, Temotu Islet. This is probably a site in or near what is now known as Neo village, but there is a possibility it was collected at Maimu, another old village site on Temotu. West wrote attached note, May 20, 1928:

> The name of this image is Melaganu. The men folk of the village worshipped this image before going out for catching sharks. The idea being that the image would help them in catching a big shark. Two large sharks was [sic] considered a big haul and was [sic] as much as they could manage at one time in their canoes, as many as 20 sometimes more canoes, would go out at times, trying to catch sharks. The flesh of the shark was cooked in leaves, and then sold.
>
> The main idea being to get the red-feather money of Santa Cruz. Mainu a village on the island of Te Motu Santa Cruz is where I got this image.

Publication: Brake, McNeish, and Simmons 1979 (pl. 4); Davenport 1990:101 (fig. 9.6); Kaeppler et al. 1997:237 (no. 141).

Photograph: © Otago Museum, Dunedin, New Zealand, 727, by permission.

156

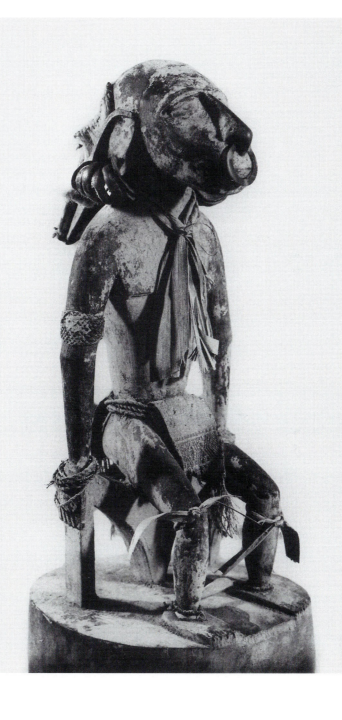

Plate 25

Museum/Collection and Catalogue Number: Otago Museum, Dunedin, New Zealand; D31.91.

Type and Style: Standing male, H. 126 cm [49⅛″]. Developed style.

Details and Distinctive Features: Head carved with very long *abe* extending nearly straight back, intact fringes on both sides; narrow raised band marking bottom of *abe*, band of hair between headdress and forehead indicated with black stain; face slightly upturned, naturalistic facial features; red stain on lips; deep-set eyes, but no prominent ridge, eyes inlaid with perforated shell discs; nose not exaggerated, septum pierced but no pendant; ears not exaggerated, lobes pierced, ring hanging from right lobe, left lobe broken out; chin and mouth naturalistic, some prognathism; neck slightly elongated, curved into shoulders, necklace of fiber; no pectoral shapes, but nipples prominent; possible stained design on chest and in bands over both shoulders; thin upper arms, upper and lower in proportion to each other, arms hanging straight down; tangles of fibers attached to both upper arms, hanging down to below waist; a breech clout of woven fabric, plain in front, possibly with patterned band on back flap; clout held up by obscured belt and neatly folded over double in front, long in the back; knees slightly indicated, thin calves, cords just below knees, but no ornaments except for fragment of a leaf at left; feet simplified flat ovate forms, no toes; no base.

Ethnographic and Historical Data: Collected by the Reverend George West and there is a note from West to H. D. Skinner, November 19, 1930: "a fairly large one which has been well kept and is in good condition, not many people knew it was even in the village. The band of shell around the waist they say is the old Santa Cruz money which was in circulation before the red feather money came into use. The name of this image is Menalo. All the images they say were to help them in catching of sharks but there must have been a lot more behind it as well."

Publication: Brake, McNeish, and Simmons 1979: pl. 1; Kaeppler et al. 1997:238 (no. 142).

Photograph: © Otago Museum, Dunedin, New Zealand, by permission.

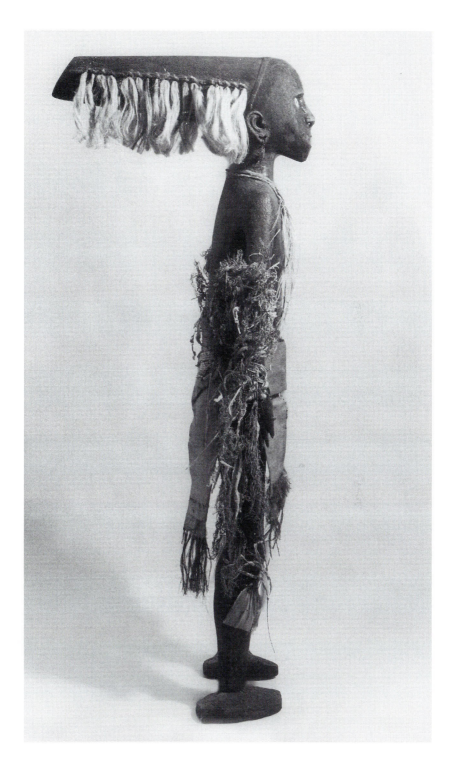

Plate 26

Museum/Collection and Catalogue Number: Otago Museum, Dunedin, New Zealand; 031.94.

Type and Style: Standing male and female pair; H. male figure 37.0 cm [14½″]; H. female figure 34.5 cm [13½″]. Developed style.

Details and Distinctive Features: Male: head carved with *abe*, face and headdress form an arc; single bar for attaching fiber on top of *abe*, but no fiber remaining; hairline indicated; long tapered nose, large nostrils; no brow ridges; inlay of perforated shell for left eye, right missing; ears stand out, perforated lobes, no earrings; chin and mouth form very prognathous form, just short of forming a muzzle; full pectoral details, trunk tapered to pinched waist; genitals indicated, no breech clout; upper legs disproportionally long, slab feet with toes indicated by grooves between; right upper arm with indentation to hold arm band in place, no fiber band; hand holding a staff, tapered and pointed at both ends and attached to base (probably a dancing baton); left arm attached to leg just above knee. Female: same features as male, face slightly less prognathous; both earlobes broken; eye inlays missing; breasts indicated but no stomach details; trunk less tapered than male, left arm hanging down straight almost to knee, right arm broken off; entire figure broken off from base at ankles, now pinned to circular base; body stained red.

Ethnographic and Historical Data: Collected by Reverend West. Correspondence from West to Skinner, November 19, 1930:

> Another image is a man and a woman standing side by side. I am sorry the woman got broken off but it was broken before I got it. But when the natives gave it to me I did not want to let them see that I was keenly interested in it and left it lying on a rock on the beach where they had put it, while I went on with my business ashore, and when I came back about 2 hours after the tide had come up and carried the woman away but left the man standing, some kiddies had seen it floating but were afraid to go near it, and although we searched for a while we could not find it and it was not till about a month later after that a native brought it along having found it washed on the beach, but parts of it were broken an arm and an ear I think.

Publication: Anson 1995 (fig. 2); Davenport 1990:102 (fig. 9.7).
Photograph: © Otago Museum, Dunedin, New Zealand, by permission.

160

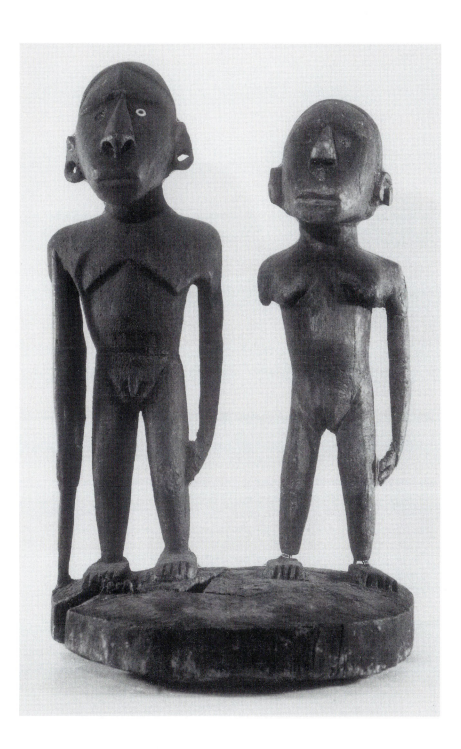

Plate 27

Museum/Collection and Catalogue Number: Otago Museum, Dunedin, New Zealand; 034.497.
Type and Style: Standing male, H. 26.5 cm [10½″]. Developed style.
Details and Distinctive: Head carved with *abe* curving down over back of figure; *abe* with prominent ridge at top for attachment of decorative fringe, fringe absent; face flat, long thin nose, no nose pendant; perforated shell disc inlay for eye, left missing; continuous brow ridge; facial features in T composition; chin and mouth fused into squared-off muzzle form which overhangs short neck; ears are indicated with rudimentary shape, no earrings; shoulders rounded; body tapered to waist, no pectoral details, but high-relief shark, head down, carved on chest; rounded ridge around upper arm to keep arm bands from sliding down, no arm bands; genitals indicated, no breech clout; left hand broken off, right hand fused with reinforcing support to circular base; angular buttocks and thighs, thick calves; simple flat slab feet; no spurs, no turmeric.
Ethnographic and Historical Data: Presumably collected by the Reverend West about the same time as the others.
Publication: None.
Photograph: © Otago Museum, Dunedin, New Zealand, by permission.

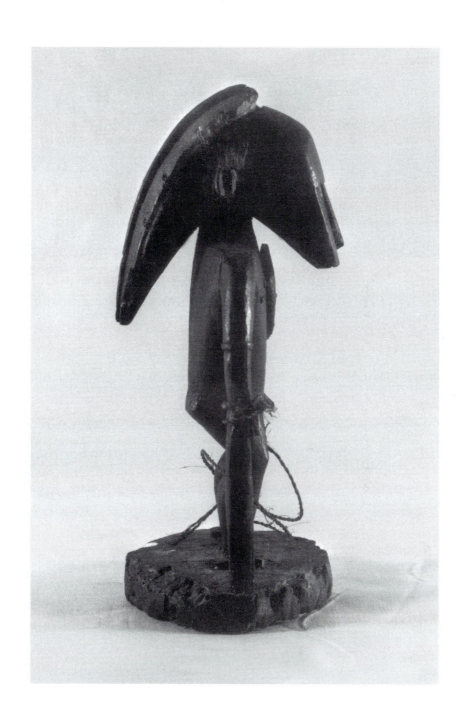

Plate 28

Museum/Collection and Catalogue Number: New Zealand Historic Places Trust, Wellington; FE 1147.

Type and Style: Standing male, H. 40.0 cm [15¾″]. Developed style.

Details and Distinctive Features: Head carved with *abe*, straight back from head; face tilted upward, raised band runs ear to ear across top of head; hair line indicated above forehead; raised band across forehead; eyes are small sockets without inlays; nostrils flared, no pendant; ears large and alongside head, left lobe broken; chin and mouth merged into rounded muzzle; neck short, pectoral areas and nipples indicated; tapered trunk and pinched waist, no belt or breech clout; thick upper arms, slight crease at elbows, forearms tapered to wrists, cords attach auger shell to left wrist; spurs on backs of hands, hands squared off, fingers indicated; horizontal groove just above pubic area; genitals barely indicated; thighs slightly quadrangular in cross section, lower legs with heavy calves; flat slabs for feet, toes indicated by grooves between; prominent spurs on both sides project upward from alongside junctures of legs to feet (no ankles indicated); figure stands on circular block.

Ethnographic and Historical Data: Collector unknown. The National Museum obtained this figure at an auction at Bethune and Company, Wellington, in 1916 for 9 shillings. It was listed as a figure from New Guinea, no previous owner mentioned.

Publication: Brake, McNeish, and Simmons 1979 (pl. 5).

Photograph: New Zealand Historic Places Trust/Pouhere Taonga (Melanesian Mission collection), by permission.

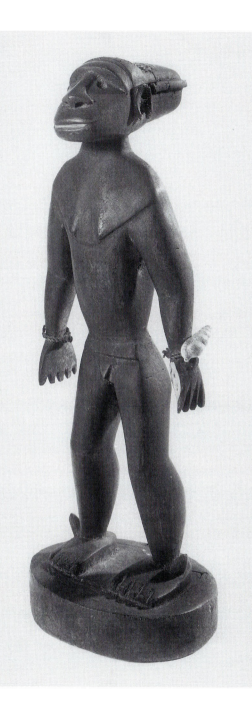

Plate 29

Museum/Collection and Catalogue Number: Auckland Museum, Auckland, New Zealand; 7335.

Type and Style: Standing male, H. 48.0 cm [19"]. Developed style.

Details and Distinctive Features: Head carved with tapered *abe* with no rails for attachment of fringe, no fringe; face and *abe* at near right angle to each other; slender nose, tip damaged; continuous brow ridge, facial features in T composition, chin and mouth merged into squared muzzle; inlaid perforated discs for eyes; short thick neck, collar bone indicated, steeply rounded shoulders; arms hanging straight down, notches indicate elbows, no arm or wrist bands; body squared, no taper to waist; cord belt holding up a blue cloth front flap, possibly a back flap as well; enlarged calves tapering to small ankles; cord ties at knees, but no shell or other ornaments attached; anklets indicated, thick squared feet, toes indicated by vertical grooves between; figure stands on circular base.

Ethnographic and Historical Data: Collected by Captain Bongard, First Mate and later Captain of the Melanesian Mission ship *Southern Cross* in the 1870s to 1890s. Presented to the Auckland Institute and Museum by F. C. Mappin in 1925.

Publication: None.

Photograph: Courtesy of Auckland Museum, C10, 980.

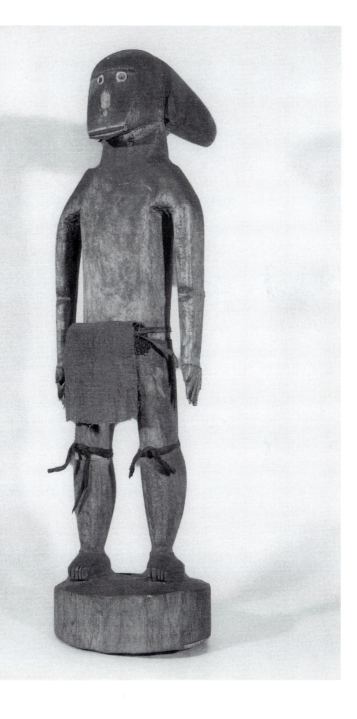

Plate 30

Museum/Collection and Catalogue Number: Auckland Museum, Auckland, New Zealand; 7334.

Type and Style: Standing male, H. 35.0 cm [13¾″]. Developed style.

Details and Distinctive Features: Head carved with truncated *abe* off back of head, fringe attachment rails on sides, no fringe; flat face nearly vertical, thin elongated nose, no pendant; eyes with perforated shell inlays; facial features in T composition; ears flared out, remnant cord hanging from right; mouth and chin shaped into squared muzzle; short neck, angled shoulders, arms in squarish cross section; pectoral features indicated with strong angles; body squared, belly slightly protruding above waist; arms squarish in cross section, elbow indicated by angle; hands reduced to minimal form; checked European cloth as breech clout.

Ethnographic and Historical Data: Collected by Captain Bongard, First Mate and later Captain of the Melanesian Mission ship *Southern Cross* in the 1870s to 1890s. Presented to Auckland Institute and Museum by F. C. Mappin in 1925.

Publication: None.

Photograph: Courtesy of Auckland Museum, C10, 981.

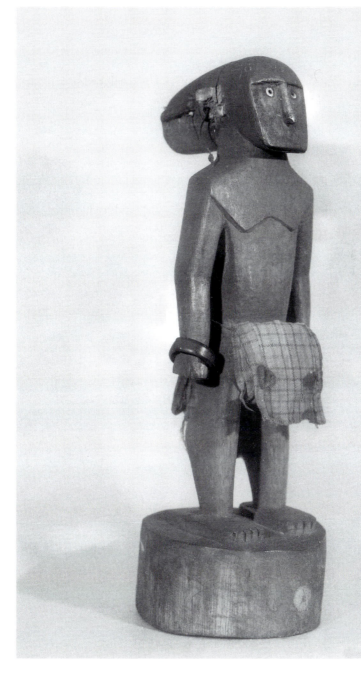

Plate 31

Museum/Collection and Catalogue Number: Auckland Museum, Auckland, New Zealand; 8134.

Type and Style: Standing female, H. 44.0 cm [17¼"]. Developed (but simplified) style.

Details and Distinctive Features: Head carved with raised skull cap, stained black; ears carved in low relief with lobes angled out, ring and pendant ring attached to right ear; face is a flat triangular surface; right eye has button-like addition affixed, left eye small circular depression; thin nose, no pendant; facial features in T composition; chin and mouth merged, tapered, and squared off into muzzle form overhanging neck and upper chest; simple linear motifs inked alongside eyes and on chin possibly to represent tattoos; breasts not fully depicted; arms hanging down, upper arm ring carved in low relief, linear design above it; bracelet indicated by inked band; hands simplified, fingers indicated by grooves between; fringe apron in front; short legs, emphasizing knees, no feet; legs rise out of circular block base.

Ethnographic and Historical Data: Gift of the Maori scholar George Graham in 1925. He had contact with many people who worked in the Pacific islands, including missionaries. The fringe apron is ethnographically incorrect for Nidu. Females always wore short wraparound skirts of bark cloth (*lepau*), latterly of cotton.

Publication: None.

Photograph: Courtesy of Auckland Museum, C10, 98.

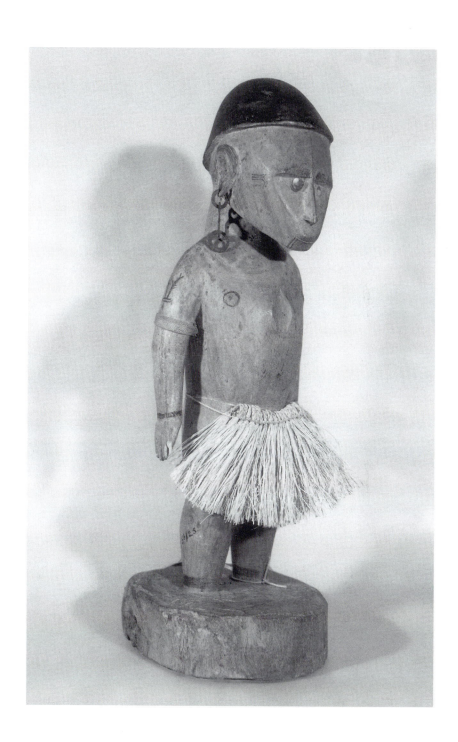

Plate 32

Museum/Collection and Catalogue Number: Southland Museum & Art Gallery, Niho o Te Taniwha, Invercargill, New Zealand; D39.40.
Type and Style: Standing male, H. 42.3 cm [16⅝″]. Developed style.
Details and Distinctive Features: Head carved with singular *abe*, which resembles a pointed skull cap, extending down over back of head, with tuft of fiber fastened to top; skull cap has heavy black line all around lower margin; narrow rectangular nose, inked circles for eyes, features in T composition; painted W bird motifs on temples; fish, porpoise or shark (?) motifs on cheeks; mouth and chin shaped into muzzle; tufts of fiber tied with European string to earlobes, two pieces of turtle shell hang from left lobe; no neck, shoulders rounded; human sketched on left upper arm; double black lines sketched over shoulders and across chest as well as around upper chest, all meeting at chest; breasts indicated; arm bands indicated by double black lines; tufts of fiber tied to wrists; genitals indicated, tufts of orange fibers tied in front of pubic area; buttocks well formed and pronounced; slight flex at knees, and cord around left knee, no pendants or shell ornaments; flat, squared slab feet, toes indicated by notches between; figure stands on circular block.
Ethnographic and Historical Data: James Stewart collection, on loan from before November 1917, acquired in 1926. Stewart was a local man and had no apparent connection with or friends in the Melanesian Mission, but he did obtain one New Hebrides piece from a Reverend Master Stoby(?) (question mark by Stewart or a later curator). Necklaces crossed in front is common for women's festive dress in the eastern Solomons, but I never observed it on Santa Cruz Island; tufted fiber pubic cover is ethnographically incorrect (as on Plate 31).
Publication: None.
Photograph: Southland Museum & Art Gallery, Niho o Te Taniwha, by permission.

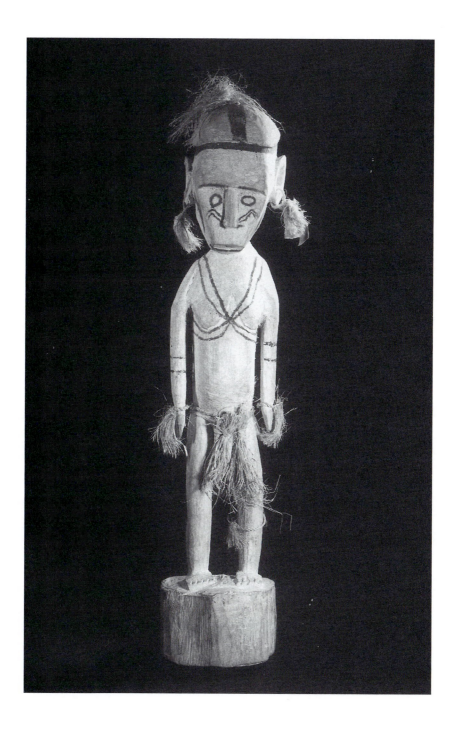

Plate 33

Museum/Collection and Catalogue Number: Melanesian Mission Collection, Auckland Museum, Auckland, New Zealand; 66.
Type and Style: Standing male, H. 68.0 cm [26³/₄″]. Developed style.
Details and Distinctive Features: Head carved with long down-curving *abe* that was broken off and re-secured with cord; perforated ridges along both sides of headdress for attaching fringe, but none remaining on this piece; low-relief band runs from ear to ear, separating *abe* from forehead; concave face, eyes with perforated shell discs, arched eyebrows; long, high-ridged nose with naturalistic nostrils, perforation through nares and septum, but no rings or pendant; very prognathous, chin and lips shaped into pointed muzzle; ears squared, no lobes, lower ear with double perforations, clusters of turtle shell hoops attached by cord; sloping shoulders, arms hanging straight down, no elbows, hands angled out, spurs emerging from backs of hands; snakes carved on upper arms, squid or snake-like image over backbone; trunk tapered to small waist, pectoral features indicated; genitals fully carved; buttocks small but pronounced; upper legs shortened, slight bend in knees; spurs emerging from sides of feet at ankles; feet thick, toes indicated by slits between; entire image smeared with turmeric; figure stands on circular base.
Ethnographic and Historical Data: There is no collection history for this piece; the Melanesian Museum is now under the New Zealand Places Trust. Iconography of animals carved on side of arms and over backbone unknown.
Publication: None.
Photograph: Courtesy of Auckland Museum.

174

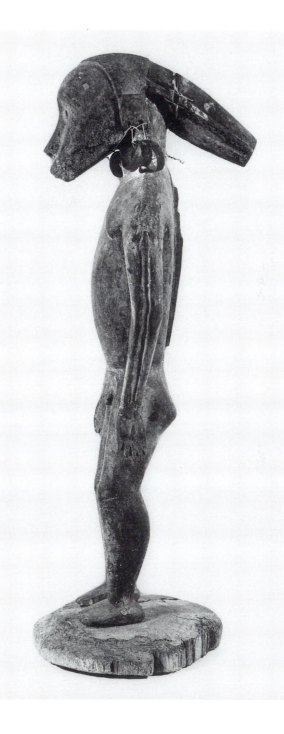

Plate 34

Museum/Collection and Catalogue Number: Australian Museum, Sydney, Australia; E61094.
Type and Style: Standing female, H. 54.0 cm [21¼"]. Unique style.
Details and Distinctive Features: Head round, hair indicated by a raised cap; facial features naturalistic, small ears, inlaid eyes; rounded shoulders with hanging arms, upper arms longer in proportion to lower, elbows indicated by crease; hands small and spread flat at hip height; breasts small with horizontal crease across the chest, slight incurve of torso and body; upper and lower legs in proportion; no female genitals indicated; slight indentation above knees, knees and calves prominent; lower legs taper to base, no feet; thin circular base; no clothes or ornaments; wood dark and polished.
Ethnographic and Historical Data: Purchased from Mr. L. D. Hunter, registered 1/10/1964. The specimen appears more like a contemporary western Solomons piece than a Nendö piece.
Publication: None.
Photograph: By Howard Hughes, Courtesy of the Australian Museum, 1668/1-2m.

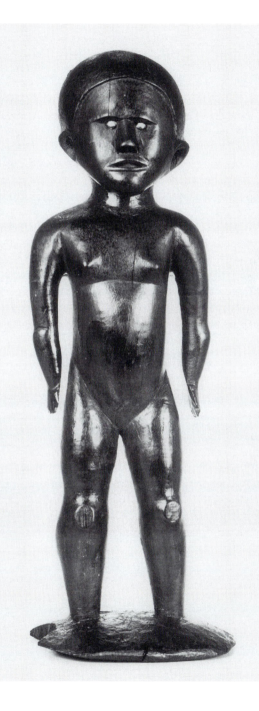

Plate 35

Museum/Collection and Catalogue Number: Australian Museum, Sydney, Australia; E77577.

Type and Style: Standing male, H. 69.0 cm [27¼″]. Developed style.

Details and Distinctive Features: Head carved with *abe*, fiber fringe attached to top; *abe* and face at right angle, hair as low-relief skull cap; face and features in normal relationship; inlaid discs for eyes, no heavy brow ridges; nose long and thin, curved slit for mouth, rounded chin; ears prominent, but no detail, small earrings both sides; cord necklace with strips of bark cloth as pendants; rounded shoulders, arms hanging down, arm bands carved both sides; arms slightly bent at elbows, cord bracelets with fringes at wrists; fingers fully carved on hands; pectorals indicated, incised bird designs right and left; no part of body trunk emphasized or exaggerated; navel indicated; belt of braided fiber holding up front and back aprons of bark cloth which have border patterns the same as necklace pendants; outside the garment is another belt of Job's tears (*Coix lacryma-jobi*); well-formed upper and lower legs, but short with respect to body proportions; knees slightly bent; simple slab feet, grooves indicate toes, spurs emerging from outside of feet; figure stands on thick squared block, low-relief fish images on right and left side surfaces. The wood appears to be harder than most images, shiny but no coloration or application of turmeric.

Ethnographic and Historical Data: The figure was given to the Australian Museum by Mrs. McCleary, who received it in July 1978 as a parting gift when she and her husband left Graciosa Bay. Her husband had worked for the Allardyce Timber Company which had been extracting kauri pine logs. The maker of the image is not known, but it is obvious that the figure is a new one, perhaps created for the occasion. This makes it the most recently carved figure, and what is surprising are the details which put it more or less in the Developed style, but not so heavily sculptural as the older pieces in this style; incorporates such details as full *abe*, skull cap to depict head hair, and spurs.

Publication: Davenport 1990:101 (fig. 9.5).

Photograph: By Adrian Pitman, Courtesy of the Australian Museum.

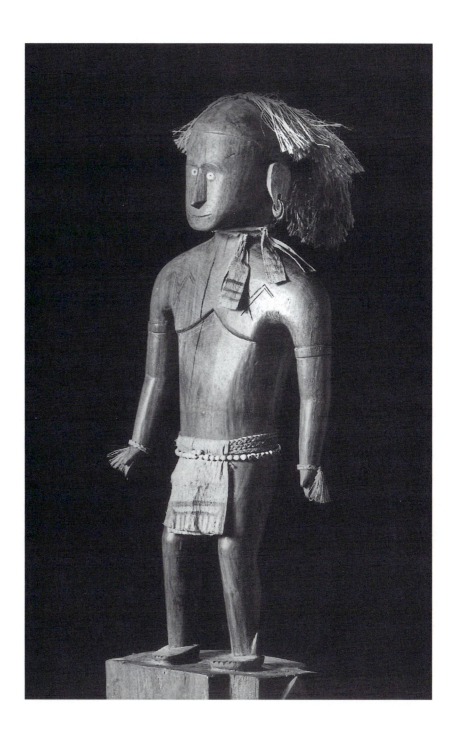

Plate 36

Museum/Collection and Catalogue Number: Solomon Islands National Museum, Honiara, Solomon Islands; 74-739.

Type and Style: Standing male, H. 41.0 cm [16⅛"]. Developed style.

Details and Distinctive Features: Head originally carved with *abe*, now broken off; a transverse ear-to-ear cap in low relief above the forehead; ears extending below head with large perforations, both broken out; head slightly upturned, O-shaped facial area; brow ridges not connected; inlaid eyes, nose pierced straight through, no ornaments or pendant; mouth, jaw, and chin rounded into muzzle; long neck with cord necklace from which a fragment of shell(?) is suspended; top of shoulders flattened, pectoral details strongly carved, slight bulge to stomach; arms hanging straight down, upper and lower arms in proportion to each other; carved ridge at elbows to retain arm bands; remnants of cord tied around neck, mid-arms, waist, and below knees, but no ornaments attached; genitals indicated, buttocks slightly jutting out; upper legs long in proportion to lower; full calves with sharp shins, tapering to flattened feet, no spurs; figure stands on square base with rounded corners; surface covered with turmeric.

Ethnographic and Historical Data: Given to the Solomon Islands National Museum by the Archbishop of Melanesia, catalogued in 1974. No information attached to figure. Possibly transferred from the Melanesian Museum in Auckland. Stylistically, this figure belongs with the Beasley group and others collected by the Reverend George West and Captain Jones. However, it is badly damaged and perhaps for this reason it was not sent on to England or offered to museums in New Zealand; it was turned over to the Bishop, hence became part of the collections of the Melanesian (Mission) Museum.

Publication: None.

Photograph: William Donner. We are grateful to the Solomon Islands National Museum for allowing publication of the photograph of the figure held in its collection.

180

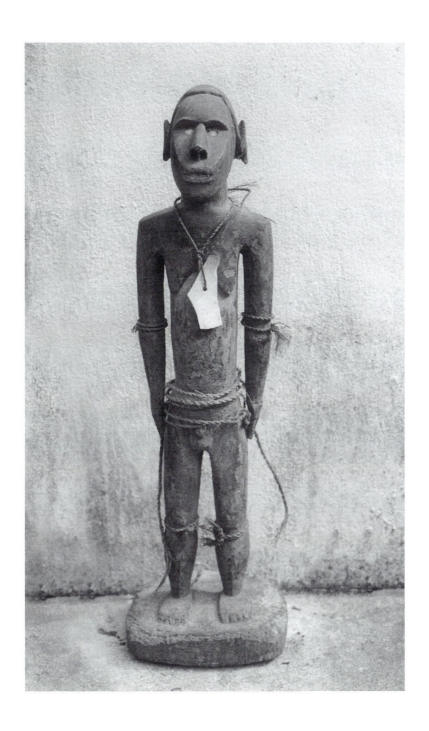

Plate 37

Museum/Collection and Catalogue Number: Field Museum of Natural History, Chicago, Illinois; Anthropology object no. 2616.277219.
Type and Style: Miniature; seated male, H. figure only 6.8 cm [2¾"]. Generalized style; stopper.
Details and Distinctive Features: Figure is seated on disc base, upturned head with pointed *abe,* hands with fingers spread out on circular base; long nose with slightly flared nostrils; chin rounded, slit for mouth, jaw and chin shaped into thin muzzle; wide shoulders, chest, and body forms all rounded; no pectoral features; thick legs stretched straight out, top of upper legs flattened, lower legs tapered to small ankles; knees slightly pointed, feet indicated by circular enlargements. Entire surface very smooth, no paint or stain.
Ethnographic and Historical Data: Fuller collection, no precise collection data. An old label reads "Cork for a lime bottle, Santa Cruz."
Publication: Force and Force 1971 (261).
Photograph: Field Museum negative no. A97550, by permission.

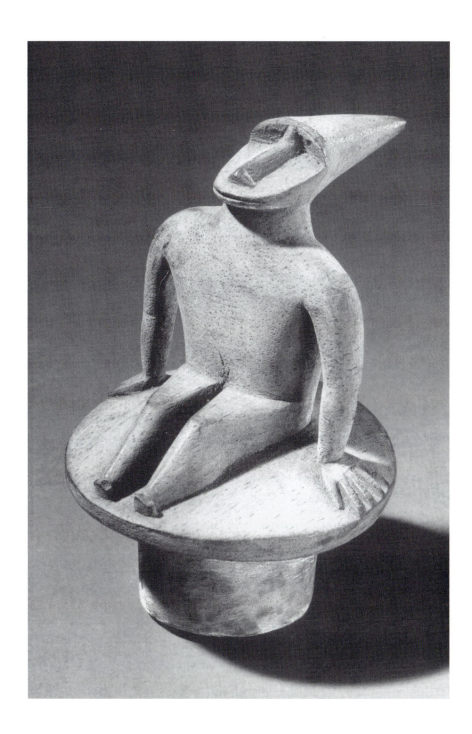

Plate 38

Museum/Collection and Catalogue Number: Bishop Museum, Honolulu, Hawai'i; 6989.

Type and Style: Standing male, H. approx. 30.5 cm [12″]. Developed style.

Details and Distinctive Features: Head carved with *abe*, with perforated bars on sides to which fringes attached, but no fringe; face vertical, headdress horizontal, curved and rounded forehead; long linear nose; mouth, chin, and jaw squared to muzzle; eyes are simple depressions, no inlay; ears without details, no perforation, no rings or pendants; shoulders flattened and slanted downward, arms hanging straight down, no elbows or differentiation of upper from lower arm; hands barely indicated with shallow grooves separating fingers; body slightly quadrangular, belly slightly bulged out; genitals indicated; upper and lower legs differentiated, but no knee shape; calves thick, fiber strand around right ankle, old label tied around left ankle; square slab feet; figure stands on circular base.

Ethnographic and Historical Data: Purchased from Eric Craig, a dealer in Auckland. Probably received by the Bishop Museum in 1894 as part of its early or founding collections. Craig is known to have had contacts with the people associated with the Melanesian Mission, but there is no direct evidence that he obtained this image from any of them.

Publication: None.

Photograph: Bishop Museum 29290a, by permission.

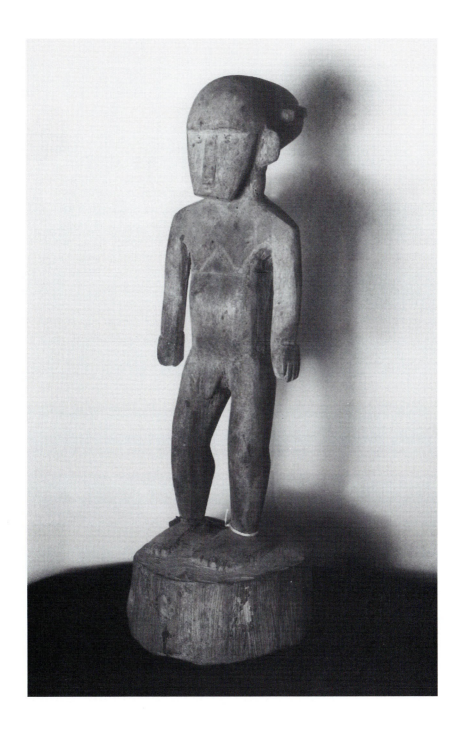

Plate 39

Museum/Collection and Catalogue Number: Bishop Museum, Honolulu, Hawai'i; D3267 (acc. 5613).
Type and Style: Standing female, H. 50.0 cm [19¾"]. Generalized style (crude).
Details and Distinctive Features: Head round, with top knot, no indication of hair or hairline; flat round face, features not in usual T composition because curved brows over eyes are not joined; secondary horizontal brow ridges just over eyes (odd configuration). Circular inlaid eyes, darkened around edges; nose nearly quadrangular in cross section, no flared nostrils, septum pierced but without ornament; rounded chin, but not in muzzle form, no mouth; ears without details, jut out but sculpturally freed from head; short neck; thin, sharply angled shoulders slant down, arms hang free, no indication of elbow joint; hands indicated as stepped blocks, both attached to hips; body circular, tapered to waist, breasts indicated but without details; a fibrous tangle is wrapped around waist, but is unlike the proper female skirt; legs circular in cross section, no knees indicated, tapered to ankles, no feet; figure stands on slightly tapered circular base.
Ethnographic and Historical Data: Carved by Buketu of Noole village on commission from author. Buketu was adopted from Utupua Island, grew up in Noole, and married there. He enjoyed a reputation of being a good canoe maker, culturally conservative, and an indifferent Christian. His comment about this image was that he deliberately did not make it to represent any particular *dukna*, because to do so might have aroused its anger which could be taken out on him. Noole is one of the least well-off communities, located on the rocky south coast with no easy canoe landings. In earlier days this made it difficult for its men to participate in the inter-island trade networks. The village was never directly proselytized by the Melanesian Mission because it was so difficult to get to, but it came over to Christianity voluntarily at the bidding of one of its leaders. Noole was the scene of a violent confrontation with BSIP government representatives and police in the 1920s; in 1958–59 the village had still not been visited by the Bishop or a priest and did not have a teacher/catechist. Image collected by author in 1958–60.
Publication: None.
Photograph: Bishop Museum, by permission.

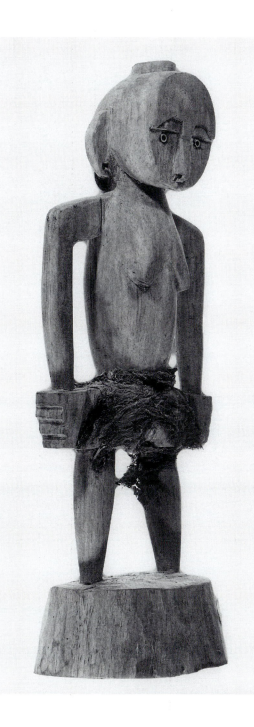

Plate 40

Museum/Collection and Catalogue Number: Bishop Museum, Honolulu, Hawai'i; D3268 (acc. 5613).

Type and Style: Standing male, H. 59.0 cm [23¼″]. Generalized style (crude).

Details and Distinctive Features: Nearly identical to Plate 39, except shoulders are thinner, no chest details, hands as square blocks attached to thighs; rude breech clout of natural coconut cloth.

Ethnographic and Historical Data: Made at the same time as Plate 39 by Buketu of Noole village, Santa Cruz Island. Collected by author in 1958–60.

Publication: None.

Photograph: Bishop Museum, by permission.

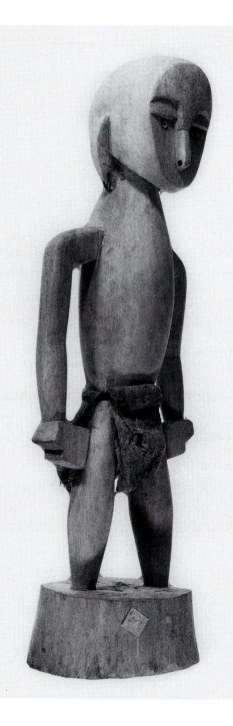

Plate 41

Museum/Collection and Catalogue Number: Bishop Museum, Honolulu, Hawai'i; D3269 (acc. 5613).

Type and Style: Standing male, H. 42.0 cm [16½″]. Generalized style.

Details and Distinctive Features: Head carved with *abe* off back of head; rounded forehead, face flat with bleached cat's eye shells inset for eyes, narrow white highlight around inset; septum pierced, with flat turtle shell pendant; head is truncated just below the nose, no jaw or chin, but still has an etched groove underneath indicating a mouth; ears without details, pierced and with hoop earrings of turtle shell; neck cylindrical and short, shoulders rounded; trunk without pectoral features, but with double dolphin motif painted in white on belly area; arms hang down, no elbows or demarcation of upper from lower arms; groove at wrist, no arm bands or bracelets; hands flattened; waist slightly narrowed, clout of natural coconut bast decorated with linear triangle motifs; legs short in relation to body trunk; no knees indicated, but calf area is delineated from thigh; thick ankle area; feet are thin slabs. Figure stained black all over and stands on circular block.

Ethnographic and Historical Data: Carved by Mekope of Napu village to represent his deity, Menaopo. Mekope was a follower of the traditional religion, but he did not maintain an altar with an image in his dwelling. He and his brother Menaplo carried out their rituals in a men's house (*madai*) that they maintained in Napu. Most of the time Mekope also slept in that *madai*; his wife brought him his food there at mealtimes.

Publication: None.

Photograph: Bishop Museum, by permission.

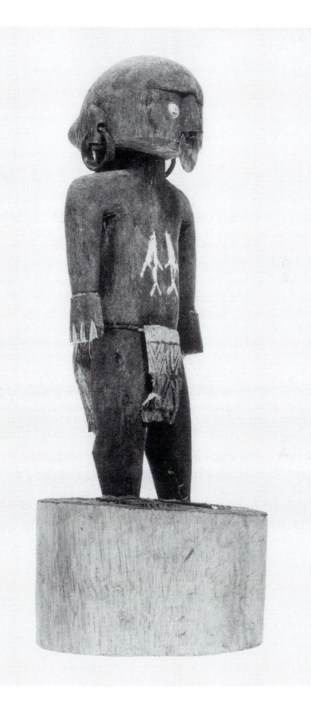

Plate 42

Museum/Collection and Catalogue Number: Staatliche Museen zu Berlin, Ethnologisches Museum, Abteilung Südsee, Berlin; VI-15-990.
Type and Style: Standing male, H. 26.5 cm [10½″]. Generalized style.
Details and Distinctive Features: Head carved with *abe* curving down over back; top of *abe* decorated with black diamond-triangle pattern; long thin nose slightly flared at nostrils, no pendant; eyes circular cavities, no inlay; chin and mouth joined into semi-muzzle, mouth slit underneath; ears project out, no details, no earrings or pendants; short neck, shoulders rounded, arms hanging slightly away from body, no elbows or distinction between upper and lower arms; hands wedge-shaped blocks, fingers as a sawtooth row; body straight, transverse ridge at waist, genitals slightly indicated; legs short in proportion to body trunk, thickest part of legs at knee joint, joint crease at back but no kneecaps indicated; lower legs taper to ankles; thin slab feet. Figure stands on thin circular base.

Linear body markings: double chevron both cheeks, W with central line at right angles on temples, curved fish motif over ears and along back of head; two parallel lines indicate arm bands but with Y above; parallel lines on back of hands; double fish motifs on chest and belly as well as on back—these motifs placed over parallel horizontal lines; parallel vertical lines around lower legs to indicate lower leg ornaments.

Ethnographic and Historical Data: This specimen was collected by Wilhelm Joest in 1897 at Lue Sialemba. It is nearly identical to two others, Plates 43 and 44. These three and the Lister Kaye figure, Plate 23, deserve special mention because they are the bases for establishing a Generalized style type that stands in contrast with the Developed type.
Publication: Graebner 1909 (fig. 63); Koch 1971 (Abb. 142); Davenport 1990:99 (fig 9.2).
Photograph: Staatliche Museen zu Berlin, Ethnologisches Museum, Abteilung Südsee, Berlin, by permission.

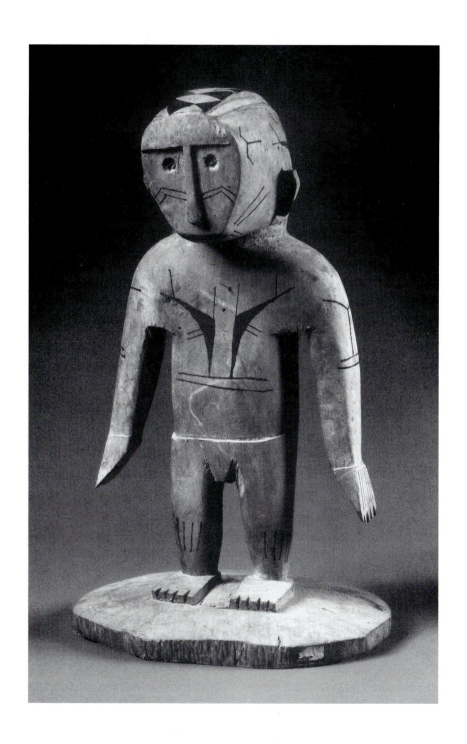

Plate 43

Museum/Collection and Catalogue Number: Rautenstrauch-Joest-Museum für Völkerkunde, Cologne; 4004.

Type and Style: Standing male, H. 27.5 cm [10⅞"]. Generalized style.

Details and Distinctive Features: One of three very similar figures collected by W. Joest at Lue Sialemba in 1897. Same description applies as that for Plate 42, except 1.0 cm taller; has one perforated disc inset for left eye; very slight differences in some of the applied details on face, side of head, stomach, back, and upper arms.

Ethnographic and Historical Data: One of three similar pieces that Joest collected.

Publication: Stöhr 1971.

Photograph: Rautenstrauch-Joest-Museum, by permission.

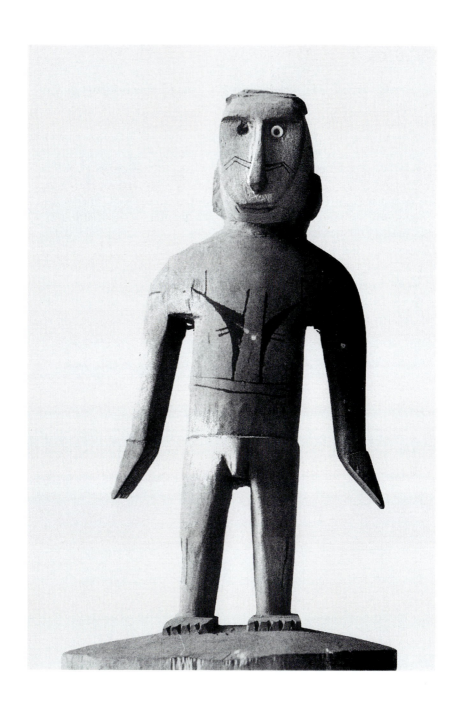

Plate 44

Museum/Collection and Catalogue Number: Linden-Museum Stuttgart (Staatliches Museum für Völkerkunde); 3443.
Type and Style: Standing male, H. 34.5 cm [13⁵⁄₈″]. Generalized style.
Details and Distinctive Features: Differs from Plate 42 in height, somewhat longer face, with less muzzle-like chin; perforated shell inlays in both eyes.
Ethnographic and Historical Data: Came to the Linden-Museum in 1898 or 1899 as gift of the Kommerzienrat Rautenstrauch which with Joest were the founders of the Rautenstrauch-Joest firm in Cologne and the Völkerkunde-Museum in Cologne which bear their names.
Publication: Schmitz 1971 (pl. 227).
Photograph: Ursula Didoni, Linden-Museum, by permission.

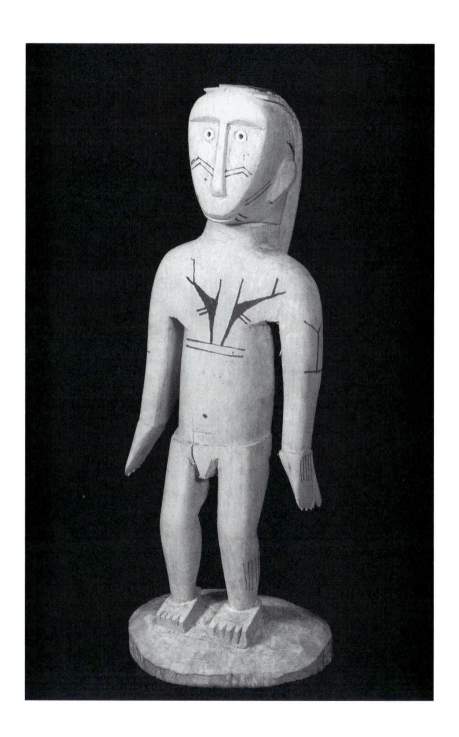

Plate 45

Museum/Collection and Catalogue Number: Musée Barbier-Mueller, Geneva; 4580.

Type and Style: Miniature; standing male, H. 14.0 cm [5½″]. Developed style.

Details and Distinctive Features: Head carved with *abe* that does not emerge from back of the head, but is attached on top of head and curves downward and over back; flanges alongside of *abe* to attach fiber decoration, but no fiber present; prominent ears set away from head, large perforations for earrings, with turtle shell pendant that resembles a nose ornament on left only; face somewhat concave with features in conventional T composition; bridge of nose elongated and nostrils greatly flared with perforations through nares; mouth and chin form a rounded muzzle, slit for mouth; perforated shell discs inlaid for eyes; square neck, flat sloping shoulders; body squarish in cross section, breasts emphasized as if it were female, belly bulges outward, then slants back to narrow waist; arms hanging down, full demarcation between upper and lower arms, forearms thickened midway; hands with large fingers fanned out; short reinforcing bar connects inner wrists to waist; full genital details; slight bend at knees, rounded kneecaps; thick calves tapering to top of feet, no ankles indicated; thin slab feet; no body ornaments or clothing; no turmeric; figure stands on circular base.

Ethnographic and Historical Data: It is possible that this miniature figure was once part of the Beasley collection, as Mrs. Beasely did transfer some pieces to J. J. Klejman, obtained by Raymond Wielgus from Klejman, sold by Wielgus to a "dealer friend" in the 1960s, acquired by Barbier-Mueller in 1974.

Publication: Waite 1983 (139); Davenport 1985.

Photograph: P. A. Ferrazzini, Musée Barbier-Mueller, Geneva, by permission.

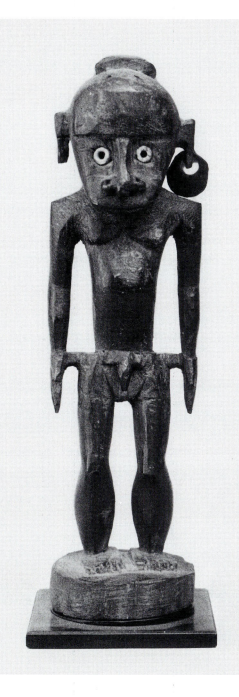

Plate 46

Museum/Collection and Catalogue Number: Musée du Quai Branly, Paris; 71.1969.51.25.

Type and Style: Miniature; seated male, H. 17.5 cm [6 ⅞"]; H. figure only 10.2 cm [4"]. Developed style.

Details and Distinctive Features: Elongated head originally with *abe* (broken off behind head); edge of *abe* across forehead; overhanging brows, oval eye sockets, no eye inlays; wedge-shaped nose, tip damaged above transverse piercing, nostrils missing; very prognathous, thick parted lips; chin overhanging upper chest; oval ears with some details, pierced lobes now broken out, no earrings; shoulders flattened all around neck, upper arms angled outward, with carved arm band; lower arms angled in, hands on thighs; body not tapered, belly tucked in at waist; large penis; thick thighs, small knees, shortened lower legs with carved anklets; small slab feet resting on disc platform (left side broken off); figure seated on solid rectangular bench. Entire surface encrusted with soot.

Ethnographic and Historical Data: Collected by Ch. van den Broek in 1935 at Nibelowi (Nababloui) on the south coast of Santa Cruz Island, during the visit of the yacht *La Corrigane* which had anchored in Nea Bay.

Publication: Valéry 1938 (fig. 4); van den Broek 1939; Girard 1971 (fig. 1).

Photograph: Musée du Quai Branly, © Musée de l'Homme, Paris, by permission.

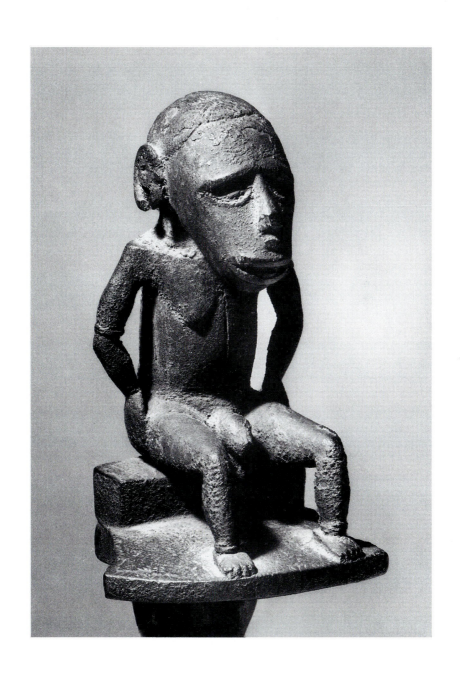

Plate 47

Museum/Collection and Catalogue Number: Museum der Kulturen Basel, Basel, Switzerland; Vb 1911.

Type and Style: Standing male, H. 51.0 cm [20⅛″]. Generalized style.

Details and Distinctive Features: Standing male figure, no *abe,* but top of head half black, half white (representing a formal hairstyle comparable to wearing an *abe* and used by *nela* choristers); eyes, eyebrows, ridge of nose lined in black; images painted on forehead, cheeks, chin, temple, left upper arm, chest; body bulges front and side, waist not narrowed; short pyramidal neck with flat shelf at its base for shoulders and collar region; arms hanging down with no clear differentiation between upper and lower limbs, very small wrists, right hand reduced to a knob, left hand missing; penis prominent but without other genital details, buttocks do not protrude behind back; grooved backbone; upper legs taper to knee, small calves on lower legs, no feet indicated; figure stands on circular block. Altogether, a poor carving.

Ethnographic and Historical Data: Collected by Felix Speiser in 1916, but no village attribution. Most likely it was one of the Temotu Islet villages with which he seemed to have been most familiar. His excellent field sketch has the note "model eines Haus-gottes." "The so-called spirit houses seem to be limited to Tumotu [*sic* Temotu] and the Reef Islands [Speiser refers here to the *madukna* of Santa Cruz Island and possibly the *fale atua* of the Outer Reef Islands; see Davenport 1972]. In a few of the men's houses [*madai*], in small niches on the wall, I saw wooden statuettes (only one in each case) similar to [the present plate] which were regarded as sacred and which even I was not permitted to touch. [Plate 47] is undoubtedly an imitation of such a statuette (or else the specimen had not yet been sanctified by any kind of ceremony)" (Speiser 1916:205; my translation).

Publication: Speiser 1916 (Abb. 50); Buhler and Kaufmann 1980 (pl. 229).

Photograph: Peter Horner, Archive Museum der Kulturen, by permission.

202

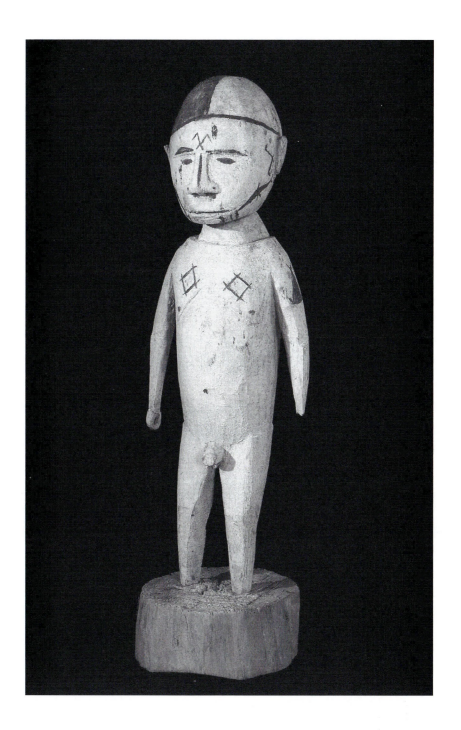

Plate 48

Museum/Collection and Catalogue Number: Raymond J. Wielgus Collection; RW 58-100.

Type and Style: Standing male, H. 35.0 cm [13¾"]. Developed style.

Details and Distinctive Features: Head carved with *abe*, but surface not continuous from forehead to top of headdress; hairline indicated on forehead; *abe* form comes off the back of the head at an angle, perforated strip both sides for attachment of fringe, but no fiber attachments; ears slanted away from side of head, no details, large perforations through lower part, with turtle shell pendants; face flat and upturned to about right angle to plane of *abe*; transverse eyebrow ridge, shell inlay eyes, star pattern drawn around them; long nose, septum pierced, flat turtle shell ornament attached; squared cheeks and chin formed into muzzle, mouth slit across front of muzzle; squarish neck and fully shaped shoulders, arms hanging down; upper arms longer than lower, groove or ridge at elbow joint, no arm ornaments; forearms taper to wrists, small hands without details; body trunk not tapered, no stomach bulge, fiber cord around waist, genitals indicated, but no breech clout; lower legs greatly shortened, but with well-formed calves, grooves at knees, cords around knees, but no attached ornaments; squared slabs for feet. Figure standing on circular block, turmeric on body surface.

Ethnographic and Historical Data: Raymond Wielgus purchased this figure from J. J. Klejman of New York City in 1958. It was his understanding that Klejman had obtained it directly from Mrs. Beasley in England. Stylistically it fits with most of the others in the Beasley collection, and so it is very likely to have come through Captain Fred Jones and was likely to have been collected by someone associated with the Melanesian Mission from Neo village, Temotu Islet.

Publications: Museum of Primitive Art 1960 (pl. 21); Arts Club of Chicago 1966; Schmitz 1971 (pl. 228); Pelrine 1996:112 (no. 46).

Photograph: R. Wielgus 58-100B, by permission.

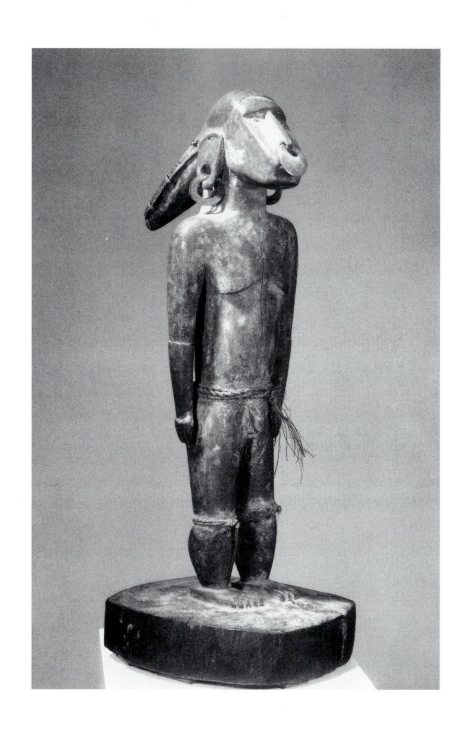

Plate 49

Museum/Collection and Catalogue Number: Martin Wright and Faith Dorian-Wright, New York City; no number.

Type and Style: Standing male, H. 40.5 cm [16″]. Developed style.

Details and Distinctive Features: Head with *abe*, axis of headdress horizontal, no down curve; axis of *abe* nearly at right angle to plane of face; no perforated strips for the attachment of fiber ornamentation; brow ridge not continuous across forehead; nearly oval face, cheeks flat, broad nose, no ornaments; eyes represented by depressions, no inlay; chin and mouth merged into curved muzzle, but not jutting forward; ears close to head, no ornaments; head rests directly on flattened, squared shoulders; arms hanging straight down, indentation inside elbows, forearms shortened in relation to upper arms; hands simplified into triangular forms, shallow grooves to indicate fingers; slim torso, rounded quadrangle in cross section; pinched waist, genitals indicated but without details; knobs at knees, calves thicker than thighs; feet and front portion of circular base disintegrated; entire surface black and polished; no clothing or adornment.

Ethnographic and Historical Data: Ex-Museum of Primitive Art, Metropolitan Museum of Art; auctioned by Sotheby–Parke Bernet to J. J. Klejman May 31, 1967; purchased by M. Wright and F. Dorian-Wright shortly after. Possibly part of Beasley collection.

Publication: Guiart 1963 (pls. 412, 414).

Photograph: Martin Wright and Faith Dorian-Wright.

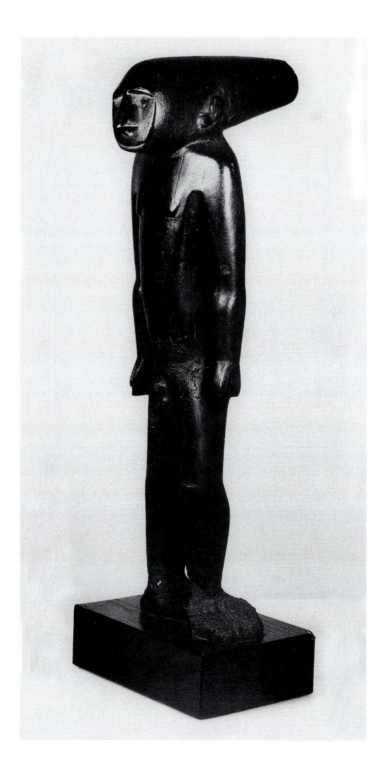

Plate 50

Museum/Collection and Catalogue Number: Martin Wright and Faith Dorian-Wright, New York City; no number.

Type and Style: Miniature; standing male, H. 9.0 cm [3½″]. Developed style.

Details and Distinctive Features: Head and *abe* form continuous arc, head-dress with perforated strips alongside for attaching fringe, but none remaining; brow ridge straight across, notch at nose; holes for eyes, no inlays; singular teardrop nose, perforated septum, no ornament; face flat, with rounded chin and mouth shaped into muzzle, but less prognathous than some; short neck, sloping shoulders, a semicircular form representing the chest area; arms hanging down, indentation on inside of elbows; slight taper to body, outcurving belly; hips project outside waist; genitals indicated, no breech clout; slightly bent knees, well-shaped thighs and calves, no feet; figure on circular base. Strings of trade beads around neck, wrists, ankles; shell tied to right ankle.

Ethnographic and Historical Data: Ex-Beasley collection, Cranmore Museum; obtained by J. J. Klejman of New York, purchased by M. Wright and F. Dorian-Wright in December 1966. The *abe* and round base render this miniature figure the only one that appears to be a scaled-down version of a larger piece.

Publication: None.

Photograph: Martin Wright and Faith Dorian-Wright.

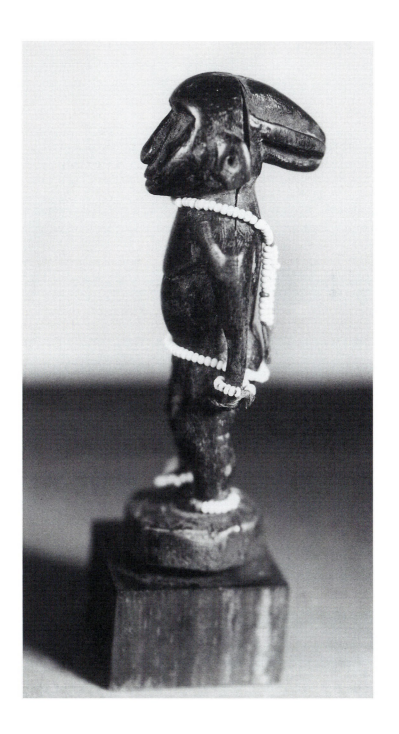

Plate 51

Museum/Collection and Catalogue Number: Wayne Heathcote, New York City; no number. Subsequently offered at auction by Christie's, London, June 28, 1988, lot 144; purchaser unknown.

Type and Style: Standing male, H. 31.0 cm [12¼″]. Developed style.

Details and Distinctive Features: Head carved with *abe,* face slightly upturned making a smooth transition to headdress, which is on horizontal axis; brow ridge straight across head; thin nose flared at nostrils, buttonlike eyes, no inlay; cheeks and chin brought together into muzzle, slit mouth slightly under face; short neck, thick rounded shoulders, arms hanging down; no indication of elbows or joint between upper and lower arms; shortened hands thicker than lower arms, grooves between fingers; body slightly tapered to waist, pectorals lightly indicated, no protruding belly; genitals indicated, protruding buttocks; slight bend at knee, calves curving and narrowing to slab feet, no ankles indicated; notched toes; figure standing on circular block; entire figure covered with turmeric, no other decorations or adornments.

Ethnographic and Historical Data: Collected by Roger Lefevre, tribal art dealer of Brussels, on Santa Cruz Island, September 1986, "in the first village of Graciosa Bay. Its later owner (unknown name) received it from one of his parents from Temotu Islet." Lefevre is probably using the landing strip as his reference point. The first village from there is an aggregated group of buildings, including the local council meeting house, jail, dispensary and hospital, post office, cooperative store, and a government guest house and other administrative buildings. The narrow strait that separates Temotu Islet from the main island of Santa Cruz is nearby. All the local people who are in one way or another connected with these administrative activities have built secondary dwellings nearby. There is no official name for this center, but locally it is in the general area of Luova. By 1974, it was being called both that and "steison," Pidgin English for "station." Lefevre collected other artifacts while he was in the area, and he also collected in the eastern Solomons, where he was associated in some way with the collector Pierre Langlois.

Lefevre offered the artifact for sale through Christie's, London; no purchaser. Subsequently, Heathcote purchased the specimen directly from Lefevre.

Publication: Christie's 1988 (lot 144).

Photograph: University of Pennsylvania Museum, Philadelphia, by permission.

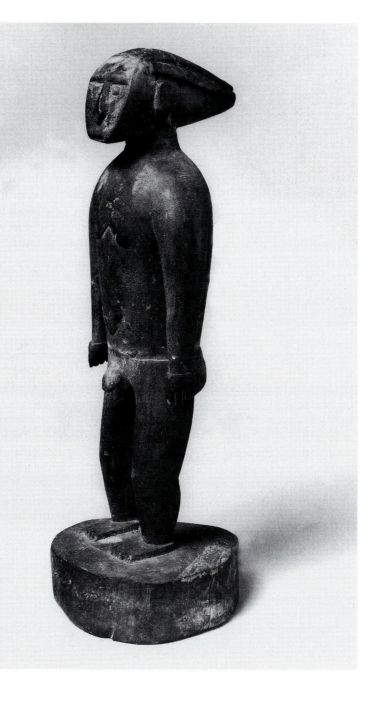

Plate 52

Museum/Collection and Catalogue Number: Mr. and Mrs. Jerome L. Liebowitz, Fort Lee, New Jersey; no number.

Type and Style: Miniature; standing male, H. 13.2 cm [5¼″]. Generalized style.

Details and Distinctive Features: Spherical head, no *abe;* depressions for eyes with no inlays; thin nose, no septum perforation; ears jutting out from head, no details, double earrings on left ear; cord around neck to which is attached a fingernail; rounded shoulders, arms thickened at elbows, hanging down; simplified hands, no fingers; small shell tied to right wrist; woven fabric as breech clout; shortened upper legs with respect to lower, no feet; anklets of small perforated discs; figure stands on square block; brown hard wood, traces of turmeric all over it.

Ethnographic and Historical Data: This figure seized by Deacon Clement Daagi of the Melanesian Mission in Nea village (south coast) in 1958; Daagi gave it to me in 1959 to pass on to Bishop Hill when I next visited the island. Bishop Hill declined to receive it, leaving its disposition up to me. Transferred to the William McCartney–Cooper collection in 1990; sold by Christie's New York on May 19, 1992, to Mr. and Mrs. Jerome L. Liebowitz.

As reported by Daagi, the figure is a representation of a *leimuba,* a class of small supernatural beings who leave charms to fortunate men, whom they then momentarily favor; these charms, if used correctly, will bring wealth to the owner. Miniature objects said to be manufactured by a *leimuba,* such as mortars for mixing the stimulant betel and dibbles for planting taro, are held by persons as charms. This miniature figure can be classified as a charm, for it was probably never set up on a regular altar for veneration. Rather, it would have been kept hidden, its existence kept secret until the owner wished to use it or speak to it, hoping to attract the attention of a *leimuba* who might make him a present of feather currency. The significance of the fingernail attached to the neck, as if it were a breast ornament, is not clear: it probably came from a corpse who was a relative of the owner of the charm (but that presumes the owner of the charm-figure had something to do with the fabrication of the image). Santa Cruz men deny that male carvers ever made images of the *leimuba;* all tokens received from *leimuba* are believed to have been fabricated by them.

Publications: Davenport 1975 (46); Davenport 1990:100 (fig. 9.4); Christie's [New York] 1992 (lot 27).

Photograph: W. H. Davenport.

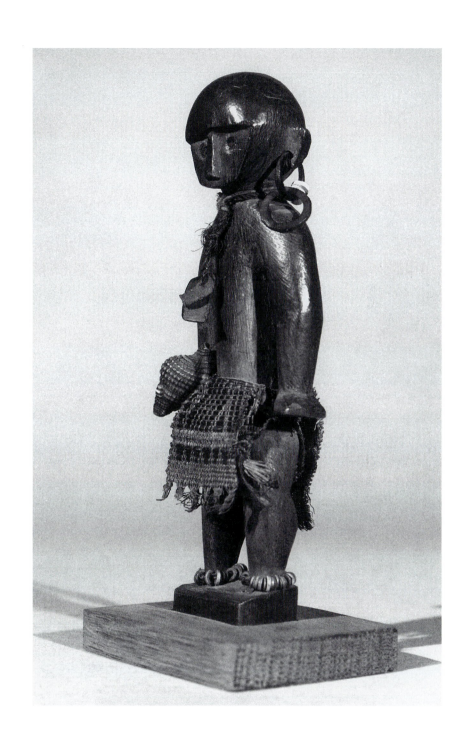

Plate 53

Museum/Collection and Catalogue Number: Allen Frumkin, New York City; no number.

Type and Style: Miniature; standing male on stopper, H. overall 16.5 cm [6½"]; H. figure only 10.1 cm [4"]. Developed style.

Details and Distinctive Features: Male figure with *abe*; upturned face, cone-shaped *abe* is, no place to attach fringes; bottom rim of *abe* indicated; hair is indicated by raised area between forehead and *abe*; continuous brow ridge; simple holes for eyes, no inlays; mouth and chin form rounded muzzle, slit mouth; long nose, well-formed nares and nostrils; simple square ears, no nose or ear ornaments; thick neck with necklace of thick perforated shell discs and large diamond-shaped pendant; well-shaped shoulders, arms hanging down, fingers extended; arm band indicated just above elbows, with strands of fiber; fiber strands also at wrists (fiber strands might have been to tie on fresh leaf decorations); incurved waist with belt of round trade beads; shortened legs, upper leg longer than lower; knobs for knees, thick calves, no carved ankles but a cord with shell ornament at ankle height, probably a knee ornament slipped down; square slab feet, toes indicated by grooves between; figure standing on slightly convex disc; check in disc on left side has been repaired with a cord lashing; disc rests on top of a petalled form; long stopper below. Figure is covered with turmeric; Beasley no. 2885 readable.

Ethnographic and Historical Data: Beasley collection; acquired by Frumkin from Mrs. Beasley.

Publication: None.

Photograph: Adam Reich, Inc., New York.

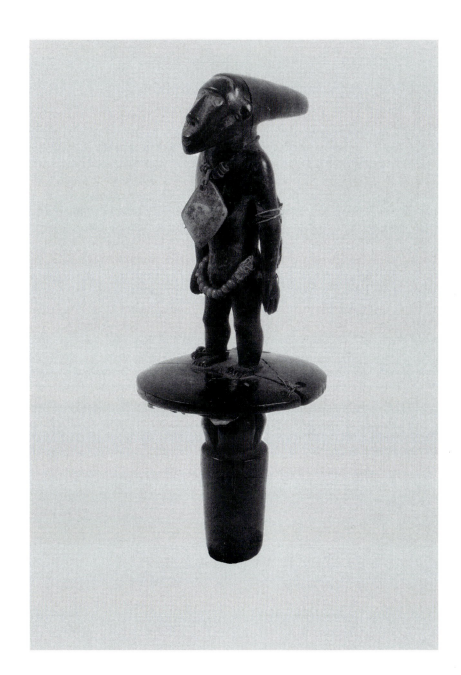

Plate 54

Museum/Collection and Catalogue Number: National Museum of Denmark, Ethnographic Collection, Copenhagen; I.3349.

Type and Style: Standing male, H. 39.0 cm [15½"]; figure only 37.0 cm [14½"]. Developed style.

Details and Distinctive Features: Head carved with down-curving *abe* with rail for attaching fringe, but no fibers remaining; face with continuous brow ridge, features in T composition, mouth and chin fused into muzzle; elongated nose flared at nostrils, no septum showing, no nose ornament; oval eyes, no inlays, pupils indicated; ears carved in detail, pierced lobes, but no earrings; brownish red pigment on head; rounded shoulders, columnar neck; thin upper and lower arms, very slight bend at elbows; left hand broken off at wrist; right hand holding an artifact with round shaft and slightly larger tubular head probably attached to circular base, now decayed; body trunk tapered to waist with groove to hold up belt; large shark or fish carved head up on chest, muzzle of face overlapping nose of fish; no belt or breech clout; male genitalia, pubic area accentuated; buttocks stand out; upper and lower legs of equal length, knees not flexed; left foot and left half of base rotted away; no knee or ankle ornaments.

Ethnographic and Historical Data: Collected by Axel Bojsen-Mollar on his Monsoon Expedition of 1933–35. Object actually purchased on Vanikoro Island but recorded as originating from Nitendi (Nendö). Received by the National Museum of Denmark in 1934.

Publication: None.

Photograph: The National Museum of Denmark, Department of Ethnography, photographer: Jesper Weng; by permission.

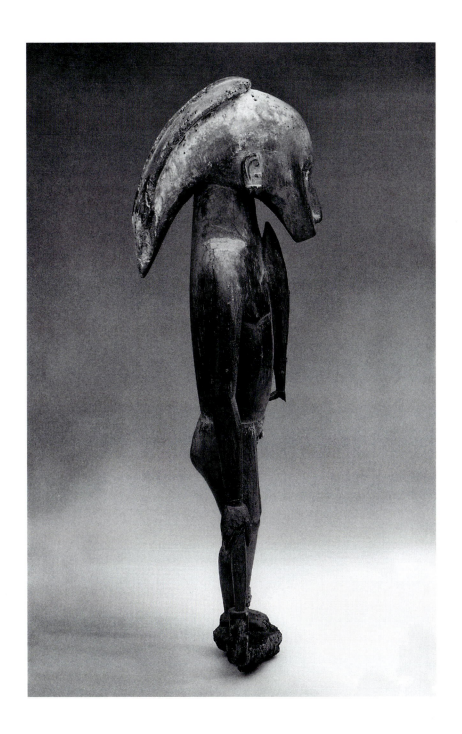

Plate 55

Museum/Collection and Catalogue Number: National Museum of Denmark, Copenhagen; I.3350.

Type and Style: Standing male, H. 24.2 cm [9½"]; H. figure only 21.0 cm [8¼"]. Developed style.

Details and Distinctive Features: Head carved with strongly curved *abe* overhanging back of image; perforated fringe rail, but no trace of fiber; slit mouth fused with chin into muzzle overhanging chest; strong browline, features in T composition; circular eyes, no inlay but dots for pupils; elongated nose, slightly flared nostrils, both pierced, but no ornament; ears carved in detail and standing off from side of head, right lobe piercing broken out, no earrings; pectoral muscles strongly carved, trunk tapered to waist; heavy cord for belt, bast fiber for breech clout; arms hanging down slightly away from hips; both hands holding supporting brace attached to circular base; slight bend at knees; flexed knees, body trunk, and buttocks not in line with lower legs; feet planted on circular base, minimally carved feet and toes. Necklace of animal teeth, species not known; no ethnographic specimen known of this sort of tooth necklace. Traces of yellow/orange pigment all over the figure.

Ethnographic and Historical Data: Collected by Axel Bojsen-Mollar on his Monsoon Expedition of 1933–35. Object actually purchased on Vanikoro Island but recorded as originating from Nendö. Received by the National Museum of Denmark in 1934.

Publication: None.

Photograph: The National Museum of Denmark, Department of Ethnography, photographer: Jesper Weng; by permission.

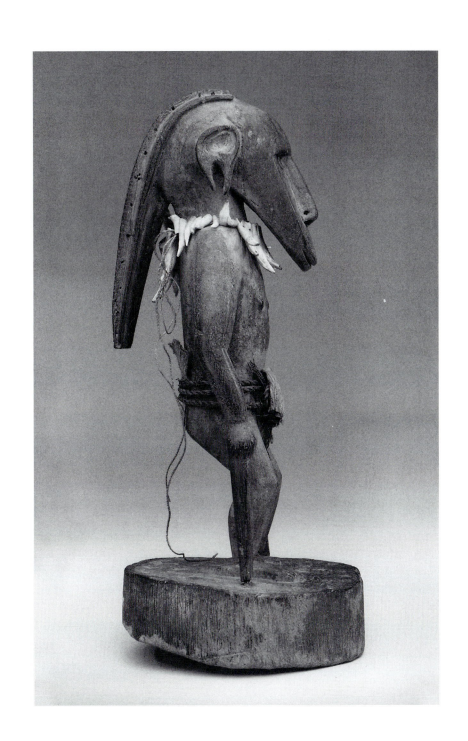

References

Armstrong, E. S. 1900. *The History of the Melanesian Mission*. London: Isbister.

Anson, Dimitri 1995. A Brief History of the Pacific Collections at the Otago Museum, Dunedin, New Zealand. *Pacific Arts* 11/12:49.

Arts Club of Chicago 1966. *The Raymond and Laura Wielgus Collection* (exhibition catalogue). Chicago: The Arts Club of Chicago.

Baessler, Arthur 1900. Wilhelm Joest's Letze Weltfahrt. *Neue Sudsee-Bilder*. Berlin: Georg Reimer.

Beasley, H. G. 1939. Tamar of Santa Cruz. *Ethnologica Cranmorensis* 4:27–30.

Brake, B., J. McNeish, and D. Simmons 1979. *Art of the Pacific*. New York: Harry N. Abrams.

Buck, Peter H. (Te Rangi Hiroa) 1953. *Explorers of the Pacific*. Honolulu, HI: Bernice P. Bishop Museum.

Buhler, Alfred, and Christian Kaufmann 1980. *Ozeanische Kunst*. Basel: Kunstmuseum.

Christie's 1988. *Tribal Art*. Tuesday, 28 June. London: Christie's.

———— 1992. *Important Tribal Art and Antiquities from the Collection of William A McCarty-Cooper*. Tuesday, May 19. New York: Christie's.

Coombe, Florence 1911. *Islands of Enchantment. Many-Sided Melanesia*. London: Macmillan.

Cranstone, B. A. L. 1961. *Melanesia: A Short Ethnography*. London: British Museum.

Davenport, William 1962a. Red-feather Money. *Scientific American* 206(3): 94–104.

———— 1962b. Comments to Arthur Capell, "Oceanic Linguistics Today." *Current Anthropology* 3(4): 400–402.

———— 1964a. Social Structure of Santa Cruz Island. In *Explorations in Cultural Anthropology*, ed. W. H. Goodenough, pp. 57–93. New York: McGraw-Hill.

———— 1964b. Notes on Santa Cruz Voyaging. *Journal of the Polynesian Society* 73:134–42.

———— 1965. Sexual Patterns and Their Regulation in a Society of the Southwest Pacific. In *Sex and Behavior*, ed. F. Beach, pp. 164–207. New York: Wiley.

———— 1968. Sculpture of the Eastern Solomons. *Expedition* 10(2): 4–25.

———— 1969. Social Organization Notes on the Northern Santa Cruz Islands: The Main Reef Islands. *Baessler-Archiv*, n.f., Band 17:151–243. Berlin: Baessler Institute.

———— 1970. Two Social Movements in the British Solomons that Failed and Their Political Consequences. In *The Politics of Melanesia*, ed. M. W. Ward, pp. 162–72. Fourth Waigani Seminar, Port Moresby, May 9-15. Canberra: Australian National University, Research School of Pacific Studies.

———— 1972. Social Organization Notes on the Northern Santa Cruz Islands: The Outer Reef Islands. *Baessler-Archiv*, n.f., Band 20:11–95. Berlin: Baessler Institute.

———— 1975. Lyric Verse and Ritual in the Santa Cruz Islands. *Expedition* 18(1): 39–47.

———— 1981. Male Initiation in Aoriki. *Expedition* 23(2): 4–19.

———— 1985. A Miniature Figure from Santa Cruz Island. *Bulletin* 28. Geneva: Musée Barbier-Mueller.

———— 1989. *Taemfaet:* Experiences and Reactions of Santa Cruz Islanders during the Battle for Guadalcanal. In *The Pacific Theater: Island Representations of World War II*, ed. Geoffrey M. White and Lamont Lindstrom, pp. 257–78. Honolulu: University of Hawai'i Press.

———— 1990. The Figurative Sculpture of Santa Cruz Island. In *Art and Identity in Oceania*, ed. Allan Hanson and Louise Hanson, pp. 98–110. Honolulu: University of Hawai'i Press.

———— 1996. Money. In *The Encyclopedia of Cultural Anthropology*. Vol. 3, M–R, ed. David Levinson and Melvin Ember, pp. 805–808. New York: Henry Holt.

———— 1998. Strophics and Society in the Santa Cruz Islands. In *The Garland Encyclopedia of World Music: Australia and the Pacific Islands*, ed. Adrienne L. Kaeppler and J. W. Love, pp. 332–5. New York: Garland.

———— 1999. Vengeful Spirits and Guardian Deities: Myth and Sculpture

in the Eastern Solomon Islands. *Expedition* 41(1): 7–16.

Edge-Partington, James 1890–1898. An *Album of the Weapons, Tools, Ornaments, Articles of Dress, etc. of the Natives of the Pacific Islands*, Part One. 3 vols. Manchester: Issued for Private Circulation.

Festetics van Tolna, Rudolf 1903. *Chez les Cannibales*. Paris: Plon-Nourrit.

Force, Roland W., and Maryanne Force 1971. *The Fuller Collection of Pacific Artifacts*. New York: Praeger.

Fraser, Douglas 1962. *The Many Faces of Primitive Art*. Englewood Cliffs, NJ: Prentice Hall.

Gillett, Joyce 1939. 'Dukas' of Santa-Cruz. *Man* 39:152–54, pl. K.

Girard, Françoise 1971. Statuette du Dieu Requin de Santa-Cruz. *Objets et Monde: La Revue du Musée de l'Homme* 11(3): 273–80.

Goodenough, Commodore James Graham 1876. *The Journal of Commodore Goodenough...Edited with a Memoir by His Widow (Victoria H. Goodenough)*. London: S. King.

Graebner, F. 1909. Völkerkunde der Santa-Cruz Inseln. *Ethnologica* 1:71–184.

Guiart, J. 1963. *Arts of the South Pacific*, trans. A. Christie. London: Thames and Hudson.

Jennings, John 1899. Notes on the Exhibition of an Ethnological Collection from Santa Cruz and New Hebrides. *Journal of the Royal Anthropological Institute* 28:164–5.

Kaeppler, Adrienne L., Christian Kaufmann, Douglas Newton 1993. *Oceanic Art*, trans. N. Scott and S. Bouladon, with F. Leibrick. New York: Harry N. Abrams.

Koch, Gerd 1971. *Materielle Kultur der Santa Cruz-Inseln*. Berlin: Museum für Völkerkunde.

Meyer, Anthony J. P. 1996. *Oceanic Art*. Edison, NJ: Knickerbocker Press.

Museum of Primitive Art 1960. *The Raymond Wielgus Collection*. New York: Museum of Primitive Art.

Newton, Douglas, ed. 1999. *Arts of the South Seas: Island Southeast Asia, Melanesia, Polynesia, Micronesia. The Collections of the Musée Barbier-Mueller*. Munich: Prestel.

Pelrine, Diane M. 1996. *Affinities of Form: Arts of Africa, Oceania, and the Americas from the Raymond and Laura Wielgus Collection*. Munich: Prestel.

Quiros, Pedro Fernandez de 1904. *The Voyages of Pedro Fernando de Quiros*, trans. Sir Clemens Markham, pp. 1–2. London: Hakluyt Society.

Rhys, Richard, and K. Roga 2004. Borava: Landtitu Deeds in Fossil Shell from the Western Solomon Islands. *Tuhinga* 15:17–26.

Rivers, W. H. R. 1914. *The History of Melanesian Society*. 2 vols. Cambridge: Cambridge University Press.

———— 1922. *Essays on the Depopulation of Melanesia*. Cambridge: Cambridge University Press.

Sainsbury, Sir Robert, ed. 1978. *Robert and Lisa Sainsbury Collection*. Norwich: University of East Anglia.

Schmitz, Carl A. 1971. *Oceanic Art: Myth, Man and Image in the South Seas*. New York: Harry N. Abrams.

Speiser, Felix 1915. Die Ornamentik von Santa-Cruz. *Archiv Anthropologie, neue folge*, B, 8,15:323–4, Braunschweig.

———— 1916. Völkerkundeliches von den Santa-Cruz Inseln. *Ethnologica* 2:153–213.

Starzecka, Dorota Czarkowska, and B. A. L. Cranstone 1974. *The Solomon Islanders*. London: British Museum.

Stöhr, Waldemar 1987. *Schwarze Inseln der Sudsee: Melanesien*. Cologne: Rautenstrauch-Joest-Museum für Völkerkunde.

Valéry, Paul 1938. Preface. *Guide de l'exposition "Le Voyage de La Korrigane en Océanie"*. Paris: Musée de l'Homme.

van den Broek, Charles 1939. *Le Voyage de "La Korrigane."* Paris: Payot.

Waite, Deborah B. 1983. *Art of the Solomon Islands from the Collection of the Barbier-Müller Museum*. Geneva: Musée Barbier-Mueller.

———— 1987. *Artifacts from the Solomon Islands in the Julius L. Brenchley Collection*. London: British Museum.

Index

Author Note

Photograph by Ed Glendinning

William H. Davenport, a social anthropologist, received his Ph.D. from Yale University in 1956. He taught at Yale from 1956 to 1963 and then came to the University of Pennsylvania, where he spent most of his working life. At Penn he served both as Professor of Anthropology and Curator of the Oceania Section at the University of Pennsylvania Museum of Archaeology and Anthropology. He also taught at the University of California at Santa Cruz, Bryn Mawr College, and the University of Hawaii.

Davenport's interest in the Pacific region began during World War II when he served in the Navy's Merchant Marine, transporting troops and supplies from Hawaii to both the Solomon Islands and New Guinea. He returned to the Solomon Islands for twenty-one months from 1964 to 1966 to conduct research in the Central and Eastern Districts, returning there again in 1974 and 1976. It was during these periods of field work that he did the basic research for this catalogue raisonné and anthropological analysis of the figurative sculpture from Nendö, the main island of the Santa Cruz Islands group. In addition to the present seminal text, Davenport has published widely in anthropological and art journals on the arts and society in the Pacific and in Indonesia. A bibliography of his work can by found in W. W. Donner and J. G. Flanagan, eds., *Social Organization and Cultural Aesthetics, Essays in Honor of William H. Davenport* (Lanham, MD: University Press of America, 1997). *Hawaiian Sculpture*, a catalogue raisonné of the sculpture of the Hawaiian Islands published with J. Halley Cox in 1974, was reprinted by the University of Hawaii Press in 1988. On retirement, Davenport moved to the town of North East on the Eastern Shore of Maryland in order to be close to ships and the sea. He remained there until his death in 2004.